THEATER
IN THE
AMERICAS

A Series from
Southern
Illinois
University
Press
SCOTT
MAGELSSEN
Series Editor

PRESIDENTIAL LIBRARIES AS PERFORMANCE

Curating American Character from Herbert Hoover to George W. Bush

Jodi Kanter

Southern Illinois University Press
Carbondale

Southern Illinois University Press
www.siupress.com

Cover illustration by Vonda Yarberry

Library of Congress Cataloging-in-Publication Data
Names: Kanter, Jodi, 1970– author.
Title: Presidential libraries as performance : curating American character
 from Herbert Hoover to George W. Bush / Jodi Kanter.
Other titles: Curating American character from Herbert Hoover to
 George W. Bush
Description: Carbondale, IL : Southern Illinois University Press, [2016]
 | Series: Theater in the Americas | Includes bibliographical references
 and index.
Identifiers: LCCN 2015050129 | ISBN 9780809335206 (pbk. : alk. paper)
 | ISBN 9780809335213 (e-book)
Subjects: LCSH: Presidential libraries—United States. | Presidents—
 United States—History—20th century—Exhibitions. | Character—
 Political aspects—United States. | National characteristics, American.
 | Performative (Philosophy)
Classification: LCC CD3029.82 .K37 2016 | DDC 973.09/9—dc23 LC
 record available at http://lccn.loc.gov/2015050129

Printed on recycled paper. ♻

*For Riley, with abiding faith in the content of your character, and
for Jasper, with delight in all you are becoming*

Contents

Illustrations

Acknowledgments

My first expression of gratitude must go to my husband, Robby Jones, whose excitement about this project inspired me to begin it; who encouraged me throughout the long process of doing the research; and who dedicated many hours to reading drafts, always providing careful, thorough, and smart editorial feedback. My parents, Carol and Arnold Kanter, also provided unwavering moral support and helpful suggestions, reading the manuscript at several key moments in the writing process.

I am hugely indebted to Scott Magelssen, who has masterfully balanced his roles as conversation partner, editor, and friend.

At the presidential libraries, I want to thank especially those people who took the time to talk with me at length, including Tim Naftali, Mark Updegrove, Jay Hakes, Sharon Fawcett, Sam McClure, Lynn Bassinese, Sylvia Naguib, and William Snyder.

At Southern Illinois University Press, Kristine Priddy expertly—and efficiently—ushered the manuscript through the review and production process. Wayne Larsen and Ryan Masteller provided excellent copy editing of the manuscript.

I am grateful to all those who helped me obtain photos of particular exhibits, including Steve Branch, Tony Clark, Caitlin Dixon, Kenneth Hafeli, Heather Joines, Will King, Erika Simon, Janlyn Slach, Jodie Steck, Kathy Struss, and Pauline Testerman. I am also grateful to those friends and family who opened their homes to me during my travels, including Caitlin Dixon and Heath Row, Caren Saiet and Eric Winzenreid, Michael Freed and Liz Geist, Jean and Morry Wise, and Alan and Tiffany Wright. And I am grateful for the hands-on (and feet-on) investment of to two great traveling companions: Jonelle Niffenegger, who made it possible for me to research the Kennedy Library with an infant in tow, and Arnie Kanter, who gamely accompanied me on the barest terrain between the Truman, Eisenhower, and Hoover Libraries.

The Presidential Libraries at a Glance

President	Term(s) in Office	Library Location	Dedication	Last Renovation Completed
Hoover	1929–33	West Branch, IA	August 10, 1962	1992
Roosevelt	1933–37 1937–41 1941–45 1945–45 (died)	Hyde Park, NY	June 30, 1941	2013
Truman	1945–49 1949–53	Independence, MO	July 6, 1957	2004
Eisenhower	1953–57 1957–61	Abilene, KS	October 31, 1959	1971
Kennedy	1961–63 (died)	Boston, MA	October 20, 1979	2015
Johnson	1963–65 1965–68	Austin, TX	May 22, 1971	2012
Nixon	1969–73 1973–74 (resigned)	Yorba Linda, CA	July 19, 1990 (Private)	2010 (NARA)
Ford	1974–77	Grand Rapids, MI	September 18, 1981	1997
Carter	1977–81	Atlanta, GA	October 1, 1986	2009
Reagan	1981–85 1985–89	Simi Valley, CA	November 4, 1991	2010
Bush (41)	1989–93	College Station, TX	November 6, 1997	2007
Clinton	1993–97 1997–2001	Little Rock, AR	November 18, 2004	None
Bush (43)	2001–5 2005–9	Dallas, TX	April 25, 2013	None

NARA, *National Archives and Records Administration.*

Presidential Libraries as Performance

INTRODUCTION
Locating American Character at the Presidential Libraries

The setting is Washington, D.C. It is winter, 1938. The curtain opens on an office, but not just any office; this one is so famous that it has its very own name, recognized around the world as a place of power: The Oval Office. Seated at the desk inside the house he has called home for the last five years, President Franklin D. Roosevelt is worrying about history. In many ways, this is the very practice for which the office was designed. But he is not at this moment worried about shaping the content of history; rather, he is concerned about influencing public access to it. Specifically, he is worried about whether "millions of our citizens from every part of the land" will have access to the historical documents of this time and place, to "the story of what we have lived and are living today."[1] He knows that he wants to be able to answer this question differently than it has been answered before. Along with some of his contemporaries, Roosevelt is perhaps the first high-ranking politician to worry about public access to presidential history in this way.

Roosevelt is not a selfless man. Like any other head of state, ancient or modern, he seeks to secure for himself a vaunted place in the history of the nation and, with it, the world. But Roosevelt has also begun to develop a critical consciousness about the relationship between history and power. He has begun to understand the problems with the prevailing approach to history that Howard Zinn would influentially articulate forty years later:

> The past is told from the point of view of governments, conquerors, diplomats, leaders. It is as if they, like Columbus, deserve universal acceptance, as if they—the Founding Fathers, Jackson, Lincoln, Wilson, Roosevelt, Kennedy, the leading members of Congress, the famous Justices of the Supreme Court—represent the nation as a whole.[2]

Traditional forms of public history, Roosevelt recognizes, promote patriotism. But they also underrepresent and even misrepresent those who lack the numbers, money, or other resources to make themselves heard.

1

President Roosevelt and his advisors were the first national leaders to act on the emerging awareness of the narrowness of American public history. They took important steps to embed within the federal government "an approach to public history that expanded the definition of the historic"[3] through efforts such as the Historic American Building Survey and the Works Progress Administration with its Federal Writer's Program of citizen-historians. And, at the president's initiative, they commissioned the first presidential library to preserve the primary sources of American history.

Before this time, presidential materials were disposed of at the discretion of the chief executive, and many collections of important documents and artifacts were lost or destroyed. Roosevelt changed this practice by preserving not only his papers but his collections (Roosevelt was an avid collector), gifts, and personal memorabilia for public consumption. Because the library would be open to all Americans, citizens would for the first time have direct access to the archive of an administration and its leader, unmediated by the inevitable ideological distortions of historiography.

It was Roosevelt himself who conceived of the administrative plan which would be the blueprint for future libraries: the library building would be privately built and then given to the federal government to run as a public institution. Before making his plan public, Roosevelt submitted it to an advisory committee of American scholars, brought together by Harvard historian Samuel Eliot Morison. The committee strongly approved the plan, being "emphatically of the opinion" that FDR's collections were "too important as source materials for the study of recent American history to be held permanently in private custody."[4]

In making his presidential materials publicly available, Roosevelt explicitly affirmed the historic value of broad civic participation, proclaiming his faith in "the capacity of [America's] own people so to learn from the past that they can gain in judgment in creating their own future." And at the library dedication, a small ceremony to which he invited the facility's neighbors through an ad in the local newspaper, Roosevelt speculated aloud that future generations of Americans would be grateful for his foresight.[5]

But the democratizing effect of this new historical form would be partial at best. As Diana Taylor has elucidated, contrary to popular understanding, archival material is never unmediated. Indeed, "what makes an object archival is the process whereby it is selected, classified, and presented for analysis."[6] In the case of the first presidential library—and most thereafter—those who did the selecting, classifying, and presenting were intimate associates of the president, the president's family, and the president

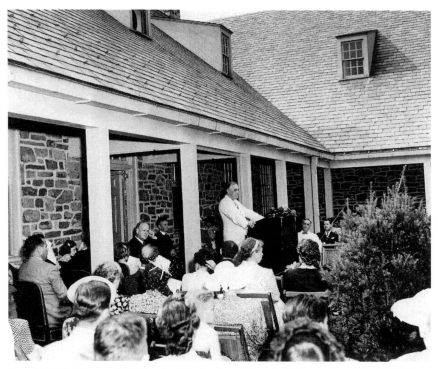

Franklin D. Roosevelt dedicates the first presidential library, June 30, 1941. *Photo courtesy of Franklin D. Roosevelt Presidential Library and Museum.*

himself. The materials would only become available to the public after the president had approved them for display. The exercise of presidential power, then, would play a major role in the performance of history at presidential museums.

Nonetheless, the idea of the presidential library opened up new opportunities for Americans to encounter the stuff of presidential history, even as new technologies made "live" presidential performance more and more subject to mediation. Even more importantly, Roosevelt ensured that the encounter would not happen in two dimensions. It was the presidential museum that ensured that presidential history, always already a mediated collection of performances, would be not just represented but re-practiced, re-performed in public space.[7]

Performance has always shaped the American presidency. In discussing the country's founders, performance scholar Tim Raphael notes that "from the beginning, the figures who would thrive on the American stage believed that their status as social actors was inextricably linked to the other kind of

acting, the kind in which their skills in the arts of rhetoric, oratory, elocution, and stagecraft constituted their political capital."[8] But, as Raphael also notes, the use of electronic technologies to enhance the efficacy of presidential performance is historically quite new.

Mediated performance came into its own with the presidency of Franklin Delano Roosevelt. Through his strategic use of radio for "fireside chats" with the American people, Roosevelt addressed a larger and more diverse audience at one time than any previous president. At the same time, through skillful vocal performance, he created a space of unprecedented intimacy between himself and ordinary citizens. It is not surprising that it was this first media-savvy president who conceived of the idea of a presidential museum in which visitors could enjoy carefully mediated stories of his own life and times long after he left office.

What *is* surprising is how little critical attention has been given to the American presidential library,[9] the chief executive's most important—and most expensive—post-presidential performance. Benjamin Hufbauer's 2006 book, *Presidential Temples*, remains the only comparative study of the museums. Hufbauer recognizes the potential of presidential museums to serve as "nodal points for the negotiation of who we are as a people," but warns that they "may increasingly become an attempt to sell uncritical acceptance of a president's self-proclaimed list of achievements and inspire veneration of an individual idol."[10] Although much of his close analysis of individual features of the museums is insightful, his disapproval, evident in his title, of what he regards as their "propagandist" purpose limits his ability to see more potential in these complex cultural spaces.

The premise of this book is different. We should not, I believe, waste our energies in lamenting the museums' tendency to misrepresent history in the service of aggrandizing the presidents they commemorate. Unquestionably, presidential museum exhibits and the buildings that house them tell the stories that certain powerful people—chief among them the presidents themselves, their families and influential friends—wish us to hear. If we evaluate them as rigorous historiography, they inevitably will disappoint.

Fortunately, we are not limited to the binary categories of propaganda and history. In *Presidential Libraries as Performance*, I argue that the lens of performance can help us view the presidential museum more productively. This lens, as Della Pollock explains, focuses our attention on the kind of representation that the linguist J. L. Austin, working in the middle of the twentieth century, called "performative utterances":

Insofar as an utterance is itself a form of action, insofar as it *performs* an action that may be followed or accompanied by other actions . . . it cannot be held to the standards of truth and falsehood that govern [other kinds of] speech. . . . As such, it makes questions of fact and fiction secondary, if not entirely moot. From the perspective of linguistic performativity, asking "is it true?" yields to "What does it *do?*"[11]

To consider a museum as a performance, then, is to approach it not as an attempt to brainwash us into believing a story that isn't "true," but as an account deliberately constructed to do particular work in a particular place, with particular consequences in mind for visitors. Barbara Kirshenblatt-Gimblett has argued influentially that museum exhibitions are "fundamentally theatrical" because they are "how museums perform the knowledge they create." Further and more importantly for the presidential library, they create what she calls a "museum effect," wherein "the museum experience itself becomes a model for experiencing life outside its walls."[12] In this sense, the museum experience invites the visitor to rehearse a new self. It models how—and who—she ought to be when she emerges.

Considered as performance, the presidential museum—not only through its exhibits but also through its setting, architecture, and spatial arrangement—acts out a particular version of the American story in order to dramatize particular ideas about who the president is and what he does. In the process, sometimes explicitly and sometimes by implication, the presidential museum also invites ordinary Americans to play a particular part in the story.

This acting out of who we are as citizens is not unique to presidential libraries. As Timothy Luke argues in *Museum Politics*, "Creating citizens is, to a significant degree, a process of institutionally organized impersonation. Each nation must develop a set of narratives for the political personality that imperfectly embodies the values and practices of its nationhood." Luke argues that museums are critical institutions in sustaining this process, possessed of "a power to shape collective values and social understandings in a decisively important fashion."[13]

This work is never finished. Museum exhibits are regularly redesigned to reflect newer values and understandings. Indeed, a few of the presidential libraries treated in this book have been renovated since I began my research, and others have renovations pending. My purpose here is not to provide a preview of or guide to what readers will see when they visit a particular museum in the future. Rather, I analyze some of what has been offered—and not offered—in these museum experiences in order to articulate and expand the

repertoire of strategies through which presidential libraries shape visitors'
performances of American character.

This book proceeds from the premise that if we have the tools to become
more adept at seeing and hearing these strategies as performances, we can
do more than cynically dismiss or naively impersonate them; we can shape
our own role in the story. In doing so, we become equipped to participate
in the making and remaking of what it means to be an American, helping
to generate a new kind of American history. By mapping performance at
the presidential museums, the present volume aims to foster this kind of
active engagement.

The Three Scripts of Presidential Museum Performance

To demonstrate how the presidential museums perform salient elements of
American character, I attend to three levels of analysis, traveling back and
forth between what might be understood as three distinct scripts. The first of
these is the *historical* script. What did the president actually *do?* What did he
accomplish and what were his failures? Although this part of the analysis at
first glance seems the most straightforward, it is in fact the most difficult. It is
difficult because of the nature of the presidency, to which our access is always
already mediated. It is difficult because presidential libraries are created and
sustained, by a system that, as I discuss in the next chapter, tends to dispose
them toward embellishing accomplishments and minimizing failures. And it
is difficult because of the nature of performance itself, which, as I take up in
more detail in chapter 3, is inherently elusive, always in the act of disappearing.

Nonetheless, there are things we can say with some degree of confidence
about what each president accomplished and what he did not accomplish.
Chapter 3, "Character Forever," takes up some of the ways in which the
libraries appropriately and effectively celebrate the presidents' enduring
accomplishments. Chapter 5, "Character Interrupted" takes up the limits
of individual achievement and the implications of these limits for the na-
tional character. Both chapters also examine some of the ways in which
the libraries perform meta-historically, enhancing our appreciation of the
nature of history itself.

Second, I analyze the *representational* script, the version of the historical
script crafted for and performed in the presidential library. Many years in
the designing, planning, and fabrication, the presidential library is the most
carefully constructed performance of every modern American presidency.
This level of evaluation is therefore subject to the challenges posed by all

historical narratives that, though they purport to present disembodied facts, necessarily mirror the mythical coherence of fictional stories.

But this challenge of historical narrative may also be its reward. "Far from being an antithetical opposite of historical narrative," writes Hayden White, "fictional narrative is its complement and ally in the universal human effort to reflect on the mystery of temporality."[14] Representation, in other words, is a necessary fiction; it fills in for what history is missing. It imposes a form on the otherwise formless series of events that comprise our past. And, in doing so, it makes our past meaningful.

Finally, I analyze the *cultural* script—that is, how are American presidents and the ordinary Americans who follow them *supposed* to perform, and where do these normative expectations come from? Over the last seventy-five years or more, sociologists have argued that what we call American character has essentially two major components: an individualist ethic of achievement and a communitarian ethic of equality.[15] Seymour Martin Lipset, whose work on American character beginning in the early 1960s has been among the most influential, identifies the roots of the ethics of achievement and equality in the Revolutionary and Puritan traditions, respectively. He argues that American character has changed very little since the nation's beginnings. Rather, it has shifted back and forth between these two core components. The tension between them is as old as America itself. It is this tension that comprises the core of American character.[16]

A performance lens encourages us to see the roots of the American ethics of achievement and equality as more expansive than Lipset suggests. Performance studies is centrally concerned with individual agency—that is, with the actor's ability to speak and act for herself. Grounded in part in the cultural theory of deconstruction, the discipline looks for ways in which subjects break through social and cultural constraints to create meaning on their own terms. This is, as I will argue in chapter 4, essentially the movement promised in the achievement-oriented narrative of the American Dream.

But performance studies is equally concerned with the formation of community. In several of the following chapters, I argue for the salience of a particular trope in the shared cultural understanding of what it means to "act like an American." Chapter 4, for example, takes up the normative power of the American Dream, and chapter 5 explores the expectation of efficiency in the American workplace. While these norms can be problematic, even damaging, many of them also facilitate growth for leaders and ordinary citizens alike.

These foundational American ethics were created and continue to be reinforced through performance. Chapter 2 compares the representations of presidential performance at two very different libraries and their effects on the visitor's experience of American character. And chapter 6 explores some elements of the American community that are underrepresented in the library system.

Throughout, I consider the museums as public performances of presidential character and of American character writ large. As prominent but neglected sites of study, presidential museums can tell us important things about the relationships between performance and politics, leaders and the people they lead, American character and American community.

Education and Inspiration at Presidential Museums

The stated mission of the presidential library system is to "promote understanding of the presidency and the American experience. We preserve and provide access to historical materials, support research, and create interactive programs and exhibits that educate and inspire."[17] The effort to create both authoritative histories (to educate) and spaces for emotional engagement (to inspire) is the archetypal struggle behind the American history museum. On the one hand, museums strive to be historically reliable, telling us the facts about what happened and guiding us on the correct path through the story. On the other hand, they seek to foster deep investments, both psychological and practical, in particular versions of particular stories. And this cannot be merely an intellectual exercise; museums cannot effectively engage visitors unless they stimulate us through affect, sensory experience, and participation. They must engage our imaginations and our bodies. This is a job for performance.

As a practice, performance has long been at home in the American museum. Because the theater was its chief institutional competitor, the museum of the nineteenth century tried to do what theaters did: "mount dramatic entertainments or present variety acts," but they did so "under the guise of education and public enlightenment." Since museum lecture rooms were not theaters, "however transparent, the fiction [of education] was effective."[18]

Today, American museums continue to navigate the tensions between education and inspiration. And, increasingly, museum administrators have resigned themselves to this tension as a permanent feature of their work. Elaine Gurian, for example, admits that "museum professionals do not want to be in show business; we want to be in academia. And yet, like it or not,

exhibitions are in part public entertainment."[19] Gurian counsels museum professionals to swallow this pill and get on with their work.

Despite museums' longstanding relationship with the theatrical, it is only in the last three or four decades that they have invited visitors to get in on the act. Susan Bennett traces the evolution of museum practices from "collection and display to pedagogy and participation."[20] Because of this shift, performance scholarship is becoming increasingly instrumental in illuminating visitors' experiences within museums. The last few years alone have seen global performance studies focusing on topics including the "bodily techniques" of the museum visitor,[21] the museum as a performance of religious orthodoxy,[22] the museum as an instrument of social management in nineteenth-century France and Australia,[23] and the museum as a reification of dominant ideologies around the world.[24] In the United States, performance-centered studies of museums have included Barbara Kirshenblatt-Gimblett's influential 1998 study of heritage and tourism, *Destination Culture*, and Scott Magelssen's recent study of historical reenactments in museums, *Simming*.

Jonas Barish argues that this pervasive element of performance, not only in the museum but in American cultural life as a whole, ought not to be lamented. There need not be an inherent conflict between entertainment and historical accuracy. For Barish, to behave authentically is not to escape the theatricality of everyday life but rather "to perform 'acts,' to invent ourselves from nothing, neither shamed nor frozen into ineffectuality by the sea of faces that surrounds us."[25] The value of theatricality is its ability to foster agency within and against social forces that would have us act otherwise. The increasing involvement of performance scholars in museum studies has helped to foster a greater appreciation of the value that "acting" and "acts" can bring to the making of history.

Nonetheless, it is important not to be too sanguine about the increasing focus on the performativity of museums and their visitors. As Susan Bennett warns, following scholars such as Michel Foucault and Judith Butler, performed outcomes "can be coerced as much as inspired."[26] And, at the other end of the spectrum, Luke warns that museum critics "must not simply critique one limited set of political engagements by the established social formations in order to substitute his or her own apparently different, but also quite limited, ends to the service of these same means."[27] Performativity, in other words, may be put to sinister use.

In the introduction to an edited volume of performance-centered museum studies, Magelssen writes, "the space of the museum is haunted by

issues of contested public memory, politics, taste, accuracy, and clashes of education and entertainment. At the same time, that very space is one of potential, change, agency, and redress."[28] This study locates potential, change, agency, and redress not only in presidential libraries' performances of American character but also in visitors' own performances as they move into the libraries, through the museum displays, and back into the world.

Presidential Libraries as Performance is divided into three sections that move loosely from a focus on how the presidential libraries perform a received cultural script of American character to a focus on how the libraries do and might further disrupt this dominant narrative of "character" in the American context. Most of the chapters examine multiple performance models across two or more of the extant thirteen presidential libraries administered by the National Archives and Records Administration (NARA).

In part one, I consider some of the ways in which the funding of the museums and their spatial organization concretely affect visitors' experiences. The first chapter, "Character in Play," examines how the institutional structure of the presidential library shapes its performance of American character. It analyzes the special case of the Richard Nixon Presidential Library, where that structure was most vigorously contested. Embroiled in legal battles from the moment the president resigned in 1974, the library only came under the auspices of the National Archives in 2007. Drawing on interviews with key presidential library designers and administrators, the chapter identifies four distinct versions of Nixon's character that the library's two major stakeholders produced. It also calls for greater transparency about the funding of representation at presidential museums.

In part two, I look at the libraries as performances of an individual-centered American character, one that emphasizes independence and achievement. Chapter 2, "Character in Motion," demonstrates how the library sites, exhibit structures, and spatial organization foster particular kinds of participation by museum visitors. Drawing on recent cultural theory at the intersection of museum studies and performance, it analyzes how the library spaces of the two most popular presidents of the late twentieth century, Ronald Reagan and Bill Clinton, invite the visitor to create strikingly different performances of American character. These differences, I argue, have important implications for what it means to act like an American beyond the museums' walls.

In chapter 3, "Character Forever," I turn to work in performance and cultural studies on mourning in public life in order to examine the representation of presidential legacy in the Truman, Eisenhower, Kennedy, Johnson,

and Reagan museums. While at their worst these legacy galleries fetishize the president's body, many of them provide valuable insight into the ways in which Americans do and might rehearse their own longings for immortality beyond the museum. In doing so, they practice a kind of hopefulness about the future that is also a core component of American character.

In the last section, building on examples from the library system, I suggest ways in which the museums might diversify their structures, contents, and modes of expression in order to more fully represent the interdependence and diversity of American experience in the twenty-first century. Building on Jill Dolan's work on utopian performatives, chapter 4, "Utopian Character," examines performance at presidential libraries as a useful aspirational fiction. It begins by using contemporary sociological studies to explore how individual merit, a core component of the American Dream, is constructed in the national imagination. The chapter provides a brief overview of representational patterns in the galleries that narrate the chief executive's development through childhood and young adulthood. It then carefully analyzes the examples of the exhibits at the Carter and Hoover Libraries, which provide the most substantive performances of the presidents' early lives. While critical of the historical obfuscations on which claims of merit inevitably depend, the chapter nonetheless affirms the importance of the tenets of individual merit in the shaping of American character.

Chapter 5, "Character Failure," explores those places in the museums where a performance lens does—or could—create an opportunity for appreciating the discontinuity of American history. Employing a performative understanding of historical narrative against a cultural script of continuous efficiency in the contemporary American workforce, it looks at three types of disruptions in presidential performance: failure of political judgment, failure of personal judgment, and failure in the contest for the presidency. It argues that making each of these disruptions more visible through representation in presidential museums would better foster the museums' dual mission of educating and inspiring visitors. Performing these disruptions would also foster better understanding of presidential character and its relationship to American character.

Finally, in chapter 6, "Performing the American Community," I focus on how the libraries represent the work of other key actors in the shaping of presidential character. These others include friends and family, members of the administration, foreign leaders, and diverse populations of ordinary Americans. Focusing on this last group, I consider the performances of American culture in several of the museums. I argue that the libraries'

culture galleries are an underutilized resource for performing the diversity of American experience. More generally, I argue that opening up a larger role for performance, both as an analytic trope and as a practice within the museums, could help us to better understand the making and remaking of American character at presidential libraries and beyond.

The coda, "Character 2.0," explores how the reinvention of the presidential library might make it more responsive to the demands of public memory keeping—and memory making—in the twenty-first century. Here I argue that a propensity for reinvention is itself a core aspect of American character.

In between several of the chapters are short interludes of my own devising that performatively extend some of the smaller, more personal moments in the museums. I include them in order to re-present the spaces of affect and imagination they opened up for me. As Rebecca Schneider and others have noted, "there has been something of an 'affective turn' in scholarship, coming close on the heels of the 'performative turn.'" The power of thinking through affect, Schneider argues, is that it "offers a radical shift in thinking about our mobilities in dealings with the binaried landscapes of social plots (such as gender, such as race)"—and such as American two-party politics. When they open affective spaces, the displays can begin to undo "the solidity of binaries in favor of the slip and slide of affective negotiation."[29] These vignettes enact my own desire for larger and more frequent examples of such slippery engagement in all the presidential library exhibitions.

Two existential questions loom over the presidential library system. First, should the extant libraries continue to exist? Are the museums worthy of the considerable sums of money and human resources required to staff, maintain, and occasionally renovate them? Second, should we continue to build presidential libraries? Do we need such an institution for every leader of our country? Does every outgoing president need to devote his own time and resources to raising the money required to build them? Will the American landscape become, in the foreseeable future, littered with them?

Both of these important questions are beyond the scope of my project here. Rather, I want to ask a more pragmatic pair of questions: given that we have—and are currently continuing to expand—a national system of presidential libraries, how can stakeholders and museum professionals shape their forms and contents so that the experience of visiting them is more meaningful for more people? And how can we, as visitors, make more meaning from what they give us?

PART ONE

*Museum Funding, Visitor Participation,
and Presidential Character*

1. CHARACTER IN PLAY
Performance Authority at the Presidential Library

It is July 19, 1990. The Nixon Library has just been dedicated in a grand ceremony featuring three former presidents as well as the current one. Now, the guest of honor is making a victory lap around the new building with his guests. He leads them proudly through the Hall of World Leaders, his favorite room and one he conceptualized himself. He basks in the oohs and aahs with which his guests greet the international affairs gallery, and they linger there awhile. Then he parades them through the domestic affairs gallery and on to the post-presidential gallery, a replica of the home office where he has worked so hard for so long as an elder statesman. But one of the invited guests feels uneasy. She thinks to herself, *Something is missing.* And then she realizes: the president has skipped the Watergate gallery.[1]

When the tour is over, she sneaks back to look at it. He needn't have skipped it, really; there wasn't much there: a cursory review of the events of the scandal and a glance at the administration's involvement. Nothing to indicate that the president himself was involved. She interrogates her own unease. *He's entitled to give the tour he wants to give, to tell the story he wants to tell—isn't he? After all, it's his library. Isn't it?*

Well . . . it was then. Even more than most presidential libraries, it would have been accurate to say that the performance of history the original Nixon Library offered its visitors was very much the president's. Today, however, performance authority at the Nixon Library, more completely than in most presidential libraries, belongs to the federal government. As in the other dozen extant presidential libraries, performance authority transferred from the president and his supporters to the National Archives and Records Administration (NARA), which appointed the museum director and administers the library on an ongoing basis. But unlike the other twelve processes, the transfer from private to public ownership did not happen smoothly. The story of the vexed funding of the Nixon Library sheds light on how strongly key stakeholders influence the performances that visitors to presidential libraries experience.

To understand the nature of performance at presidential libraries, one must first understand what these institutions are and how they are funded. Presidential libraries are, in the language of contemporary cultural studies, memory places. Along with other museums, preservation sites, battlefields, and memorials, they "enjoy a significance seemingly unmatched by other material supports of public memory, at least in the United States."[2] Like any memory place, a presidential library has many stakeholders. These stakeholders may vary from administration to administration, but in every case, the two entities with legal authority over—and the strongest economic interest in—the representation of presidential character are each library's presidential foundation and NARA. The former is an entity established by close associates of the president during or shortly after his presidency, usually created for the express purpose of raising the money to build the library and prepare the original museum exhibit. The latter legally owns many of the papers and artifacts that will comprise the library's core exhibits. It also appoints the museums' directors and assumes responsibility for the administration and maintenance of the library immediately after its opening.

The manner in which the presidential library moves from private to public ownership appears straightforward. Immediately upon its completion, the library is given to the archivist of the United States, to be administered and maintained by the National Archives. Since the Nixon administration, presidential papers have become the property of the National Archives immediately following the president's term of service, with more recent presidents choosing to avail themselves of "courtesy storage" at NARA even earlier.

But the transfer of authority to the National Archives is seldom clean. In most of the museums, the presidential foundations continue to administer parts of the institution, including the museum store, museum café, and even some exhibit spaces. And some foundations maintain a heavy influence on where the museum focuses its resources.

The partnership between the presidential foundations and the federal government is in some sense a marriage of convenience. From the government, the foundations receive assistance in the design, management, and upkeep of the library building, as well as technical assistance in the management and preservation of historical records. From the foundations, the National Archives gains a local presence in an increasing number of communities across the country and the financial resources to mount more and higher quality exhibitions than it could present alone.

Beyond these practical benefits, there is also some natural affinity of interest between these two stakeholders. Typically, the foundation leadership

is primarily invested in presenting an individual with whom they more often than not had significant personal ties in the best possible light. In the performance they would craft, the president is the primary actor in American history. Presidents themselves usually actively support the effort to construct such a performance, since "most presidents, even if they would not phrase it this way, hope to find a place for themselves in what has been called the civil religion of the United States—that veneration that has existed since the country's founding for particular events, people, and things."[3] The libraries' original exhibitions, funded by the foundations, are notorious for underrepresenting or altogether omitting episodes and elements that might reflect poorly on the president, however historically significant they may be. NARA expects and permits this self-serving selection process, content to address it through revision of the exhibit over the long term.

On the foundation side, the precise nature of the interest is complicated by the idiosyncratic nature of the organizations themselves. "The private organizations don't all share the same agenda," Deputy Director of Presidential Libraries Sam McClure explains. "There's no cohesive foundation agenda for presidential libraries. It's much more of a, almost a feudal system." At the Reagan Library, for example, "the foundation leadership is much more driving toward a vibrant, viable attraction and all that that means," especially since the president's death. There, in other words, the foundation is less interested in the history of Reagan's presidency per se than in the commercial success of the Reagan Library. The Carter Center is also driven by interests outside of presidential history. There the foundation is "fairly well funded, but their priorities are not really about promoting the legacy of Jimmy Carter in terms of museum exhibits or programs but rather fulfilling his agenda."[4] Much of the energy and resources of the foundation go toward supporting the Carter Center, which conducts global health and human rights initiatives. The Kennedy Library Foundation, by contrast, supports the library's stated mission of honoring Kennedy's memory, dedicating significant resources to museum displays on the Kennedy presidency, and leading the library system in the electronic preservation of presidential papers.

For its part, NARA, while presumably less invested in endorsing the character and behavior of any individual leader, has its own interest in creating a performance that reflects well on the government's most prestigious office and, by extension, its occupants. Sam McClure notes that, in 1974, NARA received a legal mandate to protect the chief executive from damaging displays. In the Supreme Court decision in *United States vs. Nixon*, the conceptual validity of an "executive privilege" was first formally acknowledged. As a

federal entity, however, NARA also has a greater interest in ensuring the historical accuracy of the museum exhibits than the private foundations.

But McClure also acknowledges that the government's interest in protecting the presidency extends beyond strictly legal matters. In an interview for this book he elaborated:

> In some ways we do reinforce this sort of grandeur. We do have these grand spaces that they build, that they can inhabit . . . that we'll hold for the rest of the life of the republic and give free, you know, unfettered access to or unfavored access to (we'll have legal fetters on some of that access for some time). But I do think we do reinforce some of that. I don't know how we would get around it, to be honest.[5]

Although not identical to the foundation's interest, the government, too, has an interest in funding grand performances of the presidency.

Despite these affinities, there remains a tension between the former president's wish to represent his views of his life and presidency and NARA's mandate to "represent the President both accurately and objectively and to give balanced emphasis to various phases of the historical developments involved."[6] The complex and sometimes deeply personal interests on the part of its administrators have led to frequent disagreements between the presidential libraries' two masters, the private presidential foundation and the National Archives. In the relatively short history of presidential libraries, there have been disputes not only over what should be included in exhibitions but also over who should direct a given institution (a decision made by NARA) and how new projects should be funded (with the foundation typically but not always bearing the financial burden).

Usually, such internal disputes over the work of presidential libraries and the compromises that end them remain invisible to the public. But in the case of the Nixon Library, the initial negotiation between the two stakeholders was protracted, exceptionally contentious, and unusually public, amounting to what Assistant Archivist for Presidential Libraries Sharon Fawcett called, with only slight hyperbole, "the thirty years' war."[7]

The conflict over the fate and character of the Nixon library began less than five months after President Nixon's resignation on August 9, 1974. In December of that year, Congress passed the Presidential Recordings and Materials Preservations Act (PRMPA), which authorized NARA to take possession of the president's papers.[8] This legislation was drafted in response to news

that President Nixon, only weeks after resigning office, had concluded an arrangement with the head of the General Services Administration that would have allowed him to destroy materials in the collection.[9]

The passage of PRMPA resulted in more than two decades of litigation over the Nixon presidential materials. Battles were waged repeatedly in both the D.C. District Court and the U.S. Court of Appeals. On July 19, 1990, with the National Archives still in possession of the Nixon presidential papers, the library opened as a privately owned and funded museum with NARA agreeing to loan select materials to the museum for display but retaining control of the collection.[10] This arrangement made the Nixon Library the first presidential library since the advent of the federal system to opt out of governmental administration.

Ten years later, in 2000, the Nixon estate won $18 million from the U.S. government in compensation for the value of the presidential papers it had been prevented from obtaining. The compensation was particularly important to the library because, as a private institution, it did not receive the federal funding the other presidential libraries received.

Meanwhile, the president's two daughters, Julie Nixon Eisenhower and Tricia Nixon Cox, began fighting a parallel battle over how the library should be run. Eisenhower advocated professionalism for the institution and an independent board; in the long term, she hoped that the library would become part of the federally administered system. Cox argued that in order to protect their father's legacy, the family had to maintain control of the institution. The disagreement was so heated that, in 1996, the sisters stopped speaking to each other.[11]

In 1998, Charles "Bebe" Rebozo, a close friend of Nixon's, died, leaving a $19 million bequest to the library on the condition that the money be controlled by three people: Eisenhower, Cox, and Robert Abplanalp, another close family friend. But the sisters could not agree on how the library would be run and the funds were held hostage by their feud. In 2002 the battle abruptly became public when the library filed lawsuits against Cox and Rebozo's own foundation (in California and Florida, respectively) in an effort to obtain control over the gift. Later that year in a sixteen-hour closed-door session involving lawyers and mediators, the dispute was resolved, producing an agreement that freed up the money and opened the door to the federal administration of the library.

Finally, in July 2007, following the 2004 amendment of PRMPA to allow for the physical transfer of materials outside of the D.C. area, the Nixon Library became the twelfth federally funded presidential library operated

and staffed by NARA. The Archives appointed Cold War historian Timothy Naftali as the new library's first director. Thirty-three years of negotiation, much of it highly contentious, had come to an end.

The protracted story of the change in administration of the Nixon Library makes it startlingly clear that different stakeholders are differently invested in the performances of presidential libraries. Different communities patronize, through funding and other forms of participation, the telling of different kinds of stories. Indeed, these investments are themselves part of the story, even if they remain hidden from the view of most visitors. As David Greenberg argued about earlier investments in Nixon's story, "These interpretations themselves, whatever their accuracy, mattered to postwar history. Thoughts about Nixon affected people's lives, prompted them to act, and lastingly altered their attitudes toward the world."[12] In this way, too, the performances of presidential libraries matter to American history; they affect our understanding of our leaders' characters and with it the nature of our participation in their stories.

Act 1: The Site's Story—Performing Ambivalence at the Nixon Library

Although presidents and their foundations are authorized to select their library sites, they in fact have little authority over the location of the library building. In the case of the Nixon Library, the weakness of this authority was evident both in the history of the site's selection and in its ultimate locale.

As with many presidential libraries, this one did not land at the site the Nixon family originally had in mind. When the plan to establish the library at Duke University, where Nixon went to law school, fell apart under faculty opposition, the Nixon Foundation decided upon San Clemente, California, where Nixon had his western office. But when building at San Clemente was delayed for several years, the library site was moved to Yorba Linda, the location of Nixon's childhood home.

Before my first visit even began, I understood the foundation's ambivalence about the place. The Nixon Presidential Library is located on a major thoroughfare in Yorba Linda, California, and yet it is surprisingly difficult to find. I drove there from Los Angeles in June 2011, and when my GPS announced with enthusiasm "You have arrived!," I could find nothing to confirm this proclamation on the busy, strip-mall-laden road. No signs appeared on the road or sidewalk, and no building looked conspicuously like a landmark of any kind. When the street numbers indicated that I had clearly

gone too far, I made a U-turn and, on my way back, noticed a small green sign the size of a parking regulation notice on the right side of the road that marked the library's presence behind a tall hedge. I turned right into a large parking area and drove past what looked like a car dealership, closed that early morning. I remained unconvinced that I had found the place until I finally saw the building.

The Nixon family was able to exercise a bit more authority over the design of the library building than over the site itself. The president asked architects at Langdon Wilson Architecture Planning to design a building that was traditional rather than modernist, and without pretension.[13] In the corner of the lot, anachronistic in its business district environs, I found a red sandstone building adorned with tall classical pillars and supported by a white cement foundation.[14] It did not face the main road; instead, it was tucked into the furthest back corner of the mall. Unlike the other presidential libraries, it boasted no central courtyard or generous front lawn; although the building was large, its footprint was small, even cramped. But walking in, I found confirmation that I had, indeed, arrived.

The stately lobby of the Richard M. Nixon Presidential Library was largely empty. To the left of the entrance was a shop that sold admissions tickets, and on the far periphery stood some glass cases containing a few old photos and dry-mounted bits of text about Nixon's childhood. Perhaps twenty feet further, at a seemingly random spot on the gleaming, open floor, there was a small television surrounded by a dozen haphazardly arranged folding chairs. (I learned later that the library's welcome theater was being renovated, but no signage indicated this.) Similarly, an eight-by-ten photograph of President Obama hung a few feet away in a cheap plastic frame, also appearing to have been placed there hurriedly and without much care.

Although a few visitors came straggling in later in the day, that morning I appeared to be the only nonstaff person on the premises. I sat alone through the lengthy introductory videotape, composed largely of poor-quality footage of Nixon at various public events. The video's sound was muffled, and the narrative seemed to leave off rather than conclude. While other museum introductory films boast celebrity narrators (actor Gary Sinise, whose picture is on the home page of the Reagan Library website, hosts the online introduction of that museum, and actor Martin Sheen narrates the introduction to the Carter museum), the Nixon video is narrated by the disembodied and dispassionate voice of the library director.

My first impressions of the museum, then, were of a profound ambivalence about its very existence. On the one hand, the building sat on a main

thoroughfare of Yorba Linda and commanded authority through its classical design. On the other hand, no prominent signs or markers directed visitors to what was, after all, a site of national importance. The building itself, oddly situated in profile to the street, seemed to turn its face from prospective visitors. And the low-tech introductory video and display cases seemed lost in the cavernous, marble lobby. In short, the site seemed to claim performance authority and, at the same time, to shrink from it.

Act 2: The Foundation's Story—Nixon as Success

Arguably, more people have poured more energy into the shaping of Nixon's public character than that of any other president; and no one has participated in this process more doggedly than Nixon himself. H. R. Haldeman, the president's closest aide and architect of his political espionage, described the president as a man "obsessed" with maintaining his public image. David Greenberg elaborates:

> No postwar politician did more to educate Americans to the primacy of images in politics. Nixon embraced the new tools of political artistry and used them to his advantage. Ironically, he also used them, quite often, ineptly—exposing, if inadvertently, how much artistry was at work. And Nixon served as a vehicle through which various groups struggled to make sense of this emerging image-ridden political culture.[15]

Greenberg's study, *Nixon's Shadow*, identifies eight distinct versions of Nixon's character and delineates the distinct public groups that dedicated themselves to forwarding each persona as the prevailing public image of the president through a variety of public forums. While he does not use an explicitly performance-based theoretical lens, Greenberg rigorously traces the investment of different American communities in divergent versions of Nixon's character. Not surprisingly, the performance of character in the original Nixon museum, conceived and funded by a foundation comprised of family members and friends, emphasized the most flattering of these images.

Foremost among the most complimentary versions of Nixon's character is the idea of the president as a peacemaker. "Of the many Nixons," Greenberg writes, "the foreign policy sage is the face Nixon himself worked hardest to present to history." In addition to the president and his most ardent loyalists, the group that most vigorously supported this positive, even noble version of Nixon's character was "an elite coterie of writers and

officials sometimes called the foreign policy establishment."[16] Not surprisingly, then, Nixon as peacemaker is a leading character in the original exhibition of the Nixon Library. Yet even here, the performance of Nixon's character is marked by ambivalence.

The most important rooms in the original Nixon Library are those devoted to international relations. The first of these is the Hall of World Leaders, a brightly lit gallery filled with life-sized statues of ten important statesmen of Nixon's time. The former president specifically requested the creation of this room and selected the figures whose bronze images occupy it. They include Mao Tse-Tung and Chou En-lai, Nikita Khrushchev and Leonid Brezhnev, Anwar el-Sadat, Golda Meir, and Winston Churchill. The "interactive" component of the exhibit allows one to touch the image of a sculpture on a computer screen and display the name and title of its subject. The flags of the leaders' nations hang suspended from the ceiling, and the back wall of the room showcases some state gifts.

The room does not, however, provide information about Nixon's direct dealings with these leaders, nor does it elucidate what he viewed as their most important accomplishments. In fact, Nixon himself is conspicuously absent from the room in image, voice, or text, except as part of a single photograph on display. Taken at the museum's dedication ceremony, the photo captures the five living presidents standing in the World Leaders hall. Though all of the men are relatively tall and all are accustomed to posing for photographs, the presidents are dwarfed by the more imposing figures of the bronze monuments. The men look as though they were ordinary tourists in the Hall of World Leaders rather than valuable exhibits themselves. The Hall of World Leaders has the unintended consequence of underscoring Nixon's absence among the great statesmen of his time.

The World Leaders hall opens onto the library's largest gallery. Entitled "Structure of Peace," the gallery houses three-dimensional displays devoted to each of the nations with which Nixon conducted important diplomatic relations. Beside the doorway of the gallery is a quotation from the president, the irony of which, in the context of Nixon's domestic performance, it is impossible to think would have been lost on the exhibit designers: "Let all nations know that during this administration our lines of communication will be open. We seek an open world . . ." The dark, windowless gallery includes a number of structures representing Nixon's most celebrated relationships with specific nations: gilded replicas of Beijing's China Gate and Moscow's St. Basil's and, oddly, an American-style bungalow (described by the library's website as a South Vietnamese house) with aluminum siding and a garden

hose. Here, although the presentation style feels dated and the controversy around Nixon's policies, particularly in Vietnam, is occluded, one can at least gain an appreciation for the scope of Nixon's engagement in foreign affairs.

The large amount of space dedicated to Nixon's international statesmanship in office is commensurate with his focus throughout much of his administration. In his first inaugural address, Nixon famously said, "The greatest honor history can bestow is the title of peacemaker."[17] Nixon in effect bestowed this greatest honor on himself when he chose this statement for his epitaph. At his gravesite, just steps from the museum building, it is these words that lie over—and stand in for—Richard Nixon.

One other image of Nixon from the original museum is worth noting. In both his public and private lives, the foundation performed Nixon as a winner. The erection of the museum on the site of his father's failed ranch stages Nixon's genealogy as one of ultimate triumph over defeat. The museum's introductory film, entitled *Never Give Up*, touts Nixon's perseverance through a losing presidential bid in 1960 and a losing gubernatorial bid in 1962. The film declines to acknowledge his direct involvement in Watergate, noting in passing that his aides had been involved in the cover-up, and concluding without discussing his resignation. In the final words of the video, the narrator intones, "He was in the deepest valley. But he would not stay there for long." Presumably, the allusion is to Nixon's Herculean efforts to repair his reputation in his postpresidential years, efforts the library attempts to make successful by describing them as such.

Even more revealingly, the library exhibit offers as one of the very few details about Nixon's early life a quotation from his high school football coach: "Show me a good loser and I'll show you a loser." This quotation foreshadows Nixon's central image control strategy following his presidency, and it is one the museum repeats: Nixon presented himself as a winner by baldly refusing to admit defeat. Although this strategy is evident in the original exhibit only by omission, it is made explicit in the new Watergate exhibit, discussed below.

Finally, lest there be any doubt about how the visitor should assign authority for this winning performance, the library presents Nixon as a loner. The museum provides very few details about either of Nixon's vice presidents, his cabinet members, or his political advisors. It includes the famous image of Nixon bowling by himself at the one-lane White House bowling alley, an image with even greater resonance for anyone familiar with Robert Putnam's subsequent study of the decline of community in America that used bowling as its title metaphor.[18] And perhaps most interestingly,

the museum forgoes the traditional replica of the Oval Office in favor of a replica of the Lincoln Sitting Room. Nixon, a caption explains, preferred to work in this much more private space located on the second floor of the residence portion of the White House when writing important speeches and making critical decisions.

As presented here, Nixon's isolation adds to the glory of his global triumphs. The visitor has the impression that whatever Nixon accomplished, he accomplished all alone. Absent from the library is the darker side of Nixon's isolation most evident in his relationship with the press. Nowhere does the visitor have the opportunity to learn that Nixon rarely gave interviews, that he held fewer press conferences than any president since Herbert Hoover,[19] or that he routinely refused to speak with reporters or allow them to accompany him on trips. (His hostility to the press is most famously memorialized in the 1962 "last press conference" when he told reporters that they would no longer have him to kick around, presenting himself as a victim of media mistreatment.) It was this aspect of Nixon's loner character—his efforts to prevent the press and, eventually, the American people from knowing him—that would ultimately lead him to make a very different kind of history.

(Inter)Mission: Hiding "Tricky Dick"

Some of the most indelible performances that contributed to a public memory of Nixon as an unsavory character happened long before he ran for president. Indeed, he acquired the moniker "Tricky Dick" from the "dirty tricks" he used in his 1950 senate race.[20] But finally, this version of Nixon's character was permanently imprinted on public memory by Watergate and by Nixon's insistence, ultimately proved false by legal evidence, that he was "not a crook."

At the Nixon Library, Watergate was at the heart of the battle over Nixon's character. Reviews of the library noted the omission of any substantive treatment of the events with an undisguised tone of shock. Historian Jon Wiener, for example, wrote this about the Watergate gallery:

> [The gallery] doesn't mention Nixon's use of the FBI, CIA, and White House "plumbers" to harass, spy on, and punish those on the President's "enemies list." It doesn't mention the criminal convictions of Nixon's senior aides for carrying out these actions. . . . Most incredible of all, it doesn't mention that Gerald Ford pardoned Nixon for his crimes. Instead, the Watergate Affair is described the way Nixon has always described it: not

as a systematic abuse of power, but as a single act, a second rate burglary carried out by overzealous underlings without his knowledge, followed by a partisan vendetta. . . . [21]

It was not just that the exhibit blamed the president's opponents for exploiting his mistakes for political advantage. It was not just that it blamed Nixon's aides and eliminated the direct role that Nixon played in the events. It was that the exhibit blatantly misrepresented history, denying the cover-up of Watergate and the resulting obstruction of justice.

But, in the federal presidential library system at least, there would be no Nixon without Watergate. The National Archives made the overhaul of the Watergate exhibit a nonnegotiable condition of their agreement to take over the Nixon Library.[22] The mandate to contend with the reality of Watergate has meant that those groups most invested in representing the dark side of Nixon's character have won the cultural tug-of-war, at least insofar as they have succeeded in securing a place for the unsavory elements of Nixon's character signaled by the popular moniker "Tricky Dick," in the Nixon Library.

And, no matter what one's politics, this is surely as it should be. As Greenberg writes, although other images of Nixon championed by other interested communities "were not without basis in reality,"

> the effort to judge Nixon on his entire life and career had to accept that no other president directed a criminal conspiracy from the White House; that none so grievously traduced the Constitution; that none so eagerly abused his power; that none resigned under duress because of the magnitude and scope of his wrongdoing.[23]

In order to be responsible to both American history and American culture, the library funded by the president's closest allies would ultimately be called upon to do what the president himself never could do: acknowledge the shadowy side of his character.

Act 3: NARA's Story—Performing "Tricky Dick"

In 2002, on the thirtieth anniversary of the Watergate break-in, an ABC News poll found that 65 percent of the American public said that they didn't know the basic facts of Watergate well enough to explain them to someone else.[24] Such a statistic could readily serve as evidence of Americans' much vaunted historical ignorance, the conventional wisdom borne out

by numerous scholarly studies that Americans "know relatively little about their past and have an underdeveloped sense of how history happens."[25]

In the case of Watergate, however, it is important to note that the "basic facts" are extraordinarily complicated. Woodward and Bernstein's *All the President's Men*, for example, begins with a dramatis personae that lists no less than thirty-five major characters. Although adapted by Robert Redford into the ultimate edge-of-your-seat journalistic detective story, the book takes frequent detours from this genre in order to catalogue the mind-numbing minutiae necessary to understand how each of these characters fits into the story.

In 2011, four years after its transfer to the National Archives, the Nixon Library opened a new and long-awaited exhibit on Watergate. The new exhibit occupies several galleries and exhaustively explores each phase of the scandal through text, photographs, and recorded oral history testimony from many who were directly involved. The contents of this new exhibit demonstrate the complexity of Watergate history in both helpful and problematic ways.

Information in the exhibit is organized according to several different systems. Visitors can follow a linear timeline of events along the bottom of the central wall, stand in chronologically organized thematic areas with headings like "Abuses of power," "Dirty tricks and political espionage," and "The cover-up," browse through visually linked biographical sketches of key players scattered throughout the exhibit, or track summaries of major events, also visually linked, such as the payment of the burglars, the testimony of John Dean, and the Stennis Compromise. Visitors can also use a series of interactive screens to hear White House tapes and view oral history testimony excerpts on specific topics. For example, they can listen to Nixon ordering the cover-up of the Watergate investigation and, on the same screen, watch Judge Sirica's clerk, D. Todd Christofferson, or former RNC chairman Robert Dole reflecting on the historical and personal impact of the disclosure of this material thirty years later.

The simultaneity of all of these organizational devices, perhaps paradoxically, makes the exhibit somewhat hard to track. One wonders if, for example, the biographical information on the enormous cast of characters indexed by Woodward and Bernstein at the beginning of their book might have been more helpfully presented in one place here as well. If there is a virtue in all of these systems, it is that they perform the complexity of the events of the scandal and the difficulty of managing the enormous quantities of information required to understand them.

On the wall opposite the main exhibit are several stations at which the visitor can explore key topics in greater depth, including Watergate and the

Supreme Court, the legislative legacy of Watergate, and the White House taping system. Also on this wall is a two-station "Watergate research center," where visitors can don headphones and browse indexed excerpts from the Nixon Library Oral History Project on more than thirty topics ranging from the scandal surrounding Vice President Agnew to President Ford's pardon of Nixon.

At the end of the hall and immediately around the corner from these displays is a gallery featuring a replica of Nixon's study in his home in New Jersey. The room is filled with text and photos underscoring Nixon's role as an elder statesman, and the imposing desk at its center is littered with books to suggest a serious man, still alone and hard at work.

In the very small section of open wall space to the right of the Nixon study sits one more television screen. In the footage on this screen, Nixon reflects directly on his role in the Watergate scandal. Visitors can observe the president's final speech to his staff, view excerpts from his famous 1977 interviews with English journalist David Frost, and listen to lesser-known clips of him in later years continuing to assert that "technically, I did not

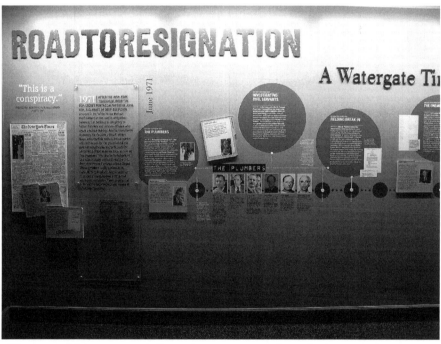

The revised Watergate exhibit at the Nixon Presidential Library and Museum is comprehensive—perhaps to a fault. This photo shows one small section of a wall-length timeline. *Photo by author.*

commit a crime."[26] The postpresidential study is meant to display Nixon as loner and winner, continuing his important work despite the circumstances of his resignation. But the screen, added after the library became part of NARA, cleverly creates a spatial link between Watergate and the post-presidency, suggesting that Watergate set the stage for all of the president's performances in the years that followed.

The content of the screen inevitably casts a somber shadow over the Nixon study. In light of the former president's performed insistence, inches from all the evidence to the contrary, that he did not consciously engage in wrongdoing, it is difficult not to view Nixon as the most sinister character in his own story.

Act 4: The Director's Story—Character in Play

Although their contributions are generally not identified as such, library directors can have a major and lasting impact on the performances the museums produce. When he was asked to serve as the first director of the federally operated Nixon Presidential Library, Timothy Naftali quickly decided to undertake a major oral history project. As the then-director of the Presidential Recordings Program at the Miller Center, a nonpartisan institute for political history, he was familiar with the advantages of oral history materials. First, by inviting those directly involved in the history of the administration to tell its story, he could avoid being an "intellectual carpetbagger, the east coast intellectual who comes in and tells everyone how it is."[27] Second and more practically, oral history collection could be done relatively cheaply. As an experienced interviewer, Naftali could do most of the work himself.

Naftali not only had general experience with oral history collection but also had personally conducted oral history interviews for the Miller Center's Clinton and George H. W. Bush projects. He was well prepared to conduct presidential library interviews. But he also knew that at the Miller Center, the interviewee was given the prerogative to edit the transcript to his or her satisfaction and that access to the original audio recordings was restricted in order to assure the greater authority of the transcript. For the Nixon Library, Naftali wanted to do it differently.

In an interview for this book he explained, "I was determined that these oral histories would be deeded to the U.S. government and that there would be no editing [of the recording]. I didn't want editing of oral histories because once you edit it then only the transcript reflects what the interviewee actually agreed to." In addition to control over editing, owning the interviews would

enable him to present them to the public in a much more timely fashion. "In the George H. W. Bush collection, I did Bob Gates in '99 or 2000 and it's still not available. I think it's opening in October [2011]."

Naftali was also determined to get a visual recording of the conversations.

> One thing you get from a videotaped interview is that you get to watch the person's reaction. You get to see their facial expression and even though they're wearing thirty-five extra years on their faces, you can still see the excitement, you can see the disappointment, you can still see the anger, and all of that would be lost [in an audio recording].

With these parameters firmly established, the biggest unanswered question was the obvious and, in the case of the Nixon Library, painfully familiar one: Who would fund the project?

"I recognized that I would have to use money that came into our trust fund from ticket sales, and I doubted that I was going to get money from the foundation because I sensed that they would have a hard time with nonpartisan programming, or at least nonpartisan exhibits."[28] Although the Nixon Foundation did provide funding for the first ten or fifteen interviews, eventually the director's relationship with the foundation worsened, as Naftali had anticipated that it would. Ultimately, between 2007 and 2010, the Nixon Oral History Project conducted 131 interviews—more than twice as many as any of the other presidential libraries had conducted—of which Naftali himself conducted one hundred. Most of the interviews were supported by the library's own funds.

The oral history materials are showcased primarily in two locations at the end of the Watergate exhibit. The final display item on the Watergate wall is a flat-screen television on which visitors can hear brief excerpts from interviews with a number of prominent Americans, including some of Nixon's lifelong friends, which together attest to the complexities and contradictions in his character. Along the opposite wall of the exhibit space visitors can sample the oral histories more extensively, choosing on a touch screen one of thirty topics relating to the Nixon administration and hearing (and watching) four or five viewpoints on each topic. This careful, topical archiving of the oral history material within the museum is unusual in the presidential library system, affording the ordinary citizen the opportunity to access selected but extensive documentation within the space of the public exhibition.

Naftali emphasizes that the oral histories are not just about Watergate. He knew that there were other significant gaps in the museum, including

coverage of Nixon's domestic policies and the post-presidency. And, beyond the Nixon administration, Naftali saw the project as a unique opportunity for the government to create content for future websites. He asked interviewees whether or not they were involved in Nixon's earlier campaigns, where they were when the assassinations of Martin Luther King Jr. and Robert Kennedy occurred, and how they experienced the moon landing.

When he talks about the relationship between the foundation and the library, Naftali's speech is uncharacteristically halting.

> I don't try to intentionally hurt anybody, but I have an obligation to create factual exhibits. If someone makes the argument to me that something is particularly—I mean I've been—I don't see myself as compromising on the truth. I don't think that's my job. I mean I may—I'm open to criticisms of style but not criticisms of truth.[29]

Of course, the very existence of the oral history project productively begs the question, "whose truth?" How do we navigate conflicting testimonies from witnesses who can all claim firsthand experience? How do we reckon with the selectivity of human memory? And how do we navigate the necessary selectivity of museum exhibits themselves? While digitization reduces spatial limitations, there are still limitations of time in a public exhibit. How many excerpts and of what length can a visitor watch before her attention or the patience of those standing behind her in line gives out?

These are important questions with which to continue to grapple. Nonetheless, given the overwhelming tendency of American public memory places to oversimplify our stories and, through them, our character, problems of complexity and inclusion are arguably *better* problems than those of oversimplification and exclusion. At least these problems make the visitor acutely aware of the existence of multiple narratives and of her responsibility to actively participate in making her own story. The Nixon Library Oral History Project, as the first presidential oral history project funded by the library itself under the administration of the National Archives, offers the visitor the opportunity to witness firsthand the complexity and multiplicity of public memories.

There are clear opportunities for other libraries to build on this success. One irreversible consequence of the "thirty years' war" is that many important histories were lost to the passage of time; more timely collection would make presidential oral history projects richer and more complete. And because, in the case of the Nixon Library, most of the oral histories involved people directly related to the Nixon administration or Watergate, the

extant interviews do not represent an optimally socioeconomically diverse cross-section of people affected by the Nixon administration's programs and policies. Addressing this second issue would require more funding as well as more diverse participation of trained interviewers in the collection process.

In addition to the support they receive from their own foundations and from NARA, all presidential museums receive one more important form of funding: patronage by the American public. In determining how best to increase this kind of funding, presidential libraries must navigate an ongoing tension between entertaining and educating the public in the making of public history. As discussed in the introductory chapter, this tension has been part of the American museum since its inception.

For his part, Naftali refuses to believe that there is a necessary conflict between learning and entertainment. "I don't believe in there being a firewall between entertainment and history," he says. "Entertainment can be an excuse for bad history. But there are so many great yarns in history. Maybe I'm just a nerd, but I think good history is entertaining, so I don't see it as a conflict at all."[30]

One would be hard-pressed to find a "great yarn" in the Nixon museum. The president's historic trip to China is told sparingly and without any narration of the encounter between the two heads of state. Even the story of Tricia Nixon's widely anticipated White House wedding is told stiffly, through the presentation of her wedding gown. This lack of entertainment value is one possible explanation for the museum's low attendance rates. In its first two years under NARA administration, the Nixon Library averaged 71,841 visitors annually, making it the third least attended presidential library in the system after the Carter and Hoover Libraries.[31]

The reality is that "a growing number of museum leaders is concerned about competition from the entertainment and cultural districts." In terms of both the financial and cultural economy, the entertainment function of museums is undeniably important to their educational mission. Kotler and Kotler pragmatically note that "without an audience and community support, even the greatest exhibition and collection will fail to generate response."[32]

Naftali suggests that one way for presidential libraries to begin to navigate the issue is to involve the public in the conversation directly, surveying visitors about what they want from presidential museums. (So far, as I will discuss in more detail at the end of the book, the National Archives' visitor studies have been limited in both scope and number.[33]) But what

the public says it wants and what it will fund through its patronage are not necessarily the same.

One thing the libraries can clearly do is work to broaden their appeal to a more diverse set of American visitors. I will examine this possibility in detail in chapter 6.

The question of how knowledge about presidential character is performed in the library system is uniquely salient at the Nixon Library. In 1962, when Nixon famously told the American press that they would not have him to kick around anymore, he was making an argument about his character; he was, the line implied, a virtuous (or at least a decent) man and leader perpetually played upon by the American press. As the history of the Nixon Library vividly illustrates, his character—and, with it, American character from his administration forward—has been in play ever since.

There has been, particularly since the mid-1980s, increased effort to coordinate the two major stakeholders' priorities from the library's inception. In 1986, for example, the passage of the second Presidential Libraries Act (the first was passed in 1955) provided for building and architectural standards that future libraries would be required to meet in order to be accepted by NARA. The act also provided the National Archives with the right to refuse the original museum exhibition as created by the foundation, though it has never done so.[34]

Time, too, affects the relationship between the foundations and NARA. In our conversation, Lynn Bassinese, director of the Roosevelt Library, explained the advantages of working at the oldest presidential library:

> As you go further from the living present, as you go further from the family that is most associated with the president, some of the tensions that our newer presidential libraries experience become less and less. [At the FDR Library, there is] no tension as to [the foundation] telling us what to put in our museum or what kinds of programs to run. . . . We are old enough that we don't have the son of FDR saying, "Well I want my father's history experienced this way," we've gotten far enough away from that that we don't. . . . I have relationships with many Roosevelt family members. They believe that we know what we're doing here and they've let us do it.[35]

As the case of the Nixon Library demonstrates, the passage of time does not always guarantee a more harmonious relationship between the NARA-administered museum and the privately funded foundation. But as original

stakeholders leave the scene, the relationship between the presidential foundation and NARA administrators does become more pliable.

For the most part, however, visitors lack the tools to understand who has authorized what pieces of the story they are experiencing. NARA administrators concede that at the presidential libraries, the impacts of the differential investments of the foundation and the government—monetary, ideological, and historical—remain relatively opaque to outsiders. When I asked Sam McClure why it was so difficult to tease out these investments, his answer suggested that both major stakeholders resisted such efforts:

> I think it's difficult for many people in either the government or the foundation side, frankly, to get into without feeling like they're either giving too much of the inner workings in a way that they're not comfortable with or . . . to give it . . . I don't know, It's difficult to describe why it's so difficult . . .[36]

McClure confirms that in the visitor's experience, the roles of the two stakeholders in funding the museums' performances are indistinguishable.

The future of public history at American presidential libraries will depend on their administrators' willingness to intentionally exhibit the contest over presidential character. The Nixon Library's uniquely and publically contentious history makes it impossible to ignore the diverse institutional and cultural "funding" of this character. Such a history encourages critical reflection on who really constructs American character and for whom.

In its original incarnation, the library was funded most strongly by those at the Nixon Foundation who, like Nixon himself, wished to remember the thirty-seventh president as an international peacemaker who triumphed over his adversaries. The first NARA-administered exhibit retained this persona but added a second character, Tricky Dick, whose final trick was his postpresidential effort to make Watergate disappear. And NARA's first Nixon Library director, Timothy Naftali, ensured that myriad performances of Nixon's character would be available to the museum visitor through the Nixon Library Oral History Project. In refusing to put forward a unified interpretation of Nixonian character, the current Nixon Library exposes the multiple complex and contradictory interests that shape the performance of character at presidential libraries.

It does not, however, clearly identify the leading actors in the conflict over the museum's authority. To do so, the library would need to be willing to preserve and display its own story. Here the Nixon Library has taken a step in the right direction, at least on its website, by narrating as clearly as

possible the history of the library's creation and transfer. But this unique and protracted history also belongs in the museum space itself.

Today it is relatively clear which parts of the extant Nixon museum exhibition are new (Watergate and the Oral History Project) and which parts are original (everything else), but this is only evident because of the newer technologies employed in the newer exhibits. The Nixon Library—and presidential libraries in general—should help visitors to understand the partiality of their stories by providing information about how their histories are literally and figuratively funded. Fawcett concedes that the National Archives could communicate to visitors "a better understanding of what they are seeing by explaining that the exhibit is donated to the government by the president's foundation."[37] As an example of how to do this, she suggests including information about the public-private partnerships behind presidential libraries in introductory materials in each museum.

This is an appropriate but insufficient step. The average visitor may miss this information entirely or miss its significance. Within the exhibition, wholly foundation-supported or government-supported galleries (such as the foreign policy gallery and the Oral History Project, respectively) should be prominently acknowledged as such. The visitor should have access to information about when each exhibit they experience was designed so that they can better understand the historical vantage point from which a particular story is being told. Information about key contributors, including architects, filmmakers, exhibit designers, curators, and museum directors should also be more readily available.

Ideally, this kind of information would be offered to the visitor not only in textual form but in other, more interactive forms as well. For example, the libraries could include visual documentation of the their own development and construction in the library itself, allowing visitors to see the president—and other important figures the displays could identify—at work on crafting his story. Libraries could also document this process through digital media and make this version of the story available to visitors through their websites.

A visual representation of how the museum's exhibits are funded would enable visitors to evaluate their performances of presidential history and character rather than simply receiving them. It would encourage them to appreciate how histories are constructed more generally and, therefore, to view themselves as active participants in the making of historical meanings. Without this information, visitors too easily experience themselves, and by extension ordinary Americans, as passive bystanders to a disembodied historical record.

Major changes to the museum over time also remain invisible in the Nixon Library. The visitor cannot know, for example, that in addition to replacing the Watergate exhibit, Naftali excised a number of panels from the original museum, including material on Vietnam, Nixon's time in the senate, the Nixon-Kennedy debate, and the Kent State shootings.[38] As the rest of the museum undergoes renovation, will more of the history of the museum itself disappear? Or will the fully renovated Nixon Library preserve space in which to document the authorship of the original exhibition and the institutions that have invested subsequently in telling particular parts of the story differently?

In considering the representation of funding at presidential libraries, we might also ask what investments fund the expectation that presidents are *not* contested characters—that they do not have advocates and detractors who will forward different versions of the chief executive according to their own priorities and values. This expectation is certainly naive. But worse, it is potentially harmful to the mission of the library system. The more the libraries perform presidential character as largely uncontested terrain, the less likely visitors are to find an active role for themselves in mapping it.

Interlude: Senator Richard Russell Reflects on the Many Characters of Lyndon Johnson

Lyndon Johnson had many different personalities—and knew how to use every damned one of them. The famous so-called "Johnson Treatment" was really just pulling out the right Lyndon Johnson for the right moment. The Johnson Treatment was a cocktail, you might say, of charm, intimidation, logic, kindness, cajolery, and horse trading.[1] You never knew just what blend you were going to get served.

You take Kay Graham, you know, the owner of the Washington Post. *That lady was no pushover. But when he needed to, Lyndon used flirtation, flattery, and southern charm to tell her what to put in her newspaper.*

And it wasn't just psychological either. Lyndon was six feet, three inches tall, just an inch shorter than Abraham Lincoln, and he used every centimeter of it. There's that famous photograph of him leaning right down into the face of Abe Fortas, the Supreme Court justice. Fortas and LBJ

are both grinning, but the justice is also leaning backwards at about a forty-five-degree angle. Ain't no question about who is in charge.

Well, I knew him well, of course, had known him for fifteen years. Hell, I'd been the one who got him to be Senate majority whip back in '51. People have called me his mentor, and neither of us have objected. When he called me in my office that day, I had been in the senate for thirty-one years. And he had been the president of the United States for less than a week. So I didn't think of myself as particularly susceptible to his treatments. I knew exactly what he was gon' ask for, and I knew I wasn't gon' give it to him.

I told him, Mr. President, I can't serve on that Warren Commission. He told me that not only could I serve but that, in fact, he had already announced that I would. I raised several different objections, and he scoffed them off one at a time. Finally I just flat-out told him that I didn't like Justice Warren and I wasn't gon' serve on any commission that he was in charge of.

"It's already been announced," Lyndon told me. "And you can serve with anybody for the good of America. Don't go giving me that kinda stuff about you can't serve with anybody. . . . This is not me, this is your country. You're my man on that commission and you gon' do it."[2]

I was speechless. Then the cat gave my tongue back and I said that if it had already been announced, then I was at the president's command.

"Well you damn sure gonna be at my command long as I'm here," he said.[3]

So that was my first "treatment" from President Lyndon Baines Johnson.

At the LBJ Library, the visitor can listen to the conversation between Russell and Johnson and the two others mentioned below through three telephones installed on a wall dedicated to the "Johnson Treatment." By placing the visitor on the receiving end, these conversations vividly demonstrate Johnson's virtuosity in shaping his performance of presidential authority to suit his audience.

2. CHARACTER IN MOTION
Visitor Performance

T he visitor's movement through the museum is shaped both by culture
and by space. As she travels, she embodies prescribed ways of walk-
ing—her pace, her rhythm—and of looking—how she is looking and what
she is looking for—that have remained relatively stable for at least the last
two hundred years of western culture. These behaviors have been cultural
expectations in museums since the eighteenth century: to walk at a mod-
erate pace, to speak at a moderate volume, to begin in the first gallery and
end in the last.

To be sure, visitors have not always conformed to these expectations.
Nonetheless, Helen Rees Leahy affirms, "As people move through a gal-
lery, their bodies articulate the shape of their museum visit, whether or
not they conform to its script or walk in the 'right' direction. Their move-
ments calibrate the space of the gallery as a quantity of both distance
and time."

The rhythm of the visit, Leahy goes on to argue, is produced reciprocally
by the visitor and the museum itself. It is

> set by the punctuation of our walking as we stop to look . . . before moving
> on again, as well as by our pace of walking and the overall duration of the
> visit. In turn, each of these factors reflects the structure of the display, the
> density of the exhibits and the size of the exhibition or building.[1]

By the ways in which they perform their subjects, museums encourage vis-
itors to move and to see in particular ways.

This chapter considers how the presidential libraries of two men, Ron-
ald Reagan and Bill Clinton, elicit particular performances of American
character from their visitors. Setting aside temporarily the major scandal
of each president's second term (see chapter 5), I focus here on how the sites,
architecture, and layout of the two museums encourage the visitor to move,
think, feel, and act. The performances these spaces move visitors toward have
significant implications for their behavior in American public life.

The Clinton and Reagan Libraries perform very different kinds of knowledge, creating contrasting visions of America's relationship to its history, the role of the president in public life, and the optimal relationship between the president and his citizenry. Explicitly and implicitly, each museum creates what Kirshenblatt-Gimblett might call a different "museum effect," offering its own model for participating in American public life outside its walls. Through these differences, the libraries produce two divergent moral imperatives for the American character—that is, two different versions of who an American ought to be.

Ronald Reagan and Bill Clinton embody American leadership at the end of the twentieth century. Together, they led the nation for sixteen of the century's last twenty years. Although President Clinton left office in 2001 and President Reagan died in 2004, the legacies of both men continue to have a major impact on our shared understanding of American character. In a 2010 poll conducted by the Public Religion Research Institute in which respondents were asked their views about a number of American leaders, including Barack Obama, George W. Bush, and Sarah Palin, Bill Clinton had a significantly higher favorability rating than any other figure, republican or democrat, with 68 percent of Americans reporting a very or mostly favorable opinion of the former president.[2] Ronald Reagan is still one of the foremost icons of conservative America. In 2008, presidential hopeful John McCain characterized himself as a "foot soldier in the Reagan revolution"[3] at a convention that featured an enormous image of the former president as its backdrop. And in September 2011, the republican presidential candidates debated each other at the Reagan Library, implicitly vying for the mantle of his legacy.

At its site and through its internal organization, the Ronald Reagan Presidential Library stages an America of limitless space in which each individual is free to make his or her own path. Its exhibits present Reagan, a radio and film actor, as a speaker whose words are performative; they conjure a mythic land into being. His is a frankly selective performance, obviously partial in both senses of the word, which derives its authority from the space between the president's body and other bodies. The museum exhibits work to create distance between Reagan and other leaders, and between Reagan and the visitor, in order to underscore the Great Communicator's unique strength. The visitor's role is to move through the landscape at a leisurely pace, and with appropriate deference to the leader who makes this independent movement possible.

The William Clinton Presidential Library presents Bill Clinton, a Rhodes scholar and Yale Law School graduate, as a student of history. His story can be told in text—lots and lots and lots of text—and requires a serious reader to understand and appreciate it. In sharp contrast to the Reagan Library, the story that the Clinton Library tells derives its force from its claims to comprehensiveness and shared authority. It is a linear narrative with a large bibliography and an extensive list of coauthors. While the Reagan Library creates distance through its uses of space, the Clinton Library creates intimacy by way of a temporal logic. The museum exhibits work to create a sense of intimacy between the president and other leaders, between the president and his predecessors, and between the president and the visitor. The museum presents the American story as one of historical progress and situates the visitor as the actor who will move us to the next critical point on the timeline.

Museum scholars agree that the visitor's experience begins outside the building's walls. Describing the Experience Music Project Museum in Seattle, Chris Bruce argues that "the building itself sends the initial message of the institution as destination, and acts as a very specific tool in connecting with and even determining an audience type. . . ."[4] I would add that the performance of the museum may begin even earlier, through the visitor's interaction with images on the library's website or as she approaches the library, before the building itself comes into view.

The Ronald Reagan Presidential Library, dedicated on November 4, 1991, is located in Simi Valley, California, nearly two thousand miles from Reagan's boyhood home in Dixon, Illinois, but near to both his early career home in Hollywood and his vacation home just outside of Santa Barbara. I visited the library in the summer of 2008.[5] As I turned onto Presidential Drive and began rounding the lazy curves up the hill to the site of the Reagan Library, I was dazzled by the beauty of the place. The wide, winding road was lined with trees and every turn offered a fresh view of the valley and nearby mountaintops. Every fifty feet or so I encountered a new banner with a sepia-toned image of one of the former presidents, beginning with George Washington and rising up toward Ronald Reagan.

At the front edge of the museum site two benches perched on the edge of the hill, inviting the visitor to sit and contemplate the sun-drenched landscape. I sat on one of them and felt the warm northern California sun on my face as I looked out. The primary feature of the landscape, a panorama of enormous mountains, towered above the valley site in every direction.

The Reagan Presidential Library and Museum boasts the most spectacular setting in the presidential library system. The western vista includes a piece of the Berlin Wall donated to the museum. *Photo courtesy of Ronald Reagan Presidential Foundation and Library.*

In the distance, the mountains embodied nothing so much as the purple majesty of "America the Beautiful." The site would inspire a love of the land in the most curmudgeonly visitor.

The building itself plays a relatively minor role in the scene. Architect Hugh Stubbins called the building style "early California," recognizable to the novice as Spanish mission style. It is a wide but modest structure, low to the ground, encouraging visitors to look over its red tile roof and through its stucco arches at the sweeping natural landscape. The Reagan Library site deflects attention from the museum building. Instead, it directs the visitor toward the contemplation of a majestic natural landscape.

The pastoral landscape has played a vital role in the American cultural imagination since the discovery of the New World. Our most treasured national myths revolve around an idyllic community that mirrors the surrounding environment. In their cultural study, *The Myth of the American Superhero*, Lawrence and Jewett describe the backdrop against which the American hero performs:

A small, well-organized community whose distinguishing trait is the absence of lethal internal conflict arising from its members; the surrounding pastoral realm echoes its inner harmony. The citizens are law-abiding and cooperative, without those extremes of economic, political, or sexual desires that might provoke confrontations.[6]

It was this mythic American community to which Reagan referred at the library's dedication ceremony, when he described his upbringing in Illinois:

I grew up in a town where everyone cared about one another because everyone knew one another, not as statistics in a government program but as neighbors in need. Is that nostalgic? I don't think so. I think it is still what sets this nation apart from every other nation on the face of the earth. Our neighbors were never ashamed to kneel in prayer to their makers nor were they ever embarrassed to feel a lump in their throat when old glory passed by. No one in Dixon, Illinois, ever burned a flag and no one in Dixon would have tolerated it.[7]

And it was this myth to which Reagan referred when, in conclusion, he alluded as he did throughout his presidency to America as a "shining city upon a hill," echoing and embellishing the famous words of John Winthrop, founder of the Massachusetts Bay Colony.[8]

Through these allusions Reagan emphasized in speech what the library emphasizes in structure: the goodness of the enduring American landscape and the correspondingly natural goodness of its people. Such a harmonious landscape does not require human intervention to prosper. It invites contemplation and prayer. The library site implicitly associates the former president with the fabled majesty of America, inviting the visitor to pause and contemplate its beauty.

Even on the brightest of days, the landscape of industrial downtown Little Rock, Arkansas, is no match for Simi Valley, California. The terrain is strikingly flat and the grounds of the Clinton Presidential Center, while well-tended, offer neither particularly attractive flora nor impressive views. As I first approached the library on a summer day in 2004, my strongest feeling was one of disappointment. In addition to the flatness of the landscape, the library building itself, a construct of glass and steel, is heavily industrial in appearance. It reminded me of a skywalk in an airport or a viaduct on a highway topped by a Howard Johnson's restaurant. At the dedication ceremony,

I later learned, the president himself had acknowledged the already circulating joke that the building resembled a doublewide trailer.[9]

Despite these unintended associations, architects James S. Polshek and Richard M. Olcott did in fact design the Clinton Presidential Library to look industrial. Specifically, the design echoes the nearby Rock Island Railroad Bridge, thereby creating "a tangible link between yesterday and tomorrow: on the one hand, a relic of the 19th century and, on the other, a major architectural statement of the 21st century."[10] The design also echoes the theme of Clinton's second term of office, in which he promised to "build a bridge to the twenty-first century."

The right side of the Clinton Library is planted firmly on the grounds of the center, which also include an archive building and the Clinton School of Public Service. The left side of the building is cantilevered out over the Arkansas River, as if toward an unseen, unknown destination. The bridge, then, is unfinished, heralding a major theme of the library exhibit, the necessity for visitors to participate actively (here through their imaginations, elsewhere in more fully embodied ways) in the ongoing construction of the American project. However one responds to the aesthetics of the exterior,

At the dedication of the Clinton Presidential Library, which echoes the theme of his second term, "building a bridge to the twenty-first century," President Clinton joked about the structure's industrial architecture. *Photo by Arnie Kanter; used with permission.*

the bridge metaphor focuses viewers' attention on the need for collaborative work in the service of community. Echoing this theme, the keynote of Clinton's address at the library's dedication was his effort to span the conservative-liberal divide; in the end he heralded an ethic of community: "What should our shared values be? Everybody counts. Everybody deserves a chance. Everybody has got a responsibility to fulfill. We all do better when we work together. Our differences do matter but our common humanity matters more."[11] As Reagan's remarks highlighted the goodness of the land and its people, Clinton's highlighted the importance of collaborative human labor.

Other features of the Clinton Library site also emphasize the importance of working for the community. In the service of economic equality, the Clinton Foundation's capital investment in a neglected and largely inaccessible piece of land beside the Arkansas River helped to revitalize a dilapidated portion of the city. In the service of environmental justice, it was designed with maximal efficiency in mind, drawing on materials such as recycled tires, bottles and cans, solar energy, and regional stone. As a result, it became a landmark building, the first presidential library to receive a silver rating for Leadership in Energy and Environmental Design, the third highest rating in the U.S. Green Building Council's system.[12] Finally, the Clinton School of Public Service, as the first institution in the country to offer a Master of Public Service degree, represents a significant investment in the development of human capital.

The exteriors of the two libraries highlight different roles for the visitor and correspondingly different ideals for the American character. The Reagan Library site encourages the visitor to privately contemplate the timeless beauty of a distant "city on a hill." The Clinton Library site turns the visitor's attention toward human progress and the collaborative work required to achieve it.

Museums act on and through the body of the visitor in what Leahy calls the "felt quality" of exhibit walking. Jill Stevenson identifies a range of design choices that "direct visitors to interact with certain material elements, to navigate the space in particular ways, and to conduct themselves in a specific fashion, while at the same time seeming *not* to force anything on them."[13]

Commensurate with the divergent postures toward citizenship the library exteriors evoke, the Clinton and Reagan Libraries command very different kinesthetic practices from visitors. Barbara Kirshenblatt-Gimblett distinguishes between "in-context" and "in-situ" displays. She explains that in-context displays textualize objects. "The larger narrative may be a story of evolution or historical development. The performative mode is exposition and demonstration. The aesthetic is one of intelligibility."

The Clinton Library follows the in-context model. It is profusely expository, replete with lengthily captioned objects and images that are, in turn, situated in a larger narrative of a given policy priority. The most prominent component of the Clinton Library's main exhibit hall is a timeline of the Clinton presidency that spans the length of the hall. The timeline consists of eight enormous panels narrating, in chronological order, each of the eight years of the administration. Each of the panels is flooded with text. In addition to text blocks within the main displays that narrate specific events or themes for each year, a text subpanel to the right of the display material narrates the year as a whole, and a large-print quotation above the display provides a keynote for the year. As if this were not enough text to navigate, at the bottom right of each year's panel is a recessed bookshelf filled with binders containing complete presidential schedules for the year. The visitor could, in theory, account for the president's whereabouts and activities every hour of every day of his administration.

The perimeter of the main exhibit hall also aims at intelligibility through in-context displays. Although the linear narrative of the timeline holds center stage, it is supplemented by information presented in a thematic rather than chronological fashion. The hall is lined with fourteen alcoves highlighting the Clinton administration's policy priorities and accomplishments. Reviewer Stephen L. Recken notes "the absence of a historian's work" here, explaining that "a historian would have organized these fourteen topics into three or four broad themes."[14] The policy alcoves, like the timeline, are swarming with text. Each is lined on all three sides with glass-enclosed display cases featuring multiple audiovisual images and artifacts. There is text below each segment of each display that narrates the artifacts, text inside many of the displays, and text on the glass over the displays, creating a palimpsest for the reader.

The in-context approach of the Clinton Library is commensurate with the educational function of exhibits championed in the late nineteenth century by Dr. George Brown Goode, director of the U.S. National Museum. Goode's model for the museum was "the public library" in which "objects were to be read like books"[15] and in which explanation of the artifact eclipsed the artifact itself in importance. According to this model, the museum visitor was a student, reading her way to greater knowledge.

The problem with this model is that it does not describe what, on the whole, museum visitors do. A number of visitor studies have confirmed that museum visitors interact with exhibits rather than study them. "Visitors devote most of their time to looking, touching, smelling, and listening, not

The main hall of the Clinton Library features large panels describing each year of the president's tenure in office and is lined with alcoves detailing policy priorities. *Photo by Arnie Kanter; used with permission.*

to reading. Visitors tend to be very attentive to objects, and only occasionally attentive to labels."[16]

Nor is it necessarily what visitors ought to do. The in-context display is also problematic insofar as it does not tend to make for a compelling museum experience. Elaine Heumann Gurian illuminates some of the problems with both historically linear and text-based museum exhibitions. "Exhibitions are places of free choice. Try as we might, the public continually thwarts our attempts to teach incrementally in an exhibition. They come when they want, leave when they want, and look at what they want while they are there. Therefore, linear installations often feel like forced marches." Furthermore, Gurian argues that "the more complex the verbal message becomes, the less understandable the exhibition turns out to be, since exhibitions are basically nonverbal enterprises."[17] In recent years, museum studies and museum practices have both focused on how to augment this inherent element of free choice in visitors' experience, encouraging the visitor to create his or her own story and to improvise a unique path through the museum.

In a history museum such as the presidential library, the in-context display's focus on intelligibility encourages the visitor to trace a narrative of more or less linear progress and, therefore, to experience herself as having

a role to play in creating it. This can be empowering for the visitor; as the ancient alphabet democratized access to knowledge, the textual approach to display makes it possible for the visitor to write her own chapter in the American story, with the stipulation that rigorous reading of the past is a prerequisite of future textual production.

On the other hand, the moral dangers of narratives of progress are legion and, by now, familiar. De Certeau argued that the entire scriptural enterprise "stocks up what it sifts out and gives itself the means to expand" in an explicitly colonialist manner.[18] The in-context museum display expands the power of those who already have it, the best educated and therefore, typically, the most economically advantaged visitors.

Further, as historiographers note, an emphasis on intelligibility tends to produce a false sense of coherence as it "strains for the effect of having filled in all the gaps, of having put an image of continuity, coherency, and meaning in place of the fantasies of emptiness, need, and frustrated desire that inhabit our nightmares about the destructive power of time."[19] Similarly, the profusion of text in the Clinton Library generates the sense of an uncensored, uncut story, eliding the selection process upon which the construction of any narrative—and any memory place—depends.

In-context displays can also make visitors weary. Museum professionals have long endeavored to understand the challenge of "museum fatigue."[20] A number of social scientific attempts to explain the waning of visitor attention over time—is museum fatigue physical or psychological? How is it affected by the arrangement of objects in space?—have been unsuccessful. But the problem persists, and continues to concern exhibit designers. No study is needed, however, to determine that long periods of standing in one place and reading will exhaust the museum visitor. Whatever other factors may contribute to its onset, the visitor to the Clinton Library is highly susceptible to museum fatigue.

Yet it is likely this very feature of the Clinton Library, its profusion of text and encouragement of methodical, linear movement through space, that prompted NARA assistant archivist Sharon Fawcett to comment that the museum "is so Bill Clinton. It's completely Bill Clinton."[21] Despite his administration's early efforts to "reinvent government" by cutting down dramatically on the textual excesses of federal regulations, Clinton himself was known for producing a profusion of text. His verbal excesses include his infamous nominating speech for Michael Dukakis at the 1988 Democratic National Convention that went on for so long that the crowd cheered when he said, "in conclusion"; the longest State of the Union speeches since

Calvin Coolidge; and, later, an autobiography that came in at just under a thousand pages. In the name of inclusivity, Clinton had a propensity for exhausting his audience.

The main exhibition hall of the Clinton library asks the visitor to read a historical narrative of progress (and to fit fourteen subplots into that narrative). Its linear presentation of the presidency directs the visitor to proceed through the exhibit methodically, chronologically, with the rigor and stamina of a scholar. The library's displays, overflowing with text, seem to offer the visitor a comprehensive performance of history, if he will only study them hard enough.

In contrast to in-context displays, in-situ displays de-emphasize exposition, modeling themselves instead on "the experience of travel and the pleasures of engaging the life world."[22] Following this kinesthetic logic, the Reagan Library surrounds the visitor with minimally contextualized objects, images, and media, encouraging affective engagement with and leisurely movement through its spaces.

The arrangement of exhibitions in the Reagan Library, therefore, commands a less disciplined performance practice. The museum's narrative divisions, both spatial and chronological, are imprecise. The central exhibits occupy three large, open spaces: a room with a series of stations representing Reagan's youth, a second with a series of stations representing his career in radio and film and his early political life, and a third representing his presidency. While the Clinton Library's main hall is bathed in natural light, all three of these rooms are windowless; like the darkened movie theater, they encourage the visitor to immerse herself in the story of the exhibit space. Although the pamphlet that guides the visitor through the museum presents these rooms in a clear and orderly fashion ("Early Years Gallery," "Gubernatorial Gallery," "First Term Gallery"—oddly, there is no second-term gallery), none of these collections are prominently labeled in the space itself.

In contrast to the Clinton Library's timeline, the eight years of the Reagan administration are represented by a series of key moments of contact between the president and the citizenry. These moments are the assassination attempt by John Hinckley Jr.; Reagan's response to the Professional Air Traffic Controllers union strike; and his speech commemorating the fortieth anniversary of the Normandy invasion. All of these moments occurred in Reagan's first term of office, the first two very early in his first term and the last toward the end. While in one sense these choices are diverse—the first a moment of personal trial, the second a moment of national challenge, and

the third an international anniversary—it is certainly impossible to construct any narrative of the Reagan presidency based on these three points.

Following these central rooms, the visitor enters a small and cluttered though more brightly lit gallery filled with gifts from Reagan's travels around the world, a feature of many presidential libraries. From there, the visitor walks down a short hallway to a replica of the Reagan-era Oval Office (another common feature) and then to another large, dark room featuring images of the Reagans' postpresidential life on their California ranch.

Not surprisingly, film is featured throughout the museum. A video program for each major gallery runs continuously on a plasma screen. These films feature collages of footage organized around themes or periods. They, too, are frankly selective and unbound by constraints of linear time. In each room one can begin watching any screen at any point and keep watching until the footage repeats itself. And in a later addition to the museum displays, the visitor can even play at being the star herself.

The three discrete sites of engagement highlighted by the exhibit on the Reagan administration do not invite the visitor to study a comprehensive historical timeline. Rather, through selective attention to events, they allow the visitor to participate in the idealized atmosphere of the mise-en-scène, Reagan's America. In this sense, they mimic the role of the nineteenth-century panoramic exhibit that, Kirshenblatt-Gimblett notes, was a valuable surrogate for travel before the advent of mass tourism. Indeed, since the exhibit omits unpleasant elements of the original experience, "viewers might prefer the panorama of Naples to Naples itself." The displays of the Reagan Library offer the contemporary analogue of the museum-as-travel, the interactive "experience" that "has become ubiquitous in both tourism and museum marketing" and that "indexes an engagement of the senses, emotions, and imagination" rather than an engagement of the intellect.

The visitor to the Reagan Library is also encouraged to move differently. The helter-skelter layout of the museum exhibits delineates, following Kirshenblatt-Gimblett, "conceptual paths through what becomes a virtual space of travel."[23] In the Reagan Library, without a clear spatial or temporal trajectory, the conceptual paths create a space not of work or study but of leisure. They encourage the visitor to simply move where her interest takes her and enjoy the scenery.

This is the leisurely movement of the cowboy on his trail, represented in the library by a life-sized bronze sculpture of the president in his riding gear and broad smile that adorns the building's central courtyard. The image was fixed in popular memory by, among others, Roy Rogers, another

radio star born in the same year as Ronald Reagan. In his signature song, "Happy Trails," written by second wife Dale Rogers-Evans, Rogers croons to the rhythmic clop of horses' hooves, "it's the way you ride the trail that counts."[24] The song celebrates the American ethic of individualism. It's the way you ride the trail and not the destination that matters. You are expected to ride alone, meeting up with others only by chance at an unspecified future time. With its slow rhythm and gentle melody, the song promises an easy, if not always happy, journey.

While the Clinton Library's narrative structure emphasizes historicity, progress, and the value of work, the Reagan Library's looser and more discontinuous displays emphasize freedom of movement, timelessness, and the value of leisure. This more independent, less structured spatial practice resonates strongly with the mythic terrain of the American West, a terrain Reagan claimed as his own through many of his presidential performances and, later, through the reiteration of these performances in his everyday life at his ranch.

Writing in the context of the art museum, Leahy describes the visitor's body as "alert to the requirements of the object on display; each exists in a relationship of dynamic symbiosis with each other, as well as with the space they occupy and everything within it."[25] In the context of the presidential library, however, this "dynamic symbiosis" is itself a subject of representation. Each library displays a different ideal spatial relationship between the president and the citizen, and each evokes a different performance from the visitor. Ideas about the relationships between the ordinary American and the president must be analyzed, then, both as they are represented within the library's exhibits and as the library invites the visitor to embody them.

The Clinton and Reagan Libraries perform strikingly different spatial relationships between the president of the United States and other citizens, important and ordinary, domestic and foreign. The Clinton Library works to diminish space between the figure of the president and a wide array of others, while the Reagan Library creates maximal distance between the president and everyone else. These spatial relationships encourage visitors to the two libraries to imagine themselves as part of a community of leaders and as independent actors, respectively.

While the idea of a bridge to the twenty-first century is self-consciously a metaphor for the future, in the Clinton Library the bridge also serves as a metaphor for working closely across differences, a major theme of the permanent exhibit. The museum displays a relationship of intimacy between the president and his political collaborators, both domestic and foreign.

Interactive screens in the model cabinet room (a feature shared only by the Ford Library) emphasize the extent to which Clinton brought people together within his administration. They note that he held more cabinet meetings than any president in recent history and solicited advice from cabinet members about matters beyond their designated roles. The museum also highlights Clinton's strong professional alliances with Vice President Al Gore and first lady Hillary Clinton, both of whom Clinton gave historically unprecedented responsibility. Of his wife, Clinton says, "To take someone with her ability and not use it I thought would have been a big mistake." Of Gore, Clinton says simply, "Al Gore knew things I didn't know."[26] The gallery dedicated to Gore's work is unique in the presidential library system for the amount of space and substantive documentation it provides the contributions of the second in command.

At the level of national policy, the museum emphasizes Clinton's ability to bridge differences between people through his domestic agenda. One of the policy alcoves in the museum's central display hall is dedicated to "Building One America" and emphasizes the policies and other activities through which the president promoted dialogue and tolerance on issues including religion, race, and sexuality, as well as the creation of the AmeriCorps national service program. And at the level of foreign relations, two double-alcoves—the only such spaces in the library—are dedicated to "Confronting Conflict, Making Peace" and "Building a Global Community." These alcoves detail the president's engagement in the Balkans, the Middle East, Ireland, and Kosovo; his efforts to preserve security in American relations with Russia, China, and Korea; his efforts to strengthen relationships with the governments of longtime allies; and his efforts to forge new international alliances.

Above all other collaborations, the museum emphasizes Clinton's work to bring together people of African and European descent in both the United States and abroad. Clinton's work on behalf of racial reconciliation in the United States is noted throughout the museum, and is highlighted particularly in the museum's final exhibit entitled "The Work Continues," which describes the work of the Clinton Foundation both in Little Rock and in Harlem, New York.

The symbolic foundation of Clinton's work for racial justice abroad is his close relationship with Nelson Mandela. It is arguably this relationship, even more than his relationships with the first lady, the vice president, and the cabinet, that serves as the museum's touchstone and moral center. Mandela and Clinton are featured together in several large photographs, in quotations on the main floor of the library, and in remarks by Mandela about Clinton

in the museum's introductory film, in which Mandela refers to Clinton as "my friend" and as a partner in working for peace.

The museum also creates intimacy between the visitor and the president through the library's audio tour, which visitors can borrow as a guide and purchase as a souvenir. The tour, comprised almost entirely of reflections by the president himself, acts as a bridge between the former leader of the free world and the visitor. Here, in a tone that is variously folksy, nostalgic, and analytical, President Clinton literally whispers in the visitor's ear. With an occasional self-deprecating chuckle, he shares his personal reflections on topics ranging from his favorite books (some of which are displayed in the museum) to his grandparents to the time in his presidency when "they were trying to run me out of the job."[27] The track about the impeachment is perhaps most striking in its performance of an intimate confidence between the visitor and the president, excluding the possibility that any visitor would herself be part of such a "they." And in a section of the audio tour dedicated to his relationship with Mandela, Clinton recounts advice Mandela offered during his impeachment hearings, letting the visitor into this private conversation among leaders.

President Clinton also casts visitors explicitly and repeatedly as his collaborators in the work of leadership. In the museum's introductory film, in the first track of the audio tour, and in the official companion book to the museum, he insists that "America will always be an unfinished project. We all have a role to play in carrying on the work."[28] The architectural metaphor of the bridge reverberates throughout the Clinton Library's permanent exhibition, from close collaboration inside the administration to Clinton's foreign policy priorities to the relationship between the president and ordinary citizens. Finally, it reverberates in the museum's consistent efforts to create a sense of intimacy between the visitor to the presidential library and its subject.

While the Clinton Library stages the president's relationships to others as intimate, the Reagan Library works to maximize the distance between the president and others. It does this primarily by reproducing the high degree of selectivity the Reagan administration exercised over his public appearances. From the beginning of his administration, one journalist noted, Reagan consistently appeared "far away and in transit."[29] Similarly, the museum exhibits offer selective, fleeting access to Reagan's presence. The audio guide to the museum is narrated not by Reagan himself but by an anonymous professional. The introductory film, made after Reagan's death, does not feature the president directly addressing visitors to the museum as Clinton's does. And the museum exhibits do not highlight his personal relationships

with other leaders, either domestic or foreign. Indeed, of the three first-term highlights mentioned above, two of them—the assassination attempt and the PATCO strike—feature the president singlehandedly defeating an adversary.

There is only one nonadversarial relationship highlighted in the museum: the relationship between the president and his wife. In all of the galleries except the first, Nancy Reagan plays a staunch supporting role. Always pictured by Reagan's side, she is the recipient of handwritten love notes first from "Your guv" and then from "Your pres." (These signatures, however lightly penned, may suggest a certain distance even in their relationship.) She is also featured in a small gallery following the postpresidential ranch room.

Mrs. Reagan's role, however, is consistent with her script in the historically male space of the Hollywood western, in which "women play roles which are conventionally secondary to male action."[30] Unlike Hillary Rodham Clinton, Mrs. Reagan is not featured as an intellectual partner or a collaborator but as a supportive, steadfast, and largely silent physical presence. She is the Tonto to Reagan's Lone Ranger. Even her most identifiable contribution to the administration's programs, the "Just Say No" anti-drug campaign, is framed as emanating from a spontaneous, in-the-moment outburst on Mrs. Reagan's part rather than from a crafted strategy.

Two other small exhibits help to create distance between Reagan and others. The first focuses on Reagan's film career, which serves as a reminder of the extent to which Reagan's was always a mediated image, one his audiences sat in the dark and enjoyed. The other centers on the Berlin Wall and features a clip of Reagan in one of his most famous moments as president, commanding Mikhail Gorbachev to "tear down this wall." Rather than representing intimacy between the two leaders, this exhibit demonstrates the extent to which Reagan could command his fellow world leaders to act, in spite of—or because of—his distant location.

Nowhere does the museum perform Reagan's distancing practices more dramatically than in the Air Force One Pavilion, a ninety-thousand-square-foot space that the Reagan Library website touts as "one of Southern California's must-see destinations!"[31] While the rest of the museum offers almost no natural light, Air Force One faces the Pavilion's massive, two-hundred-foot-wide by sixty-foot-tall glass outer wall. It is dramatically illuminated with natural light and poised, as the museum brochure narrates, for flight.

The Air Force One Pavilion was an expensive addition to the museum and is maintained by the Reagan Library Foundation rather than the National Archives. The imposing aircraft is the president's high-speed, technological steed and its presence here (it served six other presidents as well) emphasizes

the extent to which it became identified with Reagan. Indeed, visitors learn that Reagan used the plane more than any previous president, traveling over 660,000 miles. Although some of this travel was domestic, much of it was international, and the exhibit highlights his global diplomatic missions.

In a gesture that would seem to collapse the space between the visitor and the president, visitors are invited to board Air Force One. The museum sells this as an extraordinary opportunity, highlighting it on printed materials and offering photo-taking as one climbs aboard. Visitors can later purchase these photos. But the "trip" aboard the plane itself is anticlimactic. Inside, the plane is considerably less glamorous than the average commercial aircraft. The center aisle is as narrow as a small commercial flight's, the interior walls are charcoal gray with wood paneling, and mannequins dressed in flight uniforms perch awkwardly, lifelessly in two of the several small cabins.

The dinginess of the plane's interior dramatizes the performative nature of Air Force One; it is, by definition, the president's presence on any aircraft that makes it "Air Force One." When the visitor accesses the physical space of the famous plane, she finds that its aura has departed with its occupant. And, of course, this plane to which we are permitted entry cannot fly anywhere, least of all into the rarefied airspace of presidential performance. Here, inside the president's most privileged sanctuary, the visitor is further from Reagan than ever before.

The interior of the Clinton Library is designed as a library. While this may seem wholly unremarkable, in fact most presidential museums do not resemble libraries at all. In the case of the Clinton Library, however, the exhibit planners strove to make the building "more library-like than the other twelve presidential libraries,"[32] consciously modeling the main exhibit room of the museum after the reading room in the Trinity College Library in Dublin, Ireland. Clinton had a very direct relationship to this space; the Trinity Library reading room was situated in one of his favorite buildings and, significantly, was a place he first visited as a Rhodes scholar. As well-credentialed academically as any American president, Clinton's Rhodes scholarship was sandwiched between his undergraduate years at Georgetown University where he studied on a scholarship (one of many he was offered as a high-school senior) and his matriculation at Yale Law School.

Next to the main exhibit room's central timeline, the space's most conspicuous features are the surrounding, towering, twenty-eight-foot high wooden book stacks. These two-story stacks, which so closely resemble those created at Trinity College a century and a half earlier, contain close to five

thousand archival boxes—less than 8 percent of the actual historical ar-
chive of the administration. The total archive includes 80 million pages of
documents. (To put these numbers in perspective, this is 30 million more
pages of documents than can be found in the presidential library of Ronald
Reagan, Clinton's closest two-term predecessor.) If the modern library's
exterior architecture points toward the future, the physical replication of
the old reading room is one important way that the museum represents the
president as a good and serious student of the past.

Clinton most explicitly performs the role of history student through the
museum's audio tour. Early in the tour, Clinton upholds the wisdom of the
very earliest American statesmen. "If you look at the whole history of our
country, it's basically been a story of progress toward the founders' dream
of a more perfect union."[33] Later, he lists some of his favorite books, which
include several biographies of great American leaders as well as Seamus
Heaney's *The Cure at Troy*, an adaptation of a play by Sophocles that focuses
on learning from history. In its most famous passage, the chorus directly
addresses the listener, encouraging her both to study and to improve upon
history, making "hope and history rhyme."[34]

But Clinton emphasizes that his education did not only come from books.
It began, he explains, with his grandparents. Of his commitment to civil
rights, Clinton says that he deserved "no credit whatsoever," "because I
was raised that way. My grandparents opened my eyes at an early age to the
evils of discrimination. . . . It was just built into my grandfather's genes, I
think." And an entire track of the audio tour is dedicated to a discussion of
the president's high-school English teacher who, he says, "opened my eyes
to the world around me . . . and the world inside me." Ending this track,
Clinton relates that, as he was writing his memoirs, his editor reprimanded
him, "You cannot put the names of every teacher you had in grade school,
junior high and high school and college, and you cannot write a story about
each one, the book will be five thousand pages long, you can't do it."[35] Here,
Clinton jokes about his tendency toward long-windedness while simultane-
ously acknowledging his debt to all those with whom he studied, even those
there isn't space to name.

While the Clinton Library presents the president as a student working
hard to learn from both books and people, the Reagan Library presents the
president as a speaker whose words brought a better world into being. His
words are displayed, following the classic definition of J. L. Austin, as per-
formative utterances, not just describing new realities but, in the iteration,
creating them.[36] Reagan did things with words—and not, like Clinton, by

studying them or by producing them in vast quantities, but through a kind of iterative magic. Reagan's speeches were efficacious in conjuring, through repetition, a timeless (if mythic) American spirit.

Reagan is widely acknowledged as a masterful storyteller with a single great story to tell. He began formulating this story in his famous 1964 endorsement of Barry Goldwater, "A Time for Choosing." The speech began by articulating a choice that was, he argued, far more important than which political party to endorse:

> And this idea that government is beholden to the people, that it has no other source of power except the sovereign people, is still the newest and the most unique idea in all the long history of man's relation to man.
>
> This is the issue of this election: Whether we believe in our capacity for self-government or whether we abandon the American revolution and confess that a little intellectual elite in a far-distant capitol can plan our lives for us better than we can plan them ourselves.
>
> You and I are told increasingly we have to choose between a left or right. Well I'd like to suggest there is no such thing as a left or right. There's only an up or down—[up to] man's old—old-aged dream, the ultimate in individual freedom consistent with law and order, or down to the ant heap of totalitarianism. And regardless of their sincerity, their humanitarian motives, those who would trade our freedom for security have embarked on this downward course.

Approximately twenty-five minutes later, the speech concluded with a choice of mythic proportions:

> You and I have a rendezvous with destiny.
>
> We'll preserve for our children this, the last best hope of man on earth, or we'll sentence them to take the last step into a thousand years of darkness.[37]

Although Reagan gave this speech fifteen years before he ran for president, it formed the core of what his aides in the administration called "The Speech":

> The importance of "The Speech" cannot be emphasized enough for Reagan's politics . . . It was a skeleton of the speech, always to be edited and perfected and as such it had multiple shapes, but these shapes loom behind all of Reagan's public speeches. It was the one great speech Reagan spent his entire lifetime improving and recreating.[38]

"The Speech," was timeless, captivating, and ahistorical. It followed the structure of a particular kind of performative utterance Arthur Frank calls the restitution narrative. It worked to restore normative power relations. It righted wrongs and healed wounds. It restored order in the world. A quintessentially modern narrative, the restitution story concedes that things do not always run perfectly; machines, people, and relationships do break down. But it does not concern itself with the history of the problem. Rather, "the plot of the restitution has the basic storyline: 'Yesterday I was healthy, today I'm sick, but tomorrow I'll be healthy again.'" Time, in these narratives, is not progressive but cyclical; we can return to the beginning again—indeed, we are meant to do so. The restitution narrative "affirms that breakdowns can be fixed" and focuses attention on the "heroism of the healer."[39]

Important as the content of "The Speech" was for laying out the tenets of American conservatism, it was Reagan's performance rather than the ideas themselves that proved most transformative. In *Morning in America*—a title taken directly from Reagan's second presidential campaign and itself suggestive of Reagan's storytelling style—Gil Troy calls it "Goldwater-Conservatism-with-a-Smile." Reagan was a "charming optimist," who projected an "ease in his own skin" and "comfort at the helm." Reagan could "motivate Americans by identifying many challenges that infuriated them, while reassuring them that they would overcome." Reagan's performances conjured an optimistic, confident, and prosperous America, bringing to life a "storyline of decay and renaissance" that "was all the more remarkable given its tenuous relationship to the truth" of 1980s America.[40]

The Reagan Library reenacts some of the president's most memorable performative utterances. Significantly, two of these three speeches are reenactments, already conjuring the past through repetition. First, a highly condensed filmography exhibit features a young Ronald Reagan as college football star George Gipp. In his final and most famous scene, Reagan as Gipp lies bravely on his deathbed and says to his coach, "Some time, Rock, when the team is up against it, when things are wrong and the breaks are beating the boys, tell them to go out there with all they got and win just one for the Gipper."[41]

The real-life George Gipp was a college football star who died of strep throat and pneumonia in 1920, just two weeks after becoming Notre Dame's first Walter Camp All-American player. Gipp never gave the inspirational speech. Instead, Gipp's coach, Knute Rockne, invented it to rally the team during a game in 1928, the acclaimed coach's worst season.

Fictional or not, Gipp's words inspired his team from beyond the grave, turning near-defeat into victory. Similarly, throughout his political life in

general and his presidency in particular, Reagan repeatedly exhorted crowds to "win one for the Gipper," invoking a future for the "All-American" team that, as Knute Rockne had imagined, would soon be as glorious as it had been in the past.

On a screen in the first-term gallery, one can view a reenactment of another one of Reagan's most famous utterances. Here, in a space devoted to the failed 1981 attempt on the president's life, an actor playing Reagan's doctor reports that, on the brink of death, Reagan quipped that he hoped his doctors were Republicans. The actor also performs the doctor's response, "Today, Mr. President, we are all Republicans."[42] Archival footage highlighting Reagan's ease in the midst of life-threatening injury culminates in images of the president leaving the hospital, sporting a bright red sweater over his bulletproof vest and smiling at the cameras. The story of the assassination attempt is yet another performance of optimism strong enough to conquer the threat of death, here not from illness but from an evil adversary. Far from weakening a president's resolve, this threat actually brought the American community together, making us "all Republicans," at least for a day.

A gallery toward the end of the permanent exhibition deals with foreign relations and features one of two sections of the Berlin wall owned by the library. The gallery includes footage of Reagan's most famous speech act of all, his command to the Soviet leader, "Mr. Gorbachev, tear down this wall." Although the wall would not, in fact, come down until Reagan was out of office, the implication here is clear: Reagan felled the Berlin Wall, mending with a six-word performative utterance a quarter-century rift between East and West.

Although Frank articulates the restitution narrative in the context of the ailing body with the medical doctor in the role of the hero, his formulation is easily and usefully transposed to the social body, where the leader assumes the position of the doctor. In this context, it is not the sick person who tells the restitution narrative but the healer. Speaking on behalf of the temporarily afflicted body politic, Reagan's words restored the wounded nation to health. The Reagan Library presents the president as a virtuosic teller of restitution stories, both in and out of political life. In each performance, Reagan's speech restores the conservative ideals of strength and freedom to the "patient," whether that patient is the team, the presidential body, or the nation.

The Reagan and Clinton Libraries create different museum effects, moving the visitor toward very different performances of American character. Emerging from the Reagan Library experience, the visitor might pause to

take another long look at the surrounding beauty of an essentially good and peaceful landscape and experience a surge of national pride. She might proceed slowly on to her next destination, confident that she has within her all that she will need there. She might experience a deep sense of gratitude that the leader of her country is somewhere far away, restoring order and health to the world through the magic of his performances. And she might see herself as essentially different from her president, just an ordinary citizen who might play at being a movie star or a passenger aboard Air Force One, but who ultimately belongs in the audience and on the ground.

Emerging from the Clinton Library experience, the visitor might move back into the world exhausted but with a sense of urgency about the important and difficult work ahead of her. She might well feel overwhelmed by the number, breadth, and depth of the tasks to be accomplished. But she might also feel inspired to reach out to others; others who know things she doesn't know and others who need what she has to contribute. She might experience a sense of gratitude that the leader of her country is not merely acting on her behalf but inviting her to play a critical role—a role not essentially unlike the leader's—in the performance. And she might emerge understanding her own character, the characters of her leaders, and the character of the nation as ongoing, demanding, and collaborative works in progress.

PART TWO
Individualism and American Character

3. CHARACTER FOREVER
Yearning for Immortality

American presidents experience two "deaths": their departure from office, and the end of their lives. The presidential libraries will ultimately rehearse their subjects' ongoing impact on American life following each of these deaths. Performance scholarship offers a theoretical framework for thinking about how these spaces embody political power and human mortality.

Like the human body—and unlike the artifacts preserved in a museum—performance disappears. In her 1993 book, *Unmarked: The Politics of Performance*, Peggy Phelan articulated something critical about how performance works: the one certainty about a live performance, she argued, is that it will be immediately and irrevocably lost. "Performance's only life is in the present. Performance cannot be saved, recorded, documented, or otherwise participate in the circulation of representations of representations: once it does so, it becomes something other than performance.... [Performance] becomes itself through disappearance."[1] Far from being pessimistic about this ultimate disappearance, Phelan argued influentially that vanishing was a potential source of power. She distinguished performance as "the art form which most fully understands the generative possibilities of disappearance." The most important of these "generative possibilities" is simply "to learn to value what is lost, to learn not the meaning but the value of what cannot be reproduced or seen (again)."[2]

For Phelan, who is concerned with both artistic and political spectacle, one of the most important aspects of performance is its refusal to rely on strategies of visibility. These strategies reproduce oppressive structures of social power by rendering weaker those who are more exposed to view. At stake in the appreciation of performance are the generative possibilities of strategies for claiming political power outside the dynamics of visibility. At stake, too, is the value of the performing body that moves inexorably toward its own death.

And yet, does performance in fact disappear? To those who feel that we have in any way been marked by performance, this ontological claim is likely

to ring untrue. Several years after Phelan's *Unmarked*, Diana Taylor, inspired by cross-cultural responses to the death of Princess Diana of Wales, posited a "hauntology" of performance, by which the original actor's presence continues beyond her disappearance or death. In her influential book, *The Archive and the Repertoire*, Taylor argued that the power of performance was not in its disappearance, but in its ability to make what has vanished appear again:

> This is the moment of postdisappearance, rather than the moment preceding it that Phelan points to. . . . The shrine housing her remains will continue to guarantee the materiality of the global phenomenon that is Diana. . . . Politically and symbolically, we haven't seen the end of her.[3]

Diana's ghost, Taylor argues, continues to move among and even through our living bodies. More recently, in *Performing Remains*, Rebecca Schneider has argued that performance remains not merely as a ghost but as "materiality":

> The scandal of performance relative to the archive is not that it disappears (this is what the archive expects, this is the archive's requirement), but that it remains. . . . To the degree that it remains, but remains differently or in difference, the past performed and made explicit as (live) performance can function as the kind of bodily transmission conventional archivists dread, a counter-memory . . . [4]

In the context of the museum, then, performance acts as a direct challenge to archival authority.

Every presidential library performs, both implicitly and explicitly, the unending hauntology or persistent remains of presidential lives. Implicitly, the entire institution of the presidential library affirms the idea that we "haven't seen the end" of a president's influence on American life. Explicitly, a presidential library's postpresidential and legacy galleries perform the president's double reappearance—first as a private citizen and finally as a ghost.

Although Taylor theorizes hauntology from the perspective of the living person, the haunted, I want here to consider hauntology from the perspective of the visitor as a ghost-to-be. While the postpresidential galleries most explicitly rehearse the afterlives of presidencies, they also provide the visitor with productive models for imagining herself continuing to act beyond her own disappearance.

The thirteen extant presidential libraries offer a range of approaches to the idea of legacy with a range of implications for the visitor. The postpresidential

galleries of presidents Hoover and Carter provide models of ongoing civic participation after "disappearance" from public life. Apart from the function they serve in demonstrating particular presidents' ongoing importance, each of the two libraries offers the visitor a model for reimagining her own performance when her public life has ended.

The Kennedy and Reagan Libraries' performances of the presidents' "hauntologies" are characterized by a reliance on the president's unique body. This reliance precludes the visitor entering the spaces left by their departure.

In the cases of Eisenhower, Truman, and Johnson, the libraries leave open what Phelan calls "the possibility of the immaterial."[5] They represent the president's performance in office as a generative act, one that leaves new possibilities for ordinary Americans to perform in its wake. And they rehearse the president's legacy as a *dis*embodied performance, one that therefore has the power to shape (but not define) the visitor's sense of American character long after the leader's physical disappearance.

Inside the presidential library, the postpresidential gallery is a place for making explicit claims about a former president's continued agency in public life. This is a particularly important space for one-term presidents, who have less time in office to display. For living presidents, the post-presidency is often framed explicitly or implicitly as another extended act of service, a continuation of the domestic or international engagements that were most important to the president while he was in office. For all presidents, these galleries demonstrate how the chief executive's performances continue to mark the world through his retirement and aging. In this way, the galleries provide the visitor with models for reinventing herself in the wake of her own disappearance from public life.

Both the Hoover and Carter post-presidency exhibits challenge visitors to make the evaluation of presidential performance an ongoing process, one that does not stop with the leader's last day in office. While we might take for granted that a president would continue to act on the world stage after his time in office, it is in fact a recent development historically that the president continues to perform in retirement. The Hoover Library exhibition claims that he "practically invented the modern post-presidency"[6] as he was enlisted by President Truman for international and domestic missions of unprecedented scope.

Presidential scholarship supports this view. In 1990, after overseeing a major renovation of the Herbert Hoover Library, presidential historian Richard Norton Smith wrote, "In his books and speeches, his commissions, foreign

travels, and above all in his relief efforts, Hoover crafted an ex-presidency richer in accomplishment and more poignant emotionally than any before or since."[7] The veracity of the "since" part of this statement may depend on who is doing the evaluating; several presidents since Hoover have delivered noteworthy postpresidential performances. But as to Hoover's creation of a new model for such performance there is little doubt.

In the Hoover Presidential Library, several galleries on postpresidential accomplishments take the place of an explicitly identified legacy gallery. One gallery details the president's "wilderness years" of exile from government but also his prodigious writing and speaking during this period. Another describes his mission to Europe and the pivotal role he played in helping desperate populations avoid mass starvation after World War II. Another describes the Hoover Commissions' unprecedented effort to overhaul the executive branch of the federal government.

It was, in fact, Hoover's failure as president that generated his extraordinary postpresidential performance. Hoover was, the library exhibit tells us, "forced to defend himself" against those who judged his tenure in the Oval Office harshly. Historians describe these years somewhat differently:

> The quest for vindication was perhaps the dominant theme of Hoover's later life. It found expression in his crusade against the New Deal, his campaign for presidential re-nomination in 1940, his attempt to have himself appointed senator from California when Hiram Johnson died in 1945, his assistance to scholars engaged in revisionist history, and, above all, his unending series of books [including] a huge, multivolume, never-published indictment of Franklin Roosevelt's foreign policy.[8]

If these efforts (excluding the published books) are not mentioned in the museum, it is likely because they did little to resuscitate Hoover's reputation. Although he left office in 1933, it was not until President Truman sent him to Europe in 1946 on a massive humanitarian mission that Hoover's historic postpresidential performance began.

The Hoover Library's postpresidential displays vividly demonstrate the potential value of these "post-disappearance" years. As a performance model, Hoover's postpresidential legacy affected not only future American presidents but American character as a whole, helping to infuse retirement from work with a fierce determination to remain in play—indeed, to perform even better than before. As the visitor experiences Hoover's "invention" of the post-presidency inside the museum, she enters a generative space in which the death of one identity makes possible the birth of another.

The Carter Center and its integration with the Carter museum represent a further updated model of postpresidential performance. Rather than serve primarily as an American ambassador abroad (although he did this) or as a formal consultant to the federal government (although he did this as well), Carter concentrated his postpresidential efforts on building an institution that could continue his work for peace and humanitarian causes around the globe. For this work, he received a Nobel Prize more than twenty years after leaving office and is "generally considered to be America's best ex-president."[9]

In the spacious last gallery of the museum, the visitor can learn in some detail about the individual issues to which the Carter Center dedicates its work and the depth of the center's impact on each issue in specific countries around the world. The extensive digital archive here is available to visitors through large touch-screen monitors, colorful panels of photographs and text, maps, and a short film. The gallery invites—and challenges—visitors to become educated, active citizens of the world.

Since the establishment of the Carter Center, other presidents, both Democrat and Republican, have followed Carter's institutional approach to continued engagement. President Clinton consciously modeled his post-presidency on Carter's and his library's legacy gallery, titled "The Work Continues," focuses on the Clinton Foundation's ongoing work for peace around the world. The last gallery of the George H. W. Bush museum is dedicated to educating visitors about a single issue, cancer, to which the former president has dedicated considerable resources as a private citizen. This exhibit also provides visitors with resources for learning more and becoming involved as a volunteer.

Of course, not every president has a postpresidency to perform. Roosevelt and Kennedy both died in office, and Reagan's postpresidential years were effectively lost to Alzheimer's disease. But most presidential libraries that treat the subject exhibit models of active performance following the apogee of the president's career. The Hoover and Carter Libraries go further, suggesting that even for a man who once led the nation, these years may be the most important of all.

The libraries that look back on deceased presidents must, by definition, reckon with presidential legacy in a different way. Presidents John F. Kennedy and Ronald Reagan still occupy important spaces in American public life. In a 2011 Gallup poll of American adults, for example, Reagan topped the list of "greatest" presidents, with 19 percent, nearly one-fifth of the country, regarding him as the greatest president in the history of the United States. What's more, Gallup notes that "Reagan, Lincoln, or John F. Kennedy has

been at the top of this 'greatest president' list each time this question has been asked in eight surveys over the last 12 years."[10] But to say that either president "haunts" the nation seems an inadequate indication of the active hold of what Rebecca Schneider would call their material presence in American culture. In the Kennedy and Reagan Libraries, the chief executive's legacy is tied firmly to the president's body.

Both Kennedy and Reagan still occupy the role of the president so fully that they continually refuse to be relegated to the immateriality of ghosts. In a famous moment in the 1988 vice-presidential debate, candidate Dan Quayle argued that he had as much experience in Congress as Jack Kennedy had when he sought the presidency. His opponent, Lloyd Bentsen, decried the comparison to prolonged cheers and applause: "Senator, I served with Jack Kennedy, I knew Jack Kennedy, Jack Kennedy was a friend of mine. Senator, you are no Jack Kennedy."[11] Similarly, explicit efforts by Republican presidential candidates, most notably 2008 presidential hopeful Senator John McCain, to occupy Reagan's place have proved unsuccessful. Consistent with this refusal to relegate these presidents to the status of ghosts, their respective libraries demonstrate the importance of each president's unique physical presence in shaping not only his postpresidency but his posthumous legacy.

At forty-three, John F. Kennedy was the youngest man ever elected to the office of the president. (Theodore Roosevelt was a year younger when he succeeded William McKinley without being elected.) His youthful good looks worked to historic and some say decisive advantage in the first-ever televised presidential debate with an older, less at ease, and less photogenic Richard Nixon. Even earlier, as a young senator, his athletic, young, and handsome body and the body of his young wife, Jacqueline, were the subjects of national admiration. As one scholar describes it, "Kennedy had the glamorous aura of a youthful movie star with a stinging wit. His wife was gorgeous and stylish. Even his adorable children looked like products of central casting."[12]

Yet historically, John F. Kennedy's body was a vulnerable one. After a childhood in which he was very frequently sick and a serious football injury in college, the wartime re-injury of his back prompted a series of physical traumas, beginning with two surgeries.

The senator almost died of postoperative complications, including a grave staphylococcal infection; and on two occasions, he was given the last rites of the Roman Catholic Church. Even after the immediate crisis passed, Kennedy's convalescence was lengthy and difficult, and still another operation

had to be performed a few months later. . . . Unfortunately, the back operations that caused him so much difficulty actually made his back condition worse. There was some fear that he would never walk again, and that he might have to resign his seat in the Senate.[13]

Nor was this the full extent of Kennedy's physical challenges. Kennedy also suffered from Addison's disease, a failure of the adrenal glands that is itself very serious and that puts patients at heightened risk of death from other illnesses and surgeries. Ironically, the year-round tan that contributed to the popular impression of his vitality was a symptom of the disease.[14]

Few Americans knew the extent to which Kennedy's physical embodiment of vigor was a consciously—and painfully—crafted performance. Kennedy successfully hid most of his health problems from the public both directly, through his embodied performance of physical well-being, and indirectly, through his remarkable productivity in times of convalescence. He publicly denied that he suffered from Addison's disease. He wrote his Pulitzer Prize–winning book, *Profiles in Courage*, while recovering from surgery and in a period of acute physical distress. And, during his tenure at the White House, he missed only one day of work. He remained a national symbol of youth and vigor until his death.

In part because of the unique symbolic strength of Kennedy's body, his assassination was a historic moment in modern American consciousness. "Information about John F. Kennedy's shooting and subsequent death," writes one scholar, "radiated through the American population like an electrical shock jolting the nation's nervous system."[15] Kennedy's assassination became a metaphor for the loss of a mythic ideal America, innocent, beautiful, and filled with promise. Jacqueline Kennedy helped to create this symbolic association when, just one week after her husband's death, she drew a connection between his presidency and the 1960 Broadway musical, *Camelot*, based on the Arthurian legends of the mythical city. The original title song, sung by King Arthur, describes the idyllic "laws" and "conditions" of Lerner and Lowe's Camelot, where even the weather is subject to the discipline of idealism.

Significantly, it is in the reappearance or reprise of the song that King Arthur sings the lines to which the newly widowed Jacqueline Kennedy referred,

Don't let it be forgot
That once there was a spot
For one brief shining moment that was known as Camelot.[16]

In the musical, which debuted on Broadway months before Kennedy took office, the reprise functions performatively, bringing back to life the melody to which the song that describes the mythical world was sung. In American politics, Jacqueline Kennedy's analogy took hold, and many historians still use "Camelot" as a shorthand way of conjuring the America that only seemed possible through the leadership of Kennedy himself.

The Kennedy museum displays the vulnerability of Kennedy's body more candidly than he was willing to do in his public life. In one corner of the permanent exhibition, an eight-by-ten black-and-white image shows Kennedy on crutches entering the hospital with his wife for the first of his back surgeries. The caption under the photograph reads, "For much of his life, JFK suffered from severe back pain requiring numerous hospitalizations and surgeries." A quotation on the wall from Mrs. Kennedy further demonstrates the pervasiveness of her husband's physical suffering:

> The year before we were married when he'd take me out, half the time it was on crutches.
>
> And once I asked him . . . if he could have one wish what would it be . . . and he said, "I wish I had had more good times," and I thought that was such a touching thing to say because I always thought of him as this enormously glamorous figure . . . but I suppose what he meant was that he had been in pain so much.[17]

In the museum's Oval Office display, the rocking chair Kennedy used to soothe his ailing back represents the president's ongoing health problems.

The representation of the president's death at the Kennedy museum is remarkable insofar as it errs on the side of underrepresenting the national impact of the event. A dark hallway, windowless with dark blue walls features five inset screens of different sizes and at different heights, each playing at muted volume the televised coverage of Kennedy's funeral. The tone is somber and formal. There is no visual evidence of the shooting itself, nor are there any newspaper headlines, editorials, or historical commentaries. In this way, the display rehearses the performance of public mourning but does not emphasize the unique impact of Kennedy's body—in life and death—on American character.

The corporeal mystique of John F. Kennedy returns in surprising ways, however, in the legacy gallery of the Kennedy Library. The museum materials describe the legacy room as "a space resembling a research room where visitors may learn of President Kennedy's continuing influence by

browsing through books, photograph albums, videotapes, and historical objects in drawers and exhibit cases." In addition, "an interactive computer exhibit allows visitors to explore an archive of articles, essays, legislation and speeches."[18]

All of this is true, as far as it goes. Visually, however, the most prominent displays in the legacy room are photographs of the Kennedys who outlived or succeeded the president, including his younger brothers, Robert and Edward Kennedy, his son, John F. Kennedy Jr., and his niece, Kathleen Kennedy Townsend. Each photograph is accompanied by a narrative describing the family member's political accomplishments and, in the case of Edward Kennedy, a number of other supporting documents. These other Kennedy bodies, with their visible resemblance to the president's, are represented here as among the most important ways in which he continues to perform.

The vast institutional legacy of John F. Kennedy is partially represented elsewhere in the museum. A gallery dedicated to the Peace Corps comes earlier in the exhibition and, later, another dedicated to Kennedy's work on behalf of Americans with mental retardation. But one has to go to the legacy link on the library's web page to read about the many other institutional legacies of the president, including the American Ireland Fund, the Green Berets, the Harvard Institute of Politics, the Kennedy Center for the Arts, the Kennedy Scholars program, and the Navy SEALs. Nor is Kennedy's aggregated policy legacy represented anywhere.

To be sure, the other Kennedys highlighted here are important historical figures, and their inclusion in the museum is not in itself surprising. What is surprising is the placement of these materials. One might expect to find them in the long hallway earlier in the exhibition dedicated to multiple generations of the Kennedy family, or in a separate space near the end of the exhibition dedicated to the important work of other family members. But here they are explicitly displayed as embodiments of JFK's legacy. Their function suggests a curious reversal of the function of "legacy" in the college admissions process (of which many Kennedys, including John, were beneficiaries, their father, Joseph P. Kennedy having matriculated at Harvard in 1908). John F. Kennedy continues to "get in" to the ongoing narrative of history in part by way of his younger relations. Clearly, then, and perhaps not surprisingly given the governing structure of presidential libraries, the legacy gallery prioritizes genealogy as the primary modality of Kennedy's "hauntology." Only through another Kennedy can John F. Kennedy reappear.

It is not uncommon for individuals to think of their children and grandchildren—though not, typically, their younger siblings—as part of their

legacy. In his study of the quest for immortality, Steven Cave calls this "bio-logical immortality," "the belief that we live on in our offspring, that we and they are connected in a profound way that makes us in some crucial sense the same being. So when these individual bodies have withered and died, still we might flourish in the verdancy of the next generation."[19] But in this case, blood relations cannot be separated from relationships of power. These Kennedys are, after all, the privileged of the privileged, those who benefit from and maintain the family's access to the highest levels of political and cultural influence. By emphasizing the Kennedy bloodline over the rest of John F. Kennedy's ongoing contributions, the legacy gallery obfuscates the more substantial ways in which the president's performance in office con-tinues to shape public life.

It also, perhaps unwittingly, forwards an elitist view of the makers of history. For if it is true that Camelot will reappear principally through the unique DNA of the Kennedy family, there is little opportunity for the or-dinary citizen to play a role in bringing it back to life. After all, we can't all be millionaires and beauties. We can't all have the U.S. presidency in our genes. We can't all be Jack Kennedys.

Reagan was iconic in quite a different way from Kennedy, modeling, as he did for more than half a century, the mythic power of the ordinary body in both mediated and live performance. Very early in his career, Reagan's Hollywood handlers remade his physical image, changing not only his wardrobe but his hairstyle, hair color, complexion, eyewear, and even the contours of his face. With these changes to his natural appearance, Reagan filled a critical niche in Hollywood, the character of the "genial, Midwestern, corn-fed, handsome American everyman."[20] (Anomalously, Reagan became a star in Hollywood through a film in which his character's body was disfigured. In the 1942 movie, *King's Row*, Reagan played Drake McHugh, a wealthy youth suitor whose legs are amputated by a sadistic surgeon. Instead of being de-feated by this trauma, McHugh responds with a renewed will to live.) Later, as the national spokesperson for General Electric, Reagan found that his Hollywood training translated brilliantly to television and even off-screen, making this "ordinary" corporate spokesman the second most in-demand speaker in the country after then-president Dwight D. Eisenhower.[21]

Reagan was also different from Kennedy in age and experience. While Kennedy was the youngest elected president, Reagan was the oldest. It was, therefore, incumbent upon him to demonstrate his mental agility, which he often did through humor. Most famously, in his second presidential bid in

1984 during a live debate with former vice president Walter Mondale, who at fifty-six was sixteen years his junior, Reagan deflected concerns about his age, promising "not to exploit for political purposes my opponent's youth and inexperience."[22] And if Kennedy embodied physical vigor through ongoing and strenuous efforts to hide serious health issues, Reagan definitively quelled any speculation about his physical resilience when he left the hospital wearing a bright red V-neck sweater and an easy grin twelve days after he was hit by an assassin's bullet.

Reagan's image occupied the national stage far longer and in more realms of public life than Kennedy's did. In addition to his Hollywood career, his career at GE, and his tenure as governor of California, Reagan held the office of the president five years longer than Kennedy did, practicing face-to-face diplomacy and embodying leadership for nearly a decade. If Kennedy's body was a symbol of privilege, youth and fleeting innocence, Reagan's was a symbol of ordinariness, stamina, and enduring wisdom.

Reagan's departure from the presidency was also strikingly different from Kennedy's. Unlike Kennedy, whose performance as president was cut short by an act of violence, Reagan was able to complete the performance of his presidency. In his farewell address, the president invoked what Gil Troy calls the "Reagan Storyline," a simple story of "decay and renaissance."[23] With an emphasis on the latter part of the formula, Reagan emphasized the reappearance on the world stage of an original, lost America. "They called it the Reagan revolution. Well, I'll accept that, but for me it always seemed more like the great rediscovery, a rediscovery of our values and our common sense." With this substitution of "us" (Americans) for "Reagan," the departing president figured himself as an effigy, a living performance of a lost American character. In closing, he credited the "men and women of the Reagan revolution" who, he said, "brought America back."[24] This final substitution completed the ultimate success story for an American president, the leader as surrogate for the people who are surrogates for the nation.

Reagan's disappearance—and therefore, his reappearance—were also different from Kennedy's. Reagan retreated from the public eye slowly at first, then abruptly, with his 1994 announcement that he was suffering from Alzheimer's disease. For the next decade, although his presence would be frequently invoked by Republican politicians who sought, either directly or indirectly, to succeed him, Reagan himself was gone from the national stage. While Kennedy's abrupt and premature death made it difficult (if not impossible) to experience his funeral as anything other than a violent and

final disappearance, Regan's living disappearance allowed his 2004 funeral to function as the president's triumphant return.

The Reagan Library legacy room is a small, dark theater with large quotes on either wall highlighting abstract ideals, one about the imperative to "work together for progress and humanity," the other aspiring to a legacy in which "we finished the race; we kept them free; we kept the peace." On a screen in the front of the room is a kind of "greatest hits" of the introductory film, a collage with catch-phrase titles such as "American Spirit" and "Dedicated to Freedom."[25]

In sharp contrast to the legacy room, the room that deals with Reagan's death is brimming with color and life. The gallery is titled "Mourning Ronald Reagan" and is dedicated to the president's 2004 funeral. Many other libraries display the president's funeral, but none afford it as much space or visual weight. Inside the gallery, the walls are filled from floor to ceiling with six color images from Reagan's funeral and four giant video screens. The screens display looped portions of Reagan funeral events, including the private family service, the service at the National Cathedral, and the actual journey of the casket from California to Washington and back. Of the still images, two display the impact of Reagan's death on ordinary citizens and on his family. The remaining four—including one of then-president George W. Bush at the National Cathedral—foreground the casket itself. In the final image, a close-up comprised primarily of the head of the former first lady, Nancy Reagan clutches the flag that draped her husband's casket in one hand and covers her eyes with her other hand, her children leaning in close on either side to comfort her.

Diana Taylor argues that Princess Diana's funeral procession worked to rehearse the "sacralization of the remains" which "take on a life of their own."[26] Similarly, Reagan's remains take on new life at his library. The images here reenact the original mourning of Reagan, rehearsing what Troy dubs the "near-canonization" of Reagan through his funeral and the eight-day commemoration that preceded it.[27] The image of Nancy Reagan suggests as concretely as any documentary photo could the idea that the president's body *is* the nation. And the enormous size of the images suggests that it is not Reagan's ideas, policies, or even his much-vaunted communication style but finally Reagan's body that refuses to disappear. Despite Reagan's 1994 confession that he was headed into the "sunset of my life,"[28] the funeral gallery rehearses a new morning for Reagan in America.

In the museum, Reagan's body reappears as a sacred and distant presence. In doing so, it promotes civic unity, but at a significant cost. Taylor argues that Princess Diana's ghost "unites the spectators in the fantasy of loving

and losing a woman no one really knows, even as it hides the social rela-
tions among the very people who, theoretically, participate in the fantasy."[29]
Similarly, Reagan's reappearance in the mourning gallery is not so much
a haunting as a continued holding of the public stage. It places visitors in
a subordinate relationship to the lost leader, who towers above them as a
Technicolor image once again.

In both the Kennedy and Reagan Libraries' postpresidential galleries,
the president's body refuses to be separated from his legacy. This refusal
to disappear disempowers those who might create new performances of
American character in the spaces these men left behind.

The Eisenhower Library is the only presidential museum to represent the
legacy of an American general. Much of the library's exhibition space is
dedicated to exploring Eisenhower's military career, his rise through the
ranks and his role as supreme commander of the Allied forces from the
planning stages of D-Day to the end of the war. But the exhibition begins and
ends with galleries dedicated to this man of action's ideas. Biographer Jean
Edward Smith summarizes the general's philosophy: "Eisenhower believed
that the United States should not go to war unless national survival was at
stake. 'There is no alternative to peace,' he famously said. He dismissed the
necessity of conflict beneath the nuclear threshold and refused to engage
American troops in brushfire wars for political abstractions."[30] Perhaps
the best artifact of this belief is Eisenhower's farewell address as president.

The first gallery of the library holds a 1950s black-and-white television that
plays a film clip of Eisenhower's most famous speech. Delivered on January
17, 1961, the speech is remarkable both in performance and in content. The
first president to speak on television, Eisenhower sits at his desk, papers in
hand. He reads slowly and deliberately, pausing every five to ten seconds to
look directly into the camera. He articulates clearly and maintains a stern
expression. Eisenhower knew from his presidential campaign, and likely
much earlier, that he always fared better with extemporaneous speaking
than with written texts, which "obscured Ike's folksy charisma."[31] Here,
in his final public address as president, Eisenhower seems to purposefully
abandon any effort to charm. The stark, unedited footage and the lack of
rhetorical or gestural flourish are arresting to anyone who is accustomed
to seeing more contemporary presidents speak on television. Eisenhower's
sheer bodily presence commands attention.

But nothing in Eisenhower's performance is as startling as the prophetic
content of the speech. The outgoing president warns Americans to "guard

against the acquisition of unwarranted influence, whether sought or un-sought, by the military-industrial complex. The potential for the disastrous rise of misplaced power exists, and will persist."[32] In addition, he warns of the undue influence of government funding on scholarly research, the plundering of national resources for short-term goals, and the imperative of disarmament.

These concerns, Eisenhower notes briefly, arise not from abstract thinking but from experience rooted in the president's own body. He speaks, he says, "as one who has witnessed the horror and the lingering sadness of war."[33] Indeed, it is this president's success in war, unparalleled in his century, which gives him unique authority to speak for the cause of peace. Although the speech is the first exhibit in the museum, its status as a farewell address and its prophetic power lend it the power of a legacy exhibit.

The only space in the museum dedicated to Eisenhower's postpresidential years is a small sitting area called "Ike Speaks," in which one can pick up a telephone and barely make out (due to the quality of the recording) the ex-president's voice speaking with Kennedy or Johnson. There is strong his-torical evidence not represented in the museum that Eisenhower lost sight of his own best principles in his later years, advising President Johnson in ways that were deemed "hawkish" and even "inappropriate."[34] Fortunately, by this time in Eisenhower's post-presidency, successors strategically sought his advice—and then largely ignored it. Toward the end of the permanent exhibition, the visitor can review the narrative of Eisenhower's death, his body's brief but brilliant reception in the Capitol Rotunda, and its return home to Kansas City for a modest military burial.

But the final gallery of the museum returns to Eisenhower's mind. Rather than claiming Eisenhower's accomplishments in battle or in the Oval Office as his legacy, the strikingly simple "Afterthoughts" gallery again focuses on the exceptional ideas about leadership in war and peace he embodied as president. The gallery includes quotations from Eisenhower himself and from scholars of his administration. Several of these quotes echo the pres-ident's farewell address, warning against the excessive use of force. Others discuss his leadership and character. Like the first gallery in the exhibition, "Afterthoughts" focuses on the wisdom that comes from embodied experi-ence rather than the body itself.

Journalist Walter Lippmann once quipped that "Ike could be elected even if dead."[35] Though the joke was aimed at Eisenhower's unassailable reputation, it also points to the ultimate transcendence of Eisenhower's ideas over the formidable body that gave them their authority. By performing his

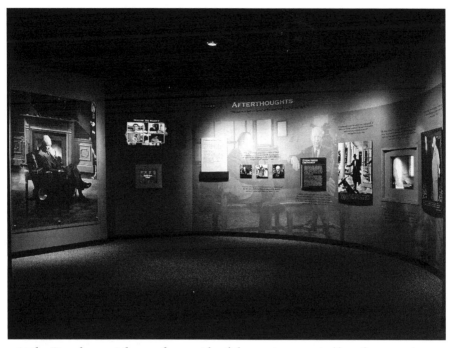

At the Eisenhower Library, the president's legacy is suggested by a few prominent quotations accompanied by photos. *Photo courtesy of Eisenhower Presidential Library, National Archives and Records Administration, Abilene, Kansas.*

legacy as one of thought, the Eisenhower Library offers the visitor one possible model for enduring beyond physical disappearance. A person's most important ideas, the exhibit suggests, haunt the public space, even when his embodied performances of them are over.

The Truman Library takes a unique approach to the president's disappearance, representing his enduring personal and political legacy in multiple ways. As in the Eisenhower museum, the Truman Library deemphasizes the president's material remains. Indeed, one has to hunt diligently in the hallway outside the basement exhibits to find mention of Truman's death and funeral. No large, color images or personal tributes here. Instead, the library presents multiple performances of presidential legacy. This strategy offers the visitor multiple models of endurance post-disappearance, encouraging her to think critically about the nature of personal legacy.

President Truman's political legacy is elegantly represented in the "Legacy Gallery," designed by Chermayeff and Geismar and fabricated by Explus, Incorporated. A generous, triangular space with a stone-tiled floor and a wall of glass overlooking the grounds, the gallery is physically inviting. The space

is largely open, though dotted with benches where one can sit, rest, and, if one chooses, pick up a sound stick to hear either Truman's own reflections on his time in office or the perspectives of several different presidential historians. Six etched glass panels along the walls of the space highlight Truman's key accomplishments in the areas of foreign policy, national defense, the presidency, domestic policy, civil rights, and the role of government. A bronze statue of Truman is tucked into one corner, facing the glass wall.

But the Truman Library does not limit consideration of the president's legacy to his political accomplishments. The final hallway, curated by Clay Bauske, displays several alternate performances of Truman's legacy. One area explores how Truman's language haunts political discourse. At the back of the hall, a video monitor plays a series of clips entitled "Who's Quoting Truman?" showing "brief excerpts from speeches in which prominent American politicians of different political parties and philosophies invoke the spirit of Truman and claim his legacy." The video collage is a veritable who's who of late twentieth century American politics. Nearly all of the politicians quote one of three famous lines: "The buck stops here," the slogan Truman kept on his desk throughout his life; "If you can't take the heat, get out of the kitchen"; or his response to supporters' shouts of "Give 'em hell, Harry," "I give them the truth and they think it's hell."[36] This display of the ubiquitousness of his most recognizable public promises—to take responsibility, to be tough, and to tell the truth—suggests the extent to which Truman continues to perform through the bodies of other public figures.

Other modest exhibits of Truman's legacy fill the remaining space. One wall of the final hallway is filled with examples of Truman's institutional legacy including academic scholarships, fellowships, and awards in his name. And, just before the museum exit, a glass-encased bulletin board displays current newspaper and magazine articles connected in some way to the work of Truman's administration. This makeshift and ever-changing display suggests that Truman's legacy is still unfolding. The case is accompanied by a visitors' book with a text panel encouraging visitors to share their own perspectives on Truman's legacy and, importantly, to reflect on its representation in the museum. Here, it is the visitors themselves who keep Truman's performances from disappearing.

Finally, the visitor can pass through the library's courtyard to gain access to Truman's postpresidential office. The exhibition here both tells the story of the planning and dedication of the library and preserves much of the original décor and layout of the library office space, which Truman used more regularly and longer than any other president, often six days a

week over a nine-year period. Truman often surprised visitors by appearing unannounced and even gave impromptu tours. "Indeed," muses David Mc-Collough, "for about nine years, the most memorable exhibit on display at the library was Truman himself."[37] Although the "exhibit" is no longer on view, this space brings Truman's investment in the library itself back to life.

The collective effect of these multiple approaches to the question of presidential legacy in the Truman Library is to foreground the complexity and unpredictability of post-disappearance performance. The library rehearses for visitors some of the many ways that she might stay in play.

The most compelling display of presidential legacy can be found in the Lyndon B. Johnson Library under the large graphic title, "LBJ and You." The exhibit was developed by library director Mark Updegrove, LBJ Foundation executive director Elizabeth Boone, and special projects manager Raine Pipkin, in collaboration with three different design firms. The display occupies a large hallway on one side of the museum's grand staircase. Like the timeline of Johnson's life on the museum's bottom floor, this area is spatially separated from the exhibits on the presidency itself. Two large, identical text panels on either side of the long hallway read as follows:

> Before he left office, President Johnson's programs began to transform America. President Lyndon Johnson did not end poverty or racism. To this day, people with opposing points of view attack his programs as too expensive, too intrusive, too ambitious, or too reliant on the power of the Federal government. But Lyndon Johnson believed that good government could be a force for positive change and a protector of the people. Millions of Americans benefitted from his vision and energy in the 1960s, and millions more still do.[38]

In between these panels, the exhibit performs Johnson's legacy through large, vivid color photographs, many of them life-sized, suspended from the ceiling or adorning posts or walls throughout the gallery. The images range widely from a portrait of Robert Redford, whose Sundance Institute, with its emphasis on land preservation, was made possible by the Johnson administration's environmental policies, to photographs of ordinary Americans who were, for example, the first to receive a Medicare check or to be direct beneficiaries of other Johnson programs; from Big Bird, whose mediated existence was made possible by the Johnson-era Public Broadcasting System, to Barack Obama and Clarence Thomas, whose political lives were made

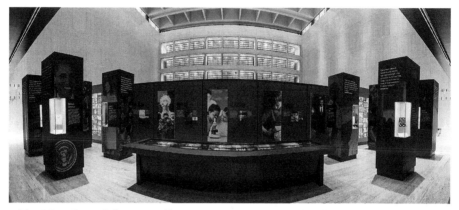

The LBJ Library's legacy gallery prompts visitors to think about how the president's work affects their lives today. *Photo by Laura Gerson; courtesy of LBJ Presidential Library.*

more possible by "safeguards to ensure American liberty" such as the civil rights legislation of the Johnson administration.

In addition, the exhibit is peppered with direct questions to visitors about their own everyday performances, accompanied by explanations of how LBJ shaped these behaviors. Simple text panels ask the visitor, "Have you ever watched a program on the Public Broadcasting System?" "Do you wear a seat belt?" "Did you get financial aid for college?" Perhaps most powerfully, other questions point to performances that LBJ helped to make obsolete, including "Have you ever been in a bomb shelter?" and "Did you practice 'Duck and Cover' in school?"[39]

By asking visitors to reflect on their own performances as American citizens, the museum at once sets a high and a modest standard for presidential legacy. Although the gallery references successful legislative efforts, it is not sufficient merely to list the names of laws passed or to marshal the support of historians to verify their significance. Here, to qualify as part of a legacy, a presidential act must affect the embodied practices of Americans in such a way that it would not be possible for them to live as they are currently living without it.

This is a tall order, but given the staying power of performance, an immanently achievable one. Indeed, the LBJ legacy exhibit makes clear that the ways in which this president's legacy haunts the visitor are so diffuse and so embedded in our daily lives that we may hardly be aware of them. To walk through this legacy exhibit is to trace the reach and endurance of LBJ's postpresidential performance. But it is also to trace the reach and endurance

of those who followed him, both known and unknown. The exhibit helps the visitor to experience the intimate ways in which the legacies of others' lives animate her body. And, perhaps, to imagine how hers might, in turn, animate the bodies that follow.

Taken together, the libraries' legacy galleries offer many possible answers to the question of what remains of presidential performance. Beginning with Hoover (and therefore including the entire span of the library system), many presidents who lived beyond their time in office kept working in the public space, demonstrating their ability to continue serving the country and, in many cases, the world. These presidents' libraries often exhibit this post-presidential work as an important part of their legacies. With its founding in the early 1980s, the Carter Center created a new model for "reappearance." Carter's postpresidency extended beyond his own embodied performance to the creation of global nonprofits. The last gallery of the museum is dedicated entirely to displaying this work.

Other libraries rehearse other ways in which presidential performances continue to haunt us, including through ideas, legislative action, public works, and words. The Eisenhower Library legacy gallery is affecting in its sparseness, suggesting that, even for a man of towering physical authority and widely heralded achievement, only a few powerful "afterthoughts" remain. The Truman Library provocatively embodies the idea that there are myriad ways of looking at how presidential performances endure. And the Johnson Library legacy hall suggests that the visitor locate the legacy of presidential performances in the bodies of subsequent performers, including her own.

For other presidents, the question of legacy is more complicated. Ironically, two of our most popular presidents offer the most elusive answers, as the Kennedy and Reagan Libraries suggest that it is the man's genetic material or embodied appearance, respectively, that will stay with us, upstaging all those who would act in their wake. Yet the body is that dimension of performance that most definitively disappears, and in fact both Kennedy and Reagan created more lasting impressions on the body politic in other ways, some of which are explored in other chapters of this book.[40]

These legacy galleries do more than perform the immortal visibility of presidential lives. They encourage visitors to think broadly, even idiosyncratically, about their own "remains," imagining their own reappearances in fragmented, multifaceted, and surprising ways. Perhaps, as Peggy Phelan suggested, the disappearance of live performance really does generate productive possibilities. If so, the performances of disappearance at presidential

libraries might move visitors, encouraging them to aspire to a disembodied immortality. Such a legacy would continue to act as an idea, a word, a gesture. It would impress itself upon the bodies of the living. It would move these bodies to perform differently without ever needing to be seen.

Interlude: A Legacy in Song—Graham Jackson Brings Roosevelt Home

Comin' to Georgia was comin' home for me. Didn't move from Virginia until I was grown, but somethin' about it, the heat, the land, the way people acted toward you. And of course the music. I was a theater organist in Georgia, which meant I got to help create the sound and the feel of the mostly made up places where the plays took place, help bring them to life. I loved it, I really did. In fact, of the places where I played organ, Georgia is a lot more home to me than Portsmouth ever was.

But not to him. Bein' from the east, he never could get into the swing of things down here. They sent him here to relax, you know, to help the pain, and the man just kept on workin'. Relaxin' just wasn't a part of his nature, I guess.

I wouldn't say we were friends, not friends exactly. Not quite "friends." But I respected him. A man grows up with more money than Daddy Warbucks and he dedicates his whole life to givin' the guy who gets the sorriest deal a better one. How are you goin' to not respect that? Oh, I know, there's folks that say he just wanted the government meddlin' in people's lives, makin' all the decisions, controllin' all the money. But I'll tell you, when he got here there were a lot of people who needed some meddlin' pretty bad.

So when we started talkin' about the song and he asks, would I work out a new version with him, well to tell the truth I thought he was pullin' my leg. But when I figured out he was serious, well a'course I said I'd do it. It was based on a line from Dvořák he loved and we called it "Goin' Home." We wasn't quite finished with it, but finished enough, I guess.

He died in Warm Springs on April 13, 1945. The day that funeral train went by was one of the saddest days of my life. We'd just been with him so long, he was like our family, even if he wasn't quite our friend. I couldn't

see her, his wife, she was way back inside the train, and I didn't really want to see him. So I just closed my eyes and started to play the song. I was thinkin' about home—not Georgia, not Virginia but, you know, the larger home, the whole United States. I thought about the kind of home he had wanted it to be and the kind of home I had wanted it to be. I kept playin' and cryin', playin' and cryin'. I was wishin' I was inside a theater so my playin' could bring up the curtain on that place.

Musician Graham Jackson and President Franklin Delano Roosevelt collaborated on the composition of a song. Following Roosevelt's death, a famous image of Jackson playing the song on his trumpet, his face streaked with tears, appeared in *Life* magazine.

4. UTOPIAN CHARACTER
The Role of the Imaginary

While some scholars have focused on the role of performance in modeling human disappearance and reappearance in everyday life, others have focused on its value as an explicitly imaginary act. Jill Dolan writes about the efficacy of what she calls utopian performatives, acts that "persuade us that beyond this 'now' of material oppression and unequal power relations lives a future that might be different."[1] By performing this future, she argues, utopian performatives can inspire audiences to work toward its realization.

In the United States, one archetype of utopian performance is the American Dream. At the core of the American Dream is a belief in the relationship between individual merit and worldly success. In *The Meritocracy Myth*, McNamee and Miller explain:

> In a general way, people understand the idea of the American Dream as the fulfillment of the promise of meritocracy. The American Dream is fundamentally rooted in the historical experience of the United States as a nation of immigrants. Unlike European societies dominated by hereditary aristocracies, the ideal in America was that its citizens were "free" to achieve on their own merits.[2]

It is the dream that every parent offers her children. And when Americans inculcate this dream into their young boys and girls, the presidency often serves as an embodied example.

The American Dream has, in many ways, made America. Although the term was first popularized in the early 1930s, it produced feelings of warmth and love because it represented "the fulfillment of the promise of meritocracy" as imagined by our Founding Fathers. McNamee and Miller argue that a dream based on a limitless potential for individual success is "not a historical accident but is firmly rooted in the religious, political, economic, and cultural experience" of Americans, including the country's revolutionary origins and the Protestant work ethic.[3] Presidential historian Doris Kearns Goodwin describes how the generation that followed the

founding fathers was shaped by the promise of what was not yet called the American Dream:

> [It] propelled thousands of young men to break away from the small towns and limited opportunities their fathers had known. These ambitious young-sters ventured forth to test their luck in new careers as merchants, man-ufacturers, teachers, and lawyers. In the process, hundreds of new towns and cities were born, and with the rapid expansion of roads, bridges, and canals, a modern market economy emerged.[4]

Goodwin's description makes it easy to understand why meritocracy is such a cherished American value.

Of course, not every American believes in these meritocratic ideals. It is not surprising that nonwhites and those with less income are less likely to endorse the idea of a meritocratic American society. What *is* surprising is that throughout most of the twentieth century, the majority of Ameri-cans believed, despite abundant evidence to the contrary, that individuals of merit succeed. McNamee and Miller summarize what survey research has repeatedly confirmed: "Most Americans not only believe that meritocracy is the way the system *should* work; they also believe that meritocracy is the way the system *does* work."[5]

McNamee and Miller unpack the term "merit" into four characteristics: an individual worthy of success, they argue, must have innate talent, a strong work ethic, the right attitude, and moral virtue.[6] They go on to deconstruct this formulation and to argue that the sufficiency of individual merit in the quest for success is a myth. Their articulation of the nonmerit components of success is important, and I will draw on it in the next chapter.

First, though, I want to suggest that the myth of meritocracy is nonethe-less a *useful* myth. Specifically, as Dolan writes of the theater, the presidential libraries' performances of merit provide the visitor with ways to "embody and, even if through fantasy, enact the affective possibilities of 'doings' that gesture toward a much better world."[7] As utopian performatives, the librar-ies' embodiments of the American Dream have the potential to produce a salutary "museum effect" for visitors as they return to cultivating their own characters in the non-utopic America in which they live.

The presidential library necessarily performs the utopian model of American success in reverse. Beginning with the achievement of success epitomized by winning the presidency, a part of the story known to all visitors before

they enter, the library works to represent the development of its subject's character through his childhood and prepresidential adult years in a way that upholds the cherished myth of meritocracy. For presidents, the history of this culturally commanded performance extends back far beyond the existence of presidential libraries, indeed to the legend of George Washington and the cherry tree. But the presidential libraries have institutionalized it.

How do the museums' prepresidential galleries perform merit as a core component of presidential character? My aim is not to critique the historical accuracy of the exhibits, but to analyze them as aspirational or utopic models for the performance of American character. These performances have significant value for visitors in understanding both presidential character and American character writ large.

Presidential library exhibits most often perform merit through a series of galleries that precede the presidential galleries and that begin with representations of the president's childhood. Although the very presence of an early childhood gallery in a presidential museum would seem to support the work of tracing the construction of presidential character, in fact they are often so small and so lacking in detail that they reveal nothing.

The presidential libraries often explicitly assert the importance of the formative years in shaping the president's values, leading him, in ways I will further elaborate, to a meritorious character. (The exception to this rule is the new George W. Bush Library, which begins with the story of his marriage. In this way, the library completely elides the future president's less-than-exemplary early life.) But many presidential libraries offer a perfunctory look at the president's childhood. Nixon's family faced economic hardship and the loss of two children. Kennedy was born into a long tradition of public service. Bill Clinton's mother left him with his grandparents in order to get a degree that would help her provide for him. These exhibits typically take up little space and serve primarily to present assertions about parental values or, more peculiarly but no less commonly, the values of the entire community in which the president was raised. (Thus Ford spent his childhood "Growing Up Grand" in Grand Rapids, Michigan, and Clinton emerged from "A Place Called Hope" in Hope, Arkansas.) They rarely provide evidence—even anecdotal evidence—of how the president's character development was directly shaped by childhood experiences.

Attention to the prepresidential years does not guarantee a meaningful performance. In my discussion of the Clinton Library in chapter 2, I argued that the exhaustiveness of the library's performance of Clinton's presidential

years actually posed an obstacle to visitor engagement by eliciting museum fatigue. A second danger of apparently exhaustive museum displays is that, in their lack of selectivity, they fail to make meaning of historical time. This is what happens in the Truman Library.

Although the Truman Library offers the most thorough presentation of prepresidential information and materials in the library system, it is also, surprisingly, minimally revealing of presidential character. Unlike other presidential libraries, it declines to make an argument, explicit or implicit, about how Truman's prepresidential years embodied the performative utopia of American success. In its refusal to do so, the library's performance misses the opportunity to guide the visitor toward imagining a better American character.

President Truman was at best ambivalent about the creation of a presidential library in his name. He dismissed Roosevelt's library as a personal shrine. When he acquiesced to the pressure to create one of his own, he hoped it would become a center for the study of midwestern history. It was not until January 2004, nearly fifty years after it opened to the public and more than thirty years after the president's death, that the Harry S. Truman Library opened an exhibit on the president's prepresidential years.

One of the most striking things about the exhibit, titled "Harry S. Truman: Life and Times," is its relationship to the other components of the museum. Most presidential libraries are organized chronologically, with the first formal gallery devoted to the president's childhood. (The Clinton Library, which ushers the visitor directly into the presidential years and treats his early years very briefly in a later exhibit, is another exception.) In the Truman Library, exhibits on Truman's presidency fill the building's main floor, and his early life is quite literally underground. This spatial stratification faithfully performs Truman's conviction, shared by most of his library's directors, that an understanding of presidential history was a much more important function for the library than an understanding of the man who holds the office. The museum exhibits clearly and intentionally deemphasize Truman's performance, and this is particularly true of the "Life and Times" exhibit.

The large exhibit space devoted to Truman's prepresidential years offers a clear and comprehensive chronology of his life. Designed by Eisterhold Associates and fabricated by Exhibit Associates, both of Kansas City, and curated by Truman Library's Clay Bauske, the space is softly lit and arranged in generous, handsome cases with comparable numbers and sizes of meticulously labeled artifacts. The prepresidential portion of the exhibit

is divided into eight sections, including "Boyhood," "Farm Years," "Military Service," and "County Judge." Four additional display areas cover Truman's professional trajectory to and social life in the White House, and less formal, more haphazardly composed displays in the brightly lit hallway outside the main exhibit room describe his life after leaving office and his death.

Most other presidential libraries' prepresidential galleries are both more selective in their representation and more consciously interpretive of the president's early life and career. At its worst, this curatorial heavy-handedness tips the representation of the president's early years so far toward "inspiration" that it is not really meaningful as public history; the representational script is simply too far removed from the historical script to be of educational value to the visitor.

The more exhaustive chronology and descriptive titles of the display cases in the Truman exhibits avoid this propagandizing tendency. Instead, the library defers to a very old concept of history, one that exhibits "the effect of having filled in all the gaps"[8] through its apparently evenhanded attention to events. But in the process, the designers decline to assign value and relative importance to the events of Truman's early life. This evenhandedness, in

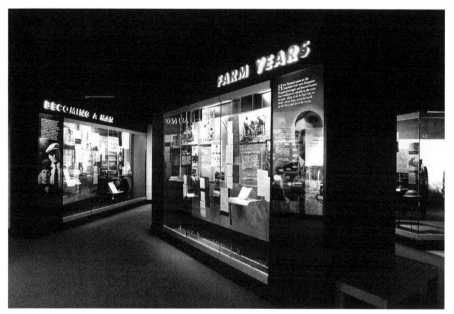

Each of the handsome glass cases in the Truman Library's "Life and Times" exhibit holds a comparable number of artifacts and text. Each represents a span of time within Truman's prepresidential life. *Photo by Bruce Mathews; courtesy of Harry S. Truman Library and Museum.*

other words, actually makes it more difficult for the visitor to construct a meaningful narrative of Truman's life.

A lack of focus in curatorial choices is a common problem in the museum world. Falk and Dierking observe that "museum presentations are often unfocused and ambiguous in their priorities. Visitors experience the museum as a smorgasbord of unrelated objects, images, and ideas, few of which strike a sufficiently resonating chord to be recalled years later."[9] Visitors, they argue, want to know what the museum values.

In fact, as Hayden White has argued, it is the very impulse to treat events *un*evenly, to judge and rank them with respect to their importance, which "makes a narrative representation of real events possible." "Where, in any account of reality, narrativity is present, we can be sure that morality or a moralizing impulse is present too."[10] And while historians may feel uncomfortable with the subjective and imaginative nature of this impulse, White argues, it is the very thing that helps human beings make meaning of the sequence of events that comprises historical time.

To locate any moralizing impulse in the Truman prepresidential exhibition, the visitor must read the displays in fine detail—which, as I have already noted, they rarely do. In the boyhood section, for example, under the subheading of "Great Men and Famous Women," the visitor learns of young Truman's love of books, particularly history books. Although the fact is not noted in the exhibit, the section is named after a book Truman's mother gave him for his tenth birthday, a gift he would later count as "one of life's turning points." Other details of young Truman's intellectual life go unrepresented as well. Biographer David McCullough describes the mise-en-scène of the future president's youth:

> John [Truman] kept loose change in a tray from an old steamer trunk, to save for a set of Shakespeare. Harry would never recall being bored, "not once," he said, because "we had a houseful of books." He read the Bible (twice through by the time he was twelve, he later claimed), "pored over" Plutarch's Lives, a gift from his father, and in time to come, read all of the new set of Shakespeare.[11]

The museum narrative indicates young Truman's academic seriousness by noting in small print that, unlike many of his contemporaries, he completed high school. What it notes only by omission is Truman's distinction, unique among twentieth-century presidents, of being elected to the presidency without a college education. This information would provide greater

heft to the assertion in the postpresidential exhibition that Truman loved his presidential library because he loved to study history.

The only major heading in the exhibit on Truman's life that is not purely descriptive is "Becoming a Man," the title of a display case that chronicles a number of Truman's failed business ventures as a young adult. (Several other business failures are included in the display titled "Home from the War.") The idea that, contrary to the meritocratic mythology, failure is an integral part of character development is an important and, in the context of presidential displays, original contribution (see chapter 5). Were the connection between the themes of moving toward maturity and weathering failure explicitly articulated in the Truman displays, such a "moralizing impulse" might empower visitors to think differently (whether the journey is in their past or in their future) about their own setbacks on the path to adulthood.

The exhibit titled "County Judge" explains briefly Truman's connections to Alderman Jim Pendergast, creator of Kansas City's first political organization, and his family. Jim's younger brother, Tom, inherited the family business from his ailing older brother shortly before the latter's death in 1911. Tom's nephew, also named Jim, served with Truman during the war and introduced his friend to his father and uncle in 1921. It was the Pendergasts who decided to "run" Harry Truman for county judge and, later, for the senate. And it was the Pendergast organization that was primarily responsible for the success of both campaigns.

McCullough describes the Kansas City in which Truman served as county judge as follows: "That gambling, prostitution, bootlegging, the sale of narcotics, and racketeering were a roaring business in Kansas City was all too obvious. Nor did anyone for a moment doubt that the ruling spirit behind it all remained Tom Pendergast."[12] Truman's relationship with the Pendergasts was both long and deep. He considered Mike Pendergast, Tom's brother and his nephew Jim's father, a second father to him. He kept in close touch with Tom Pendergast throughout the latter's life, often making trips from Washington to New York to visit his benefactor and friend. And, despite the buzz about his beholdenness to the family—he was, as the exhibit notes, sardonically labeled "the senator from Pendergast"—he kept a framed portrait of Tom in the lobby of his senate office.

Still, according to all known sources, Truman kept above the fray and managed to get a great deal accomplished as judge, most notably overseeing the construction of new roads and, in a later term as "presiding judge," a new courthouse. As the opening text in the county judge display narrates, "Although he was picked by the local political machine and remained loyal

to Mike and Tom Pendergast, he managed to sidestep the political corruption endemic to county politics at the time."[13] And when, in 1939, Pendergast was indicted for tax evasion and sentenced to fifteen months in Leavenworth prison, Harry Truman's reputation remained untarnished.

Although Truman's success in maintaining both his professional connections and his personal integrity is remarkable, it is easy for a visitor to miss it entirely. The library display greatly diminishes the significance of Truman's ability to stay above the fray. The online version of the exhibit acknowledges this performance of strong moral values much more prominently:

> Between 1930 and 1934, Truman occasionally took refuge at the Pickwick Hotel in downtown Kansas City. He had become increasingly tense, prone to headaches and insomnia, and the Pickwick was a place where he could think and work uninterrupted. During his stays, Truman became introspective, pouring out his thoughts about Jackson County politics and personalities on page after page of hotel stationery. He described the corruption he had witnessed and the ethical dilemmas he faced. His "Pickwick Papers" provide remarkable insight into the difficulties a future President struggled with early in his political career.[14]

If ever there were compelling evidence of a man's strength of character in the face of corrupt morality, the story of Truman and the Pendergasts would seem to be it. By deemphasizing this story, the library fails to display one of the most compelling qualities of Truman's character.

The exhibit, while thorough, largely declines to exercise an interpretive influence. Every stage of Truman's early life is accounted for, each receives the same visual framing and roughly the same visual treatment. Labeling is descriptive rather than interpretive and no particular attention is drawn to any single experience by either the scale or the narrative of its display. It follows what White identifies as the historical genre of the chronicle, an account with sequence as its organizing principle of discourse which typically "lacks closure, that summing up of the 'meaning' of the chain of events with which it deals that we normally expect from the well-made story."[15] Yet, though admittedly a product of the imagination, it is precisely the exercise of meaning-making from chronological sequences of events that gives history its value for contemporary readers.

Similarly, it is the practice of curating—the foregrounding of some materials, the deemphasizing of others, and the construction of the interpretive voice that guides the visitor through the exhibit—that makes the libraries'

performances of presidents' early lives meaningful. By declining to fore-
ground some materials, deemphasize others, and postulate explicitly the
value of any particular experience, the exhibit on Truman's life and times
obscures the contribution of Truman's early experiences to his character and
of that character to his success. Whether in the name of personal modesty or
in order to embody a traditional kind of historical rigor, the lack of a strong
narrative or moralizing influence in the Truman Library's "Life and Times"
exhibit in fact makes it more difficult to understand, let alone emulate, the
president's early performances.

In order to embody the American Dream, an individual must begin without
material advantages—that is, in a position of equality with the common
man. Only then can he demonstrate that he achieved his success through
his own performance. The rise from humble origins is another cherished
American narrative, still read as authentic evidence of good character.

The origin of our romance with the narrative of humble origins is both
political and cultural. Politically, it can be traced back to the presidency of
Abraham Lincoln, whose "rise from frontier origins became both fable and
staple in the American Dream narrative."[16] Culturally, it can be traced back
to the now little read but often cited American writer of juvenile fiction,
Horatio Alger.

A contemporary of Lincoln's, Alger wrote more than one hundred novels
and stories in the second half of the nineteenth century. He was "the literary
figure most closely associated with the ahistorical self-help formulas of popu-
lar culture." Indeed, today the name is "shorthand for someone who has risen
through the ranks—the self-made man, against the odds." Alger's heroes
are "genuine, honest and sincere" men who "depend upon themselves, their
characters, and efforts for their advancement."[17] Alger's rags-to-riches nar-
rative, written to appeal to young boys, became grafted onto the grammar
of political success through Abraham Lincoln. And, despite radical changes
in Americans' social and economic realities over the ensuing hundred years
and more, a materially humble background continues to be seen as an asset
in creating a narrative of success based on merit.

There are, of course, candidates for the presidency for whom this construc-
tion is simply not viable. These candidates often accrue merit not through
humble origins but through acts of service to those in need. Still, many pres-
idential libraries do rehearse their subjects' humble socioeconomic origins.

This is delicate representational ground. The libraries stage these per-
formances of "humble" origins against the backdrop of an America where

poverty and even destitution are longstanding historical realities. Too heavy a focus on humble origins could cause visitors with personal or even intellectual awareness of these realities to reject the exhibit's performance of meritorious character. The library must therefore create an origin story of modest means without minimizing the more difficult lives of those raised in genuine poverty or without other material advantages.

Although it did not involve a major reallocation of exhibit space (the space devoted to the early years is still relatively small), the Carter Library's 2009 renovation dedicated substantial energy and resources to the careful redesign of the early years exhibit. In news stories covering the renovated museum, this expansion tended to escape notice in favor of a high-tech new exhibit dramatizing a single day in the work of a president and narrated by the ultimate meritocratic president, *The West Wing*'s Martin Sheen. Nonetheless, library president Jay Hakes notes that one of the most significant things that happened in the period between the original and new exhibitions was the publication of Carter's book *An Hour before Daylight: Memories of a Rural Boyhood*, from which much of the new material in the early years exhibit is taken.

As in many presidential libraries, the renovated early years gallery at the Carter Library represents the president as a boy developing the "right attitude" and moral virtue, two of the core characteristics of individual merit. Unlike the childhood exhibits in most presidential libraries, the exhibition also presents audio and visual evidence to support these assertions of Carter's nascent merit. Throughout the Jimmy Carter museum exhibition, the persuasive marshaling of evidence of merit reinforces some important ideas about the American character.

The economic and geographic location of Carter's boyhood facilitate a representation of humble origins. Although in his book Carter accurately describes his family's economic situation as "middle income," this characterization is omitted from the exhibit. Furthermore, "middle income" meant something very different in the rural South of the 1930s than it does today. Childhood photos on display in the museum (all black and white) show a young, bony Jimmy in simple clothing and dusty surroundings, often barefoot, shirtless, and squinting in the sun. To the casual viewer, these photos do not look conspicuously different from Dorothea Lange's portraits of Depression-era families living in poverty.

The photos also embody the Carters' humble surroundings. The displays do not highlight the lack of modern conveniences at the Carter farm—the kerosene lamps, outdoor privy, and absence of mechanized power one can

read about in the memoir—but they do emphasize his close relationship with the land itself. One prominently displayed quotation, taken directly from Carter's book, reads, "My most persistent impression as a farm boy was of the earth. There was a closeness, almost an immersion, in the sand, loam, and red clay that seemed natural, and constant."[18] The visual and verbal evidence of the exhibit represents Carter's early years as simple and, quite literally, down to earth.

The exhibit also performs Carter's development of "right attitude." Mc-Namee and Miller explain that "having the right attitude is associated with qualities like ambition, energy, motivation, and trustworthiness. It may also involve subtler traits like good judgment, sense of personal responsibility, willingness to defer gratification, persistence in the face of adversity, getting along with others, assertiveness, independence, and the like."[19] Of these qualities, one with particular and ever-increasing importance in presidential politics is the ability to get along with others, especially across differences of race, class, and gender. Because of the unique salience of race for the diversity of the American citizenry, I want to focus on it here as it is represented in the presidential museums generally and the Carter Library in particular.

All presidential libraries deal, either explicitly or by omission, with the president's relationships with people of different races and ethnicities. In the American political context, the ability to navigate these differences is a key test of the ethic of equality and, therefore, of good character. As early as Roosevelt's time and especially in the decades between the Kennedy and Clinton administrations, this has meant, above all, attending to the concerns of African Americans. In Martin Luther King Jr.'s famous "I Have a Dream" speech, he appealed to the ethic of equality, explicitly linking it with an evaluation of American character:

> . . . I still have a dream. It is a dream deeply rooted in the American dream. I have a dream that one day this nation will rise up and live out the true meaning of its creed, "We hold these truths to be self-evident; that all men are created equal." . . . I have a dream that my four little children will one day live in a nation where they will not be judged by the color of their skin but by the content of their character.[20]

With this watershed utopic performance of meritocracy, King held the content of American character up for public scrutiny.

Historically, Republican presidential libraries have declined to prominently represent engagement with difference as a major theme. (Interestingly, the original childhood gallery at the Reagan Library contained a story in which Jack Reagan welcomed two African American players on his son's football team into his home after the boys were refused at a local hotel. The story was a casualty of the renovation.) This has been a more or less faithful representation of their subjects' priorities in office. As Lipset writes in the context of education policy, "Republicans were simply more interested in *achievement*, or the problem of the gifted child, while Democrats were more interested in *equality*, or the problem of the underprivileged."[21] This is also consistent with the demographics of the Republican Party, which has historically attracted primarily white voters.[22]

Democratic presidents, whose party has traditionally relied heavily on the support of minority voters, have had to address their understanding of difference explicitly, especially since the beginning of the civil rights movement. And so, too, have their libraries. Although Kennedy's record on civil rights was decidedly imperfect, the Kennedy Library features the civil rights movement in an unusual way, by placing pertinent images and audio materials directly within the replicated oval office. A longstanding activism on behalf of people of African descent is also a major theme of the Clinton Library, which prominently features the president's alliance with Nelson Mandela.

But because his father's farm relied heavily on the work of sharecroppers, President Carter lived with racial difference more intimately than any other twentieth-century president. At the end of his memoir, he writes:

> My own life was shaped by a degree of personal intimacy between black and white people that is now almost completely unknown and largely forgotten. Except for my own parents, the people who most deeply affected my early life were Bishop Johnson, Rachel Clark, my Uncle Buddy, Julia Coleman, and Willis Wright. Two of them were white.[23]

In the photos of the Carter Library's boyhood exhibit, the future president is seldom alone. Most often, he appears under the guardianship of either an older family member or an African American farmhand, though occasionally he appears with his sister, Rose, or with his best friend, Alonzo Davis, also African American. There are photos here, too, of Bishop Johnson and Carter's grade-school teacher, Julia Coleman. Each photo is carefully labeled with the first and last names of its subjects. In these photos, the parallel

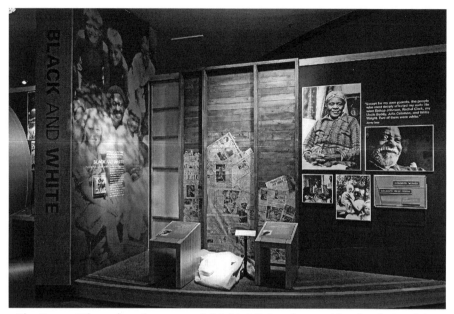

The Carter Library's early-years exhibit highlights the president's relationships with African Americans in rural Georgia. *Photo courtesy of Jimmy Carter Presidential Library.*

positions of African American caretakers or playmates and family caretakers or playmates provides visual evidence of Carter's closeness to the African Americans in his community, demonstrating that the future president has long had the right attitude about racial difference.

McNamee and Miller argue that, of all the characteristics that comprise the myth of meritocracy, moral virtue is the most dubious. Looking at the "history of industrial capitalism," McNamee and Miller theorize that the overall effect of a virtuous character is to hinder rather than facilitate success. "The logic of this argument is that those who limit themselves to strictly honest means to get ahead have fewer opportunities to do so than those who do not limit themselves in this way."[24] This is certainly true in the presidency as, for example, James P. Pfiffner's work on the pervasiveness of presidential lies makes clear. Nonetheless, Americans expect their presidents to display moral virtue.

Two important stages on which the performance of moral virtue in American politics has been enacted are a commitment to family and strong religiosity. The last unmarried president, and the last to be childless, was James Buchanan, whose single term as president ended in 1861. Since at least the 1940s, American culture has been more preoccupied than other societies

with the traditional nuclear family—in the realm of theatrical performance, the two classic dramas of American theater's golden age, Miller's *Death of a Salesman* and O'Neill's *Long Day's Journey into Night*, exemplify this focus.

Americans are also strongly religious, with 80 percent claiming some religious affiliation.[25] Especially since the turn of the twenty-first century, displaying a strong religious background has been critical to the success of presidential candidates. While Ronald Reagan could get away with affirming his strong private relationship with God as evidence of his good character, and Bill Clinton could marshal religious rhetoric to great effect, since George W. Bush's mobilization of the so-called "values voters" in his 2004 reelection campaign, the public has demanded more embodied evidence of presidential candidates' religiosity. With the Christian right's endorsement of Mormon candidate Mitt Romney in 2012, it became clear that the nature of that religiosity was far less important than its strength.

Given the moral crisis of the Watergate scandal that preceded him, perhaps no modern president has been elected with a stronger expectation of performing moral virtue than Jimmy Carter. And, in terms of engagement with both family and religion, there was much evidence to support Carter's claim to the rehearsal of strong moral values in his youth.

The renovation of the Carter Library brought much of this evidence forward. Carter's strong connection to his family is not confined to the boyhood exhibit but is displayed throughout the museum and especially in the exhibit on his campaign, presented as a family affair with Carter children, brothers and sisters dispatched to every state in the union. The ethic of "family" even extends to the making of the exhibit itself. When I asked Sylvia Naguib, Carter museum curator, who led the redesign, she said that she didn't know how to answer the question. She mentioned the design firm, the fabricators, the scriptwriter, the museum staff, the archival staff and the staff of the Carter Center. Eventually, she described the collaboration to me in this way:

> [Library Director] Jay Hakes and our project manager, Dan Lee, were guiding forces, along with our Vice President of Operations and Development, Phil Wise. . . . It was just a beautiful thing to watch, because he was the one involved in raising the money, and there was a level of agreement and a trust among them, and they had the confidence of President and Mrs. Carter . . . [26]

Naguib's description of the process evokes the values associated with family relationships.

The exhibit represents Carter's deep involvement in religious life through photographs of him with his sister and father on the steps of their church in Plains, Georgia, and in a photograph of Bishop Johnson, the pastor of the African Methodist Episcopal church in neighboring Archery, whom Carter cites as a major influence on his life. These artifacts lend credence to the common claim that "perhaps no contemporary president personifies a strong religious background like Carter."[27]

As a president who returned to his small-town roots following his time in office (approximately half of the presidential library presidents did so), Carter's story also provides opportunities to represent the endurance of a president's childhood values. In the gallery dedicated to Carter's childhood, his religiosity is further represented by video screens on which one can watch footage of several different sermons he has given as a Sunday school teacher at his childhood church over the last decade. This is the only example in the presidential library system of audiovisual materials from a president's old age occupying the same space as artifacts of his childhood. Footage of an elderly Carter speaking the language of scripture in his Sunday best is underscored by a written text that notes the regularity of these performances; of the forty-three weeks per year that Carter is in the country, the caption tells us, he teaches Sunday school on forty of them. The exhibit illustrates through both audiovisual evidence and spatial logic how values from the president's childhood carried through to the president's old age.

Taken as a whole, the exhibit faithfully represents the general historical assessment of Carter's moral character. Indeed, if there was criticism of Carter's moral virtues, it was that he was overconfident in their purity. In his presidential years, he was often seen as a "moralistic crusader"[28] who brazenly disregarded the counsel of his advisors, as he did in the case of the Iranian hostage rescue mission (see chapter 5). And after his presidency he used his influence to undermine the foreign policies of George H. W. Bush, whose advisors later called Carter's campaign to delay the Gulf War treasonous, and Bill Clinton, who regularly found himself in a "breathless fury" over the former president's flagrant violation of explicit limitations the current president had placed on his diplomatic actions in the Middle East.[29] Carter, in other words, had the wrong attitude about his own moral virtue. But, for historians and the general public, his right attitude in other areas and his performance in the post-presidency have decisively eclipsed this shortcoming.

The Carter Library's exhibit on the president's childhood is not without its drawbacks. The photographs, as I've suggested above, present a somewhat misleading picture of the Carter family's economic status, and it may be

said that one learns little to nothing about any of his siblings' considerable influence on his life. (Ruth Carter Stapleton, for example, was the catalyst for her brother's 1966 born-again experience, and Billy Carter was in some ways a more prominent public figure during his brother's presidential campaign than the candidate himself.) Additionally and perhaps more importantly, the exhibit does not communicate the considerable social influence of Carter's father, "a prospering merchant farmer of Sumter County," the head of one of the "two leading families around Plains" and eventually a state representative.[30]

Nonetheless, the visitor does get a relatively full sense of Carter's childhood environment, friends, and mentors and of how, particularly with respect to religious practice, the president continued to rehearse his moral commitments in the same places (his hometown and his home church) throughout his post-presidency. In this way, the rituals and relationships of Carter's youth become utopian performatives for the visitor, representations of a morally virtuous American character that lasts a lifetime.

With few exceptions, still less space in presidential libraries is afforded the president's experiences in early adulthood than his moral development as a child. To the extent that the libraries include the president's postacademic, prepolitical years, they do so to indicate, in an abbreviated way, how this work prepared the future president for performance on the national (and international) stage. The Carter Library narrates his nine years back in Plains before running for public office in this way: "He quickly became a leader of the community, serving on county boards supervising education, the hospital authority, and the library."[31] Similarly, the Nixon Library condenses the eight "wilderness" years following his failed presidential bid into one sentence: "Although largely out of the public eye, Nixon remained active in politics, commenting on the policies of the Kennedy and Johnson administrations and campaigning for Republican candidates."[32]

Those libraries that do dedicate significant space to the president's early adulthood use that space to rehearse crucial elements of merit, including innate talent and a strong work ethic. More persuasively, they also rehearse elements of merit that find unique expression in the particulars of the president's chosen prepresidential career. In the Reagan, Hoover, and George H. W. Bush Libraries, this time period enjoys significant attention. [33] The early career displays in these three libraries do more than illustrate the requisite "hard work" that is a core component of merit. They demonstrate how specific kinds of work experiences can shape the content of a character.

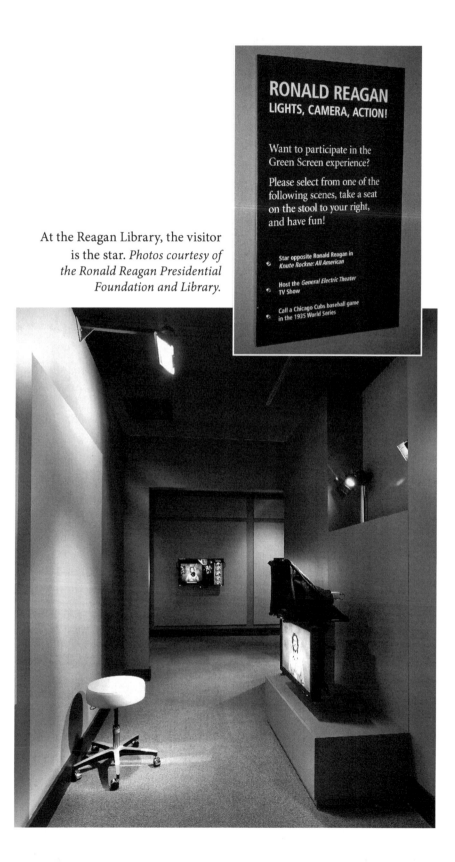

At the Reagan Library, the visitor is the star. *Photos courtesy of the Ronald Reagan Presidential Foundation and Library.*

RONALD REAGAN
LIGHTS, CAMERA, ACTION!

Want to participate in the Green Screen experience?

Please select from one of the following scenes, take a seat on the stool to your right, and have fun!

- Star opposite Ronald Reagan in *Knute Rockne: All American*
- Host the *General Electric Theater* TV Show
- Call a Chicago Cubs baseball game in the 1935 World Series

These performances invite visitors—and particularly young visitors—to better understand how early work experiences can affect character and can, therefore, impact success in future performances.

In Reagan's case, the representation of an "early career" was unavoidable; his time as an actor was both too long and too public to escape display. Reagan did not formally enter politics until his late fifties and was elected president just shy of his seventieth birthday, making him the oldest man ever to attain the office. The mere length of Reagan's "early career" might have posed a problem for the Reagan Library—he spent more of his life as an actor than he did as a politician—had not his first career been so easily staged in the museum space. Before he formally entered politics in 1966, Reagan spent the majority of his career as a performer—five years as a sports broadcaster (1932–37), sixteen years as a movie actor (1937–53) and eight as a spokesperson for General Electric (1954–62).

The renovated Reagan Library dedicates significant space to each of these chapters in his career as a performer. The visitor can watch a clip of GE Theater and highlights from both Reagan's radio and film careers. She can stand in a recording booth and deliver one of Reagan's speeches from General Electric Theater, or, even more cleverly, play opposite the future president in a quotidian scene from one of his movies. If she chooses to review these scenes at a station across the hall, she can see how her performances inevitably pale in comparison to the veteran actor's. Through these exhibits, the library demonstrates Reagan's talent as an actor. It also performs his early career *as* entertainment. As a young boy exclaims on a commercial for the library's other technological innovation, the "Guidecam" (a modified iPhone), "This is so fun!"

What is missing, though, is an engagement with the substance of his early career and, therefore, any sense of how it concretely shaped the president's character. The visitor cannot, for example, gain any insight into the kind of sports broadcasting practiced in the 1930s, requiring "colorful" storytelling by announcers who never saw the game, and how this practice might have shaped Reagan's sense of what constituted the "event" in the game of politics. Nor is she given enough information about Reagan's career as an actor to understand how this work might have shaped his mind and body.

There is only one quotation, buried in a short film about Reagan's early years, in which the museum takes up the substance of a career in performance. Here, Reagan explains, "I tried hard to understand the characters I played, especially their motivations. The process called empathy is not bad

training for someone who goes into politics or any other calling."[34] But there is no information here about the kinds or number of roles Reagan played—about what sorts of characters Reagan was trained to empathize with and how this might have affected his successful performance in politics.

Reagan's political transformation began in the thick of his Hollywood career. The exhibit mentions that Reagan was once a committed Democrat, but does not provide the visitor with any of the information necessary to gain insight into how his early career as an actor affected his political ideology. The exhibit does not mention his rising political activism as president of the Screen Actors Guild or the staunch conservatism of his new off-screen love interest, Nancy Davis, and her prominent and outspoken stepfather, Dr. Loyal Davis.

More importantly, the exhibit does not reveal the practical and political influence of GE, a company "obsessed with conservatism" which, by sending him to GE plants, chambers of commerce, and civic clubs around the country, "gave Reagan the opportunity to forge a more fully developed conservative critique."[35] The library's exhibits on Reagan's prepolitical life present his early career performances for visitor consumption and participation. They do not, however, open space for a deeper understanding of the relationship between the future president's early career as an actor and his success in politics.

Although the work of an actor in the 1980s may have in fact been more directly applicable to the work of presidential leadership, it is the Hoover Library that more successfully explores how a leader's early career can influence the formation of a meritorious character—and how that character can in turn influence the nature of his leadership.

The Herbert Hoover Presidential Library exhibition, redesigned in 1992 under the guidance of then-director Richard Norton Smith and curator Maureen Harding, dedicates significant space to Hoover's early work, first as an engineer (his "Years of Adventure") and later as an international humanitarian (his "Years of Compassion"). Here, unlike in the Reagan museum, the exhibition provides substantive details about Hoover's experiences as an engineer on four continents, with particular attention to his earliest work in Australia and China. It is clear that the nature of the work was deeply meaningful to Hoover. One wall is filled with a lengthy, large-print quotation from his memoirs about the work of an engineer:

It is a great profession. There is the fascination of watching a figment of the imagination emerge through the aid of science to a plan on paper. Then it

moves to realization in stone or metal or energy. Then it brings jobs and homes to men. Then it elevates the standards of living and adds to the comforts of life. That is the engineer's highest privilege.

The great liability of the engineer compared to men of other professions is that his works are out in the open where all can see them. His acts, step by step, are in hard substance. . . . If his works do not work, he is damned.

The prominence and eloquence of the quotation suggest that Hoover was moved to be the kind of leader he was in part by his chosen early career. Not incidentally, he valued that career for the very concrete results it produced.

The exhibition also provides visual and textual evidence of Hoover's work ethic in his second career as an international humanitarian. It details the different strategies he implemented to provide humanitarian relief during different phases of World War I and in its aftermath, serving a number of European nations with differing strengths and needs.

Perhaps the most affecting original artifacts from Hoover's early career are four videotaped oral histories, rich with sensory detail, spoken by citizens of different European nations directly affected by Hoover's humanitarian efforts. One German man, for example, recalls thinking that the aluminum plate and cup he was given by American relief workers were "the most wonderful thing that happened to me when I was a kid." Others recount the long-awaited experience of warmth and the smell of "Hoover rolls." Hoover's work ethic as a humanitarian is also on display in the postpresidential galleries, linking Hoover's young adulthood to his old age as Carter's religiosity links his earliest and late years.

The displays on Hoover's presidency suggest that it was his failure to adapt to his second career and act more like a politician, primarily through being a better public speaker—the text references his "statistics-laden" speeches and "dishwatery monotone" delivery—that caused him to become a national scapegoat for the Great Depression. "Hoover's failure to dramatize himself was his greatest strength as a humanitarian and his greatest flaw as a politician."[36] Although this explanation conveniently sidesteps the substantive failures of Hoover's presidency, the text does prompt the visitor to think about the ways in which on-the-ground work, either in a trade or in direct humanitarian aid, may not be optimal training for the kinds of performance the country's highest political office demands.

The exhibition on George H. W. Bush's early years states candidly that "his family's social status and financial condition sheltered him from the

suffering that so many families experienced"[37] during the Great Depression and offers as examples of his character development a series of Polonius-like aphorisms from his mother. The visitor learns, among other things, that his mother told him not to brag or to be too self-centered, and that at school he was nicknamed "Have-Half" for always giving half of his sandwich to a classmate. Then, immediately after attending the prestigious Phillips Academy preparatory school, Bush enlisted in the U.S. Navy.

Although every president between Franklin Roosevelt and Bill Clinton served in the U.S. military—and some, like presidents Truman, Johnson, and Nixon, devoted more than twenty years to military service—few presidential libraries devote significant space to the president's military career. Perhaps this is because a record of military service has been the rule rather than the exception among U.S. presidents. Or perhaps it is because few of our most popular presidents had combat experience, and even fewer could boast distinguished service. (In this light, the Kennedy Library's fleeting treatment of the future president's Purple Heart is surprising.) Or perhaps, as some performance scholars have argued with regard to traumatic experience, there is something about military service that resists representation in narrative time.

In any case, the most successful treatment of a president's military career appears not, as one might expect, in the Eisenhower Library but in the George H. W. Bush Library, which offers a robust exhibit on the president's service in World War II.[38] Rich with artifacts, photographs, and typed letters home, the exhibit movingly performs Bush's transformation from an eager young enlistee into a chastened and mature adult.

The library offers a detailed account of the president's military experience before, during, and after its most dramatic event, the shooting down of Bush's airplane in the waters of the Pacific near Chi Chi Jima, Japan. The visitor follows Bush through his excitement in enlisting on his eighteenth birthday and becoming the Navy's youngest pilot, his enthusiasm for his regular assignments as a pilot and aerial photographer, to the crash in the Pacific Ocean in which his two-man crew was killed.

Of the latter, he writes in a letter home, "I'm afraid I was pretty much of a sissy about it cause I sat in my raft and sobbed for a while. . . . I feel so terribly responsible for their fate." Despite his report that he was a "sissy," the letter dramatizes the final stage of the shift in Bush's understanding of service, from the good behavior of giving away half a sandwich to the romance of a maritime adventure to the weight of a solemn responsibility. The exhibit demonstrates that Bush's career in the navy was instrumental in this transformation of his character.

There is some evidence that over the course of the last decade, the American Dream has begun to lose its hold on the popular imagination. Citing three separate sociological studies, McNamee and Miller note that "the prospects for fulfillment of the American Dream have generally dimmed in recent years, and Americans appear to be responding by becoming more pessimistic about the future."[39] This is welcome news insofar as it heralds a long overdue recognition in the American public of the unlevel playing field on which Americans begin our lives, and the inequality of resources that continues to influence our opportunities as adults. The cherished myth that there is a direct connection between merit and success is objectionable not only because it is empirically false that all meritorious people are successful but also because a number of powerful predictors of success are not merit-based—social capital, for example, and plain dumb luck.

But while the causal link between merit and success is highly problematic, the tenets of merit are not in and of themselves objectionable; few would argue against the inherent value of hard work, for example, or appreciation for family, or concern for people who are different from oneself. It is through the utopian performance of merit that presidential libraries make sense of presidential success, selectively displaying evidence of experiences from childhood and adulthood that resonate with the American Dream. This high degree of selectivity certainly involves, as historical narratives always do, significant interpretive omissions, exaggerations, and extrapolations. But as the presidential library embodies, *even if through fantasy*, a utopic American story, it demonstrates "the impact and import of a wish."[40]

The waning of the American Dream is unwelcome news insofar as it indicates a decreased willingness on the part of Americans to cultivate merit and through it not success per se but, following Dolan, a better world. Although the American Dream taken as a whole is a problematic formula for success, the first part of the formula, which prescribes the cultivation of merit as a utopian performative, is useful.

Performance theory emphasizes the inherent value of an ongoing engagement in self-making that values process over ends, individual agency over systemic power. Through the performance of the tenets of merit in the prepresidential galleries, the presidential libraries offer the visitor something more important than a rationalization of presidential success: they give her a utopic American character.

If the visitor experiences these prepresidential galleries as utopian performances, they may create an important museum effect. They may send the visitor back into the world determined to make her own performances

more closely resemble those she experiences at the museum, both with respect to her own character and with respect to her relationship to the American community.

In this sense, utopian performatives are rehearsals for action. As Dolan writes, "Perhaps utopian performatives create the *condition* for action; they pave a certain kind of way, prepare people for the choices they might make in other aspects of their lives."[41] Scott Magelssen, writing about museums that assign visitors fictional identities, argues, "Visitors imagine, hope, and keep vigil with their individuals at these threshold moments, embodying the *possibilities* of outcomes ahead. . . ."[42] If we view performance in this way, as a hopeful rehearsal for action, it is not difficult to imagine that the widespread embrace of the utopian performances in the prepresidential galleries of presidential libraries could foster a stronger American character and a better world.

Interlude: Origins on Display—Gerald Ford Encounters His Father

I thought people should know, that's all. I just thought that everyone should know. Because first of all there's my name, and people would naturally assume, since we have the same name, that Jerry was my dad. And if there's one thing I promised the American people and stuck to, it's that I would put an end to the lies. So I wasn't going to leave out something as basic as who my real dad was.

And the other thing was, I wanted Jerry to get the credit he deserved. For raising me right, putting me to work in the paint store, teaching me how to help other people, giving me the normal life that I sure wouldn't have had without him. Because if she had been alone it would have been a miserable, lonely life and if she had stayed with him, well she might have ended up dead.

So it seemed like the most succinct way to tell the story was to ask people to walk with me into Jerry's paint shop where I was working that day. And once they were there, they could see him like I saw him: a stranger walking in, wanting something more than paint. Leslie Lynch King. My father.

I didn't recognize him, of course. And he sure couldn't have recognized me. But the store was pretty empty and I was the only kid there. He walked up slowly, came right up close to me, pulled that rolled up twenty dollar bill out from behind his ear—he had it tucked there like a cigarette—and rolled it out on the counter in front of me. Twenty dollars for sixteen years of child support. Twenty dollars for hitting my mother. Twenty dollars for just disappearing.

I didn't move until he left the store. Then I picked up the twenty, went over to the cash register, and slipped it in the drawer. I asked Jerry if he would tell Mom about it because I thought she should know and I didn't want to talk about it. He put his hand on my shoulder and told me I could go home if I wanted to. But I said thanks, I'd rather stay here in the store with him. So I did.

I hope it's not just a selfish thing, sharing this story. I'm sure it'll be a surprise to a lot of people. But I want them, and especially the kids to know: not every American—not even every president—receives "family values" from his biological mother and father. Now and then a parent might demonstrate indifference, even contempt. Sometimes a family might have something really ugly in it. And I wanted them to know: it can still come out okay.

The biographical details cited here and the story of King's visit (including his gift to Ford) are all part of the early years exhibit at the Ford museum.

PART THREE
Disruption, Inspiration, and the American Community

5. CHARACTER FAILURE
Efficiency and Discontinuity

In the business world, the organizational model of "performance," conceived of as a model of efficiency, demands continuous achievement. In *Perform or Else*, Jon McKenzie describes the turn to performance as a rubric for evaluation in the late twentieth-century American workplace:

> As part of their administrative practice, thousands upon thousands of organizations administer "performance reviews," formal evaluations of the work performed by their employees. . . . Depending upon the work, performance reviews evaluate such things as productivity, tardiness, motivation, innovation, and the ability to establish and fulfill goals which support the organization's own goals.[1]

Indeed, most Americans face this kind of performance review with great frequency long before they enter the workplace, in the form of grades in secondary school, admission or nonadmission to particular colleges, and academic honors in higher education.

In the presidential library, the pressure to "perform" in this organizational sense is compounded by the economy of representation in which the president is made to stand in for the ordinary American. Just as the president is the embodiment of the American Dream of success (see chapter 4), he is also the model American worker who, since the middle of the twentieth century, must meet the challenge of "'working better and costing less,' of maximizing outputs and minimizing inputs, the challenge of *efficiency*."[2] The normative representation of optimal presidential *job* performance, then, displays the president's time in office as a continuous historical narrative in which unerring achievement results in the steady fulfillment of goals.

But a representation of the presidency as what McKenzie calls "cultural performance"—such as the museum displays I have been examining throughout this book—tells a more complex and, cultural critics argue, a more authentic story. In contrast with the model of organizational performance as a seamless narrative of productivity, a cultural performance model,

as Della Pollock explains, "takes its pulse from a specifically Foucauldian sense of history," one which "introduces discontinuity into experience."[3] A performative history of presidential achievement, then, would include disruptions, inefficiencies, and missteps in the chief executive's work. The extent that it is willing to include these elements is a measure of its value, not only aesthetically but politically and, I am arguing, morally as well. In other words, the president's (and his representatives') willingness to participate in a performative practice of history-making is a measure of his character. Far from debasing the president, the presence of such disruptive events in a representation of presidential performance lends it added authenticity and value.

In the libraries' metanarratives of maximally efficient job performance, there are moments where failures protrude, introducing discontinuity into the visitor's experience. Although they are not plentiful, these disruptions can be found at a number of presidential museums. Insofar as they lend authenticity to the cultural performance of presidential achievement, their inclusion has a salutary effect on the visitor's evaluation of presidential character and on her experience of his performance as a model for her own.

President Truman famously kept a sign on his desk throughout his presidency that read, "The buck stops here." The sign was a witty reminder that the president could not "pass the buck"; he was ultimately responsible for the impact of his administration's decisions on ordinary Americans. In terms of presidential character, the buck stops with the president's library. This is the president's last and most visible opportunity to acknowledge his responsibility for the events of his presidency. This is easy, of course, when things go well and, as I will discuss in the next chapter, presidential libraries often err on the side of assigning an excess of credit to the president for the successes of his administration.

But it is not so easy to do when things go badly. Hoover's decision to send military forces to contain the protests of the "Bonus Army," to send "infantry, cavalry, and even tanks against ragged, hungry veterans and their wives and children," is considered by historians not only to have been a bad decision but also to have confirmed suspicions that the president was "heartless and out of touch with humanity." Carter's effort to rescue the American hostages in Iran, launched against the strenuous objections of Carter's secretary of state, Cyrus Vance, is widely considered to be one of the most consequential failures of his presidency.[4] Yet these decisions are represented as a case of insubordination (by General Douglas MacArthur, who ignored Hoover's instructions about when to halt his offensive against the Bonus Army) and an act of moral conviction, respectively.[5]

The presidential library system contains only one decision-making failure clearly identified as such: the Bay of Pigs Invasion of 1961. The invasion, led by American-trained Cuban exiles and aimed at the overthrow of Fidel Castro, was crushed by the Cuban military in less than seventy-two hours. More than one hundred members of the exile brigade were killed and another twelve hundred were taken prisoner in Cuba.[6]

The Kennedy Library openly and thoroughly represents the invasion's "disastrous outcome." A large wall display includes a narration of the events of the invasion, the entire front page of the day's *New York Times*, a typewritten CIA report on the deplorable living conditions of the Cuban exiles captured in the invasion, a photograph of the Kennedys greeting the surviving prisoners (who had been held captive for nearly two years and who served, therefore, as embodiments of the president's failure), and a copy of the address with which the Kennedys greeted them, the president in English and the first lady in Spanish. The display is peppered with quotes from Jacqueline Kennedy that give affective weight to the evidence. Another display describes how the men were "shot down like dogs or going to die in jail."

The library also amply represents the consequences of the failed invasion for Kennedy's presidency. A large quotation from Jacqueline Kennedy hanging over one wall describes how Kennedy "just put his head in his hands and sort of wept" after learning the outcome of the invasion. A large quote printed high across the entire wall reads, "And it was so sad, because all his first 100 days and all his dreams, and then this awful thing to happen . . ."[7]

Although the library is unusually thorough in its performance of the failed outcome of the Bay of Pigs invasion, it does not display the failure of presidential decision-making widely thought to have caused it. Specifically, the exhibit does not mention Kennedy's fateful decision to dramatically reduce the size of the air strike, despite being advised by many, including his predecessor, to the contrary. Why would a new president ignore such advice? Why would he not heed the plan developed by President (and five-star general) Dwight Eisenhower? Was it hubris? Insecurity? How did Kennedy evaluate his decision-making process in the aftermath of this event? These questions remain unanswered.

The omission squanders the Kennedy Library's opportunity to be exceptional in its candor and, in so doing, to both provide insight into presidential decision-making and reflect well on this particular president's character. Instead, the library continues a system-wide pattern by at least partially eliding presidential error. This in itself casts the president in a negative light. Poor performance in the making of a single decision—even

an important one—does not necessarily constitute a failure of presidential character. But representational decisions that edit those decisions out of public history do.

In addition to failures of commission, presidents fail by omission. Presidents, that is, ignore things. As with the making of bad decisions, this kind of inattention is inevitable and perhaps even necessary for national leadership. Sometimes, however, the things presidents ignore are so important that their neglect can rightfully be considered a failure. The magnitude of culpable neglect in a given administration tends to be in inverse proportion to its representation in the museum; the more egregious the neglect, the less likely it is to be displayed.

Three examples of presidential neglect about which most historians now agree are Kennedy's belated recognition of the civil rights struggle, Reagan's lack of attention to the AIDS crisis, and Clinton's insufficient attention to global terrorism. Each president has been roundly criticized for inattention to these respective issues. The Reagan administration's AIDS policy has been described as at best "halting and ineffectual"[8] and at worst intentionally obstructionist.[9] The history of Clinton's leadership on terrorism has been described as at worst one of "dithering and delay,"[10] at best one in which no strong action was taken until nearly the end of his first term in office.[11] And Kennedy was conspicuously silent on civil rights as a moral issue until June 1963, two and a half years into his presidency and less than six months before his death.

The Reagan museum reifies the president's lack of attention to the issue of AIDS while in office by omitting the issue from its exhibition altogether. The Clinton Library defends its record on international terrorism, albeit rather weakly, in a policy alcove titled "Preparing for New Threats." Here, amid photos of Clinton with servicemen, the text cites an increase in counterterrorism funding and an increase in defense spending that enabled the administration to equip the U.S. military with "the advanced technology it would need to respond rapidly and decisively to coming threats"—something it failed to do with catastrophic consequences on September 11, 2001, less than a year after he left office.[12]

As with its approach to presidential mistakes, the Kennedy Library exhibition takes a different approach to the problem of neglect. The library neither ignores the civil rights struggle nor explicitly defends the president's record on the issue but attempts, in a highly visible way, to compensate for Kennedy's neglect. Civil rights occupies a uniquely important place in the Kennedy museum as a central feature of the Oval Office. The other presidential libraries that contain Oval Office galleries—and most do—focus on

authentically reproducing the décor, measurements, and staging of the space at the time of the president's occupancy. At the Kennedy Library, the display intentionally sacrifices some of that representational authenticity in order to highlight the importance of the civil rights struggle. A large screen hung in the center of the Oval Office's back wall plays a video presentation comprised of excerpts from King's "I Have a Dream" speech interspersed with footage of nonviolent civil rights protests turned violent by police action.

Here the museum performs an act of redress by placing the issue of civil rights in the center of the president's work space. The display is both affecting and somewhat misleading, suggesting as it does that the issue was at the center of President Kennedy's attention. Other areas in the museum highlight Robert Kennedy's much more active work on behalf of civil rights. Nowhere, however, does the museum acknowledge the historical reality of the president's slow awakening to the injustices of segregation.

It is perhaps unfair to chalk up either the original neglect to act on an issue or the reification of that neglect in the museum displays as failures of

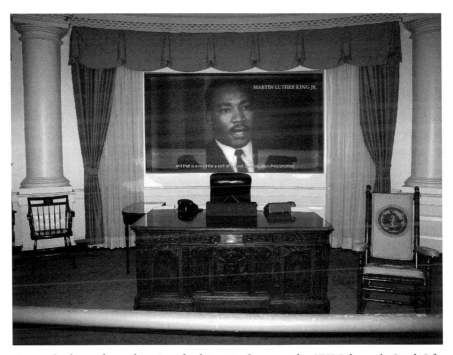

Instead of merely replicating the historical space, the JFK Library's Oval Office exhibit incorporates video footage to highlight the importance of the civil rights movement during the president's time in office. *Photo courtesy of the John F. Kennedy Presidential Library and Museum.*

presidential character. But it is worth imagining, as I will do in the last section of this chapter, how a presidential museum might represent culpable neglect in a more forthright way and, in so doing, substantively enhance the visitor's understanding of presidential history. A greater willingness to represent neglect would also, paradoxically, perform strong presidential character, embodying an honest and graceful acknowledgment of this variety of presidential failure.

Much of the most damning criticism of presidential libraries has focused on their unwillingness to properly represent the failures of the president and his administration. Benjamin Hufbauer writes that the presidential library typically "helps to create an idealized historical account of a president that represses miscalculations, unintended consequences, lies, and cover-ups."[13]

In addition to exercising bad decision-making and neglecting important issues, American presidents occasionally exhibit bad and even criminal behavior. Historians often speak of presidential history since Richard Nixon operating within a "culture of scandal," and it is certainly the case that Watergate provided a new dramaturgy, as it were, of disruption in presidential performance. Watergate "perfected a range of instruments for torturing politicians. Special prosecutors and congressional committees wielded vast subpoena power. The judiciary increasingly plunged into many aspects of American life. Journalists yearned to crack another Watergate case."[14] But in fact, there have been only two failures of this magnitude in the ensuing forty years: The Iran-Contra affair under Ronald Reagan and the Whitewater/Lewinsky scandal under Bill Clinton. Both, like Watergate, turned on a president's efforts to conceal bad behavior. The representation of these scandals at the two museums, while certainly flawed, indicates some progress in the presidential library system's willingness to display a more complex presidential history.

As a matter of American history, Reagan's cover-up was the more consequential. James Pfiffner explains that although a number of the administration's decisions over the course of the Iran-Contra affair constitute "infractions," the "secret attempt to fund the Contras was in direct violation of public law and a serious threat to the Constitution."[15] Elsewhere, Pfiffner evaluates presidential infractions more generally:

> The most serious presidential lies are lies of policy deception in which the president says that the government is doing one thing when in fact it is doing another. Such lies undermine the basis for democratic, republican governance. Citizens and voters cannot determine how to vote or how to evaluate those in power if they are deceived about what the policies of the government actually are.[16]

In 1991, as the "thirty years' war" continued to rage around the funding of the Nixon Library (see chapter 1), the Reagan Library opened to the public. Its original museum exhibition omitted the Iran-Contra scandal altogether.

The renovated exhibit, unveiled nearly twenty years later in 2010, describes Iran-Contra in a hallway of panels cataloging Reagan's many foreign-policy activities. The panels are arranged alphabetically by country, with Iran therefore appearing somewhere in the middle of lineup. Importantly, the exhibit also includes audiovisual evidence of Iran-Contra in the form of Reagan's final televised address on the matter, displayed on a small television screen set into the wall. In the brief and quietly played speech, visitors can see and hear Reagan address his culpability, clearly calling his actions a "mistake," though also saying that his "heart and best intentions" still told him that he did not in fact trade arms for hostages.[17] The new text and visual display do not give the visitor any sense of the space that the incidents and their investigation occupied in Reagan's second term or the threat Iran-Contra posed to his presidency. Nonetheless, the textual and audiovisual inclusion of the scandal is a clear move toward a more performative practice of history-making.

The original Clinton Library exhibition, opened in 2004, did not attempt to omit the Whitewater/Lewinsky affair, although it did not own up to Clinton's serious failures during both the affair and the investigation. Here, scandal is recast as political bloodlust with the president's impeachment battle subsumed under the heading "The Fight for Power." The impeachment proceedings share this space with other ways in which Republicans used "radical means" to pursue a "radical agenda," including two shutdowns of the federal government. All of these incidents, the exhibit narrates, brought "partisan opposition to a new high," affected the "lives, reputations, and financial well-being of many public servants," and "wast[ed] millions of taxpayer dollars."[18] The narration hints at the proportions of the scandal, though it does nothing to represent it visually or spatially. More significantly, unlike the new Reagan display, "The Fight for Power" does not either name Clinton's infractions or include his—also equivocal—admission of wrongdoing. These omissions rob visitors of the basic tools by which they might independently assess the infractions and their consequences.

It may well be impossible for new presidential museum exhibitions to deal effectively with bad presidential behavior, both because of the differential and deep investments of the institutional primary stakeholders in the president's legacy and because of the real difficulty of accurately evaluating recent historical events. But perhaps there has been some slow progress in this area over the life of the library system. It took thirty years to include Watergate

in the Nixon Library and nearly twenty to include Iran-Contra in the Reagan Library. The Clinton Library included the impeachment scandal from the outset, albeit in somewhat occluded form. As the libraries demonstrate increased willingness to deal with these most radical disruptions of presidential job performance, they create cultural performances that better help visitors to understand both a particular president and the making of history. Such a performance in itself models a strength of character that visitors might emulate as they face their own, inevitable performance disruptions.

In a discussion among prominent American presidential historians about the definition of character, David McCullough offered this contribution concerning presidential performance: Character, he argued, is revealed in how presidents handle defeat.[19] One "failure" that the libraries of all one-term presidents must account for in some way is their subjects' failure to win a second term in office. The conception of the one-term presidency as a failure is a distinctly modern one. George Washington set an important precedent by serving no more than two terms in office, a limit of custom rather than law that all subsequent chief executives observed. But legally, no barriers stood in the way of a president's reelection to a third term in office until Congress passed the 22nd Amendment in response to the unprecedented fourth term of Franklin D. Roosevelt's tenure. The amendment established that, no matter how effective or popular a president was, he could not run for reelection more than once.

As importantly but less frequently noted, before the 22nd Amendment, presidents could choose *not* to run for a second term. Although in theory this is still the case, the pursuit of a second term has become "a corollary of being elected in the first place,"[20] with only one modern president, Lyndon Johnson, opting not to run for reelection.

In the twentieth century, it fell to Presidents Hoover, Carter, Ford, and George H. W. Bush to represent this "failure" in their libraries. The Carter museum dedicates minimal space to the failed reelection bid, though it offers some indication of the president's reaction to the defeat over time. The small second-election display represents the president as "angry" and "disappointed" over the defeat by a charismatic opponent (Reagan), while at two other points in the museum Carter jokes about his "involuntary retirement." The Bush Library also spends little time on the defeat. It, too, attributes Bush's failure primarily to the charisma of the opponent (Clinton) and, secondarily, to public "perception." Ultimately, the display argues, the election was decided on the perception that Bush was "out of touch." There

is no speculation as to how Bush's performances in office might have shaped this perception, or about how his campaign failed to alter it.

The Hoover Library dedicates more space to the president's failure to retain his office, representing him as a victim of circumstances, a poor actor, and a sore loser. Much of this narrative comes in the gallery following the Great Depression displays, titled "From Hero to Scapegoat." Here, the emphasis is on circumstances, with a prominently displayed quotation from Will Rogers: "If someone bit an apple and found a worm in it, Hoover would get the blame."[21] The gallery narrates the dire economic and social circumstances in which Hoover campaigned. It also points to a smear campaign by a Democratic National Committee consultant and the "magic" of his opponent's personality as obstacles.

Belatedly, in a small foyer between the reelection bid materials and the postpresidential gallery, a compact display highlights the impact on Hoover's campaign of the New York banking crisis of 1933 that reached its peak on the eve of FDR's inauguration. The arresting visual component is comprised of two large, brass bank doors held together with an enormous chain. The text places blame for the crisis squarely on Roosevelt, who refused to extend Hoover's policies despite repeated appeals from the outgoing president. Although the closure of banks happened after his reelection bid had failed, the exhibit clearly blames Roosevelt for the definitive closure of the Hoover presidency.

There are indications throughout the exhibition that Hoover had a hand in his own loss of office. The exhibits repeatedly own up to Hoover's deficiencies as a political actor, although these are sometimes portrayed as virtuous attributes; Hoover "shied away as if by instinct from the emotional aspects of modern mass leadership," refusing to exploit situations or answer critics "for his personal political advantage." At other times, the exhibit suggests Hoover's incomprehension of the political game, most pointedly in his one word answer to the news of his failed reelection bid: "Why?"[22] Scholarship on Hoover's presidency affirms that this incomprehension had serious consequences. Through his ineptitude as a politician, Hoover came to seem "out of touch with the misery that the American people were experiencing on a daily basis."[23]

Taken together, the exhibit's myriad attempts to shift the blame represent Hoover as a poor politician and a sore loser. They also illuminate some of the domestic socioeconomic realities with which Hoover had to contend, realities that were certainly as grim as any faced by a twentieth-century president. What they do not do is suggest the real failures of Hoover's leadership.

The library's unwillingness to accurately represent Hoover's series of misjudgments in relation to the Bonus Army specifically and the Depression in general reflect poorly on the character of the president.

The Ford Library dedicates the most space to the president's unsuccessful bid for reelection and, in this space, creates the most nuanced representation of this variety of presidential performance disruption. In Ford's case, a single presidential act—the pardon of Nixon—has historically been deemed decisive in his failed reelection bid. But the exhibits resist the temptation to attribute Ford's loss entirely to this act. A hall dedicated to the Republican primaries narrates a little-remembered challenge to the incumbent president by then-governor Ronald Reagan. In another room, a full wall is dedicated to Ford's costly errors in his second debate with Jimmy Carter—both an erroneous statement about foreign affairs and a weak and belated public admission of the error. The relevant portion of the debate is even on display on a television screen that plays continuously above visitors' heads.

Finally, a full gallery is dedicated to the 1976 election. Here, visitors can track the electoral math through a large map of red and blue states that fills one wall. They can read a narrative of the loss under the shockingly frank title, "Falling Short." They can view Ford's treatment of various campaign issues on the air. And they can watch the president fighting back tears as the first lady reads his concession telegram to the campaign staff. The library's extended exploration of Ford's failed reelection bid makes the dramaturgy of such campaigns more intelligible to the visitor than it is in any other presidential library display. In its move toward a more discontinuous presidential history, it also displays a strength in the president's character.

Presidential libraries rarely make presidents' bad decisions, neglect of pressing national issues, bad behavior, or shortcomings as political competitors part of the story. Instead, they are wont to demonstrate good character through the president's ability to exercise unerring political judgment, neglect nothing, exhibit exemplary personal behavior, and win reelection campaigns. In omitting these failures and their historical contexts, they prevent visitors from understanding more about how presidential leadership works.

More importantly, they encourage visitors to think of themselves in relation to the president in one of two ways: either as inferior people who, because they themselves make bad decisions and exhibit bad behavior, are essentially different from the president and therefore ought not to use him as a model for their own performance; or as superior people who, because

they are essentially the same as the president, don't make bad decisions or exhibit bad behavior at all. In the first case, the narrative of presidential performance discourages visitors from active participation in public life, since they are better off leaving things in the president's unfaltering hands. In the second, exceptional presidential performance promotes a smug satisfaction on the visitor's part about her own past performance and expectations of an impossibly continuous history of achievement going forward.

Alternate Modes of Performing History: Decision Theaters

Following a model established by the Truman Library, several of the presidential museums have created "decision theaters" whose purpose is to shed light on the process of presidential decision-making by inviting the visitor to act as the president in crisis situations. Decision theaters are designed to help visitors understand the kinds of information available (and unavailable) to the president at the time of the decision, the pressures of public opinion, national and international political pressures, and the historical vantage point from which the decisions were made. In theory, decision theaters also have the potential to teach visitors about how the outcomes of these decisions are evaluated historically and to encourage them to think through multiple possible courses of action.

They do not always realize this potential. The Reagan Library's Air Force One Discovery Center is a case in point. In January 2011, National Public Radio's *This American Life* excoriated the Reagan Library with a piece reported by Starlee Kine about the Reagan museum's Discovery Center (unlike decision theaters in other museums, available only to schoolchildren), where fifth-grade students are "immersed in a historical crisis during President Reagan's term in office."[24] Specifically, this program dealt with Reagan's decision to authorize an invasion of Grenada in 1983. The Discovery Center is a variation on the decision centers found at several of the presidential libraries. It engages the children in playing the roles of Reagan's key advisors, members of the press, and the president himself. But the decisions the children make are far from free. Kine explains:

> Before they start, the kids were [*sic*] told that there aren't right or wrong answers, but the whole thing's rigged to make what Ronald Reagan did in 1983 look like the most appealing option. Each time the kids choose to do what he did, a bell goes off as though they've won a tropical vacation in Grenada, instead of an invasion.

The piece went on to describe both a situation in which the fifth grader playing President Reagan made the "right" decision and one in which a fifth grader made a "wrong" decision. In the case of the "wrong" decision, "the sound that comes out of the phone is one that anyone who ever watched a game show on TV will immediately recognize as the sound of being wrong." Kine concluded:

> Adults can sometimes put on this big show, letting you make the decisions, letting you be in charge, when what they really want is to convince you that their way is best, that they're not bad people, that the decisions they made were the right ones, and that if you were in their position, you'd have done it the same way. They'd really like you to believe that, maybe so they can believe it too.[25]

Rather than demonstrating the complexity of presidential decision-making, Kine suggests, the Air Force One Discovery Center demonstrated, through performance, the infallibility of Reagan's judgment, and the corresponding goodness of his character.

A similar argument can be made about the new George W. Bush Library's decision theater where, for example, despite offering the visitor multiple decision-making options, the program gives the last word on Hurricane Katrina to the president. Larger than life on the theater's screen, Bush concludes the portion of the film dedicated to the disaster, revealing his own decision and stating that the decision he made was "what the situation demanded."

The LBJ Library's decision-making exhibit, which is displayed on touch screens in the Vietnam gallery, is more successful in demonstrating the complexity of presidential decision-making. This program focuses on three decisions within a single crisis: whether or not to retaliate at the Gulf of Tonkin, the decision to escalate the war (here described as a decision to increase the number of ground troops in Vietnam), and the question of whether or not to "pursue peace" in Vietnam through a temporary cease-fire. The exhibit also includes documented historical advice Johnson received from specific, named advisors in a variety of forms—over the phone, in memos, in recorded Oval Office conversations.

The difficulty here is that the focus on discrete decision points obscures the larger picture and, in fact, the real historical questions behind Johnson's failures. In the case of Vietnam, the most vexing questions are about decisions Johnson *failed* to make. These include why, especially in the case of escalation, Johnson did not seriously entertain dissenting voices among his

advisors and in Congress; why he did not call for a *larger* increase in ground troops, as his military advisors repeatedly asked him to do; and why, when opinion both within the administration and among the public turned so strongly against the war, he refused to reconsider his approach.

The most successful of the decision theaters can be found at the Truman Library. Hufbauer praises the decision theaters at the Truman Library for "address[ing] presidential decisions in historical context rather than simply creating a Happy Meal version of presidential history."[26] And he is right in saying that the Truman decision theaters dramatize better than any other presidential museum display the complexity of some of the key decisions of Truman's administration. The first named decision theater, for example, takes up three key decisions Truman had to make in 1948. The gallery is labeled "Decisions Made during an Election Year," lodging the political stakes of the decisions firmly in the visitor's mind.

In describing the first of these decisions, whether or not to recognize the state of Israel, the exhibit details some of the advice Truman received from Niles, Clifford, Forrestal, Marshall, and Weizmann, administration advisors with differing perspectives and different kinds of authority. The exhibit then asks the visitor to speculate about the most important factor in Truman's decision from among four choices: interest groups/public opinion, personal values, recommendations of advisors, long-term national interest. Finally, the visitor hears Truman's decision and the basic reasoning behind it.

Most remarkable of all is the second decision theater focusing on McCarthyism and, specifically, on Truman's implementation of a peacetime loyalty program for federal employees. The program, established by executive order in 1947, determined that evidence of disloyalty to the United States would include affiliation with any organization on the Attorney General's List of Subversive Organizations (AGLSO).

> The publication of the list transformed what was supposedly a tool solely designed to help screen federal employees for loyalty into what effectively became an official government proscription blacklist, whose influence spread across American society, severely damaged or destroyed the listed organizations, and cast a general pall over freedom of association and speech in the United States.[27]

Although the theater does not mention the AGLSO or any other results of the loyalty program, it explains that Truman implemented the loyalty program "with misgivings" because he felt that he had no other choice politically.

It goes on to ask visitors to consider whether the program was an overreaction and whether or not the decision could be made in the same way today.

The small theater re-creates the mise-en-scène of a courtroom. Visitors sit on wooden benches facing a mirrored wall in which they see themselves and their fellow visitors reflected. The lights become unnaturally bright as a disembodied voice asks, "Are you a citizen of the United States? Do you attend church? Do you attend church regularly? Do you belong to an organization suspected of communism? Do you suspect friends or coworkers of communism? Would you be willing to share those suspicions with members of this board?"[28] In creating the atmosphere of the courtroom through lights, set, and text, the exhibit dramatizes not only Truman's decision but also the culture of paranoia in 1950s America. It also shows the president making a bad—arguably even an un-American—decision. The theater is unique in the presidential library system in that it focuses our attention on a decision that seemed defensible to many observers at the time but, with historical perspective, appears to violate the fundamental principles of democracy.

The Ford Library decision theater demonstrates that historical perspective can work in the opposite direction. It is housed in a replicated cabinet room—one of two in the library system—performatively emphasizing Ford's inclination to consult with his advisors on difficult decisions. A program on a large screen gives the visitor background information on each of three situations. Many things about the decision theater make identifying with the president difficult, most importantly the fact that the program on the screen does not clearly articulate what Ford actually chose to *do* in several of the scenarios, or what the outcome of that action proved to be. (A woman sitting next to me turned to me after one of the cases and said with anxiety, "So what was the answer?" suggesting that even adults yearn to get it "right" by matching the president's decision.)

The Ford cabinet room does one thing well, and no other decision theater attempts it: the program suggests that it is not only presidential decision-making but also our evaluation of presidential decision-making that is contingent on our historical vantage point. It does this most explicitly in the case of Ford's decision to pardon Nixon in 1974, only one month after he came into office. In acting so quickly, the program acknowledges, Ford "misreads the willingness of the American people to forgive and forget."[29] But the film also makes clear that history has come to Ford's defense and that now most historians condone the decision. Although the effect of historical distance is less pronounced in the other examples, the program highlights the issue of historical vantage point by asking visitors two separate questions, one

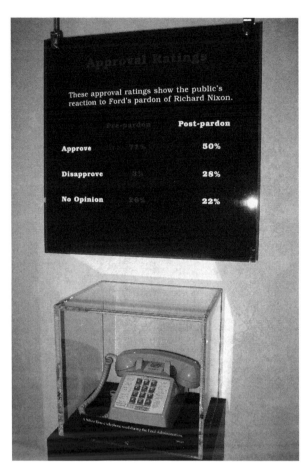

These approval ratings show the public's reaction to Ford's pardon of Richard Nixon.

	Pre-pardon	Post-pardon
Approve	71%	50%
Disapprove	3%	28%
No Opinion	26%	22%

The Gerald R. Ford Presidential Library and Museum highlights, through this and other displays, Americans' angry response to the president's decision to pardon his predecessor, Richard Nixon. *Photo by author.*

about how they would have responded to a given situation at the time and another about how they would assess the president's decision today.

The historical contingency of the pardon is foregrounded in an exhibit dedicated to the decision as well. The Ford Library does not shy away from documenting how unpopular the decision was at the time. The exhibit states frankly that "public anger over the decision ended the new president's honeymoon"[30] and goes on to quantify that anger, ending with a chart that demonstrates the dramatic drop in Ford's approval rating after the pardon. Statistics on the number of phone calls to the White House operator and the amount of mail received in the aftermath of the pardon further illustrate the public discontent.

At the end of the exhibition, visitors can watch video footage of Ford receiving the Profiles in Courage award from Caroline Kennedy twenty-seven years later. Following the presentation, Democratic senator Ted Kennedy

speaks admiringly of the Republican president, embodying the contingency of historical evaluation. He identifies himself as one of the many who criticized Ford's decision to pardon Nixon at the time and came to approve of it much later. "Time has a way of clarifying things," he says. "And now we see he was right."[31] This clip, the decision theater, and the Ford Library as a whole demonstrate the performative nature of history; not only its discontinuity as it unfolds in real time, but the discontinuity in our ability to represent it.

It might rightly be said that the Ford Library is in a good position to emphasize the historical contingency of decision-making, since the transformation of the pardon's evaluation over time was in Ford's favor. Nonetheless, its examination of a presidential decision whose evaluation has changed significantly over time serves as a powerful model of what other museums might do to teach visitors about the performativity of both history and its representation.

At their best, the decision theaters put the visitor in the role of the chief executive, not to make the president's decision seem correct but to enhance her appreciation for the complexity of presidential decision-making. Even more importantly, the best decision theaters empower the visitor, through this rehearsal, to actively participate in imagining an alternate American history.

Presidential libraries that excise failure from their performances of the presidency promote an understanding of the chief executive as an extraordinary worker, endowed with an unerring vision and an unfaltering ability to realize that vision. This is not just a partial but also a badly distorted narrative of history. The omissions required to construct such a story lead Herbert Hoover Library visitors to conclude that presidents lose reelection because of public misperception about who they are. They lead Clinton Library visitors to conclude that presidents can be impeached as political sport. And they lead visitors to many of the libraries to conclude that, contrary to Truman's dictum, there are some failures of his own political judgment for which the president is not responsible. These failures of representation redouble the failures of the president's job performance and reflect poorly on his characters.

By eliding mistakes and losses, this model squanders the opportunity for presidential library visitors to explore the causes of political (and personal) failure and the roads to recovery from it. And worst of all from the perspective of the library's mission, to the extent that visitors recognize it as such, an artificially coherent historical narrative reflects poorly on presidential character and the museum stakeholders who authorize it.

As a model of leadership, an unerring president also fosters a passive museum effect. If the nation's chief executive is represented as always deciding and behaving well, then the participation of ordinary Americans in the political process is no longer necessary. And by promoting a false understanding of presidential performances, museums hinder the visitor's ability to understand, minimize, and make use of her own failures outside the museum walls.

In the future, presidential libraries might find creative ways to perform the lapses and gaps in presidential job performance, especially in their original exhibitions. Decision theaters that genuinely seek to empower the visitor to rehearse alternate histories are one model for doing so, but certainly not the only one. Imagine, for example, that the structure of the museum narrative were expanded to include a Gallery of Regrets. Although this may sound preposterous under the current institutional structure, in fact a number of presidents have been forthcoming about the limits of their own success. In his final address to the nation, Eisenhower began a tradition of a president reflecting on his regrets as well as his achievements.

> Disarmament, with mutual honor and confidence, is a continuing imperative. Together we must learn how to compose differences, not with arms, but with intellect and decent purpose. Because this need is so sharp and apparent I confess that I lay down my official responsibilities in this field with a definite sense of disappointment. As one who has witnessed the horror and the lingering sadness of war—as one who knows that another war could utterly destroy this civilization which has been so slowly and painfully built over thousands of years—I wish I could say tonight that a lasting peace is in sight.[32]

Similarly, in his final State of the Union address, President Johnson said, "I regret more than any of you know that it has not been possible to restore peace to South Vietnam."[33] In his farewell address to the nation, President Reagan voiced regret over the deficit he was leaving behind. And since leaving office, Bill Clinton has expressed regret in a number of public outlets about his failure to send troops to Rwanda sooner to stop the genocide there.[34] Of these expressions of failure, only one, Eisenhower's, is represented in the presidential library.

Nor would a greater willingness to display contingencies and disruptions in presidential history weaken the libraries' performances of presidential character. Paradoxically, exhibiting failure is the president's final opportunity to embody the strength of American character.

Interlude: Ivaniz Silva Remembers
Saying Good-Bye to the Bushes

It was such a sad day. We all loved them so much and we'd expected to have another four years with them. We were all gathered at the bottom of the stairs waiting and I'm sure every one of us had a story playing in our heads, a time she'd asked how we were and really wanted to know, or a time it was evening and one of them would say, "Go home to your family!" Some of us even got phone calls from the president, if we'd had a loved one die and they were away. Even the staff who had been there a lot longer than I had felt closer to Mr. and Mrs. Bush than to other families.

They reminded me of my own mama and papa, the way they'd horse around with each other, teasing and having a good time together. Maybe it was that their kids were grown and they didn't have any family living in the house, so it was easy to feel like we were their family. Maybe it was just their nature.

He came out on to the landing and saw all of us standing there below and he just burst out sobbing. She was a little teary too, but he was broken up. She put her arm around him and he recovered pretty quickly, laughing because he was a little embarrassed, I think.

"Anybody got a tissue?" he asked. Well I always keep some in my pocket for little mishaps, so I drew one out and started up but he walked down the stairs to get it from me. "Thank you, Ivaniz," he said, putting one hand on my shoulder. It was clear he was saying thank you for a lot more than the tissue.

I was surprised when I got that call a few years later about having the photograph taken for the library. One of our most important jobs at the residence is to be unnoticed. We don't call attention to ourselves and we try to stay out of the way. But if anyone was going to have us in their library, then of course it would have been them. I don't know how many people would really take the time to leaf through a whole book of staff portraits. Why would they be interested in us? Still, I am proud to be there.

The senior Bushes' emotional response to telling the staff good-bye is mentioned in Kate Andersen Brower's recent book, *The Residence*.[1]
The details of Ivaniz Silva's response are invented.

6. PERFORMING THE AMERICAN COMMUNITY

Since its inception in the late 1970s, the field of performance studies has been helping scholars and practitioners from a wide array of disciplines to understand their subjects through the lens of performance, with important ramifications for understanding how we make meaning as socially and culturally embedded actors. For at least the last thirty years, the field has been centrally concerned with the agency of individuals to act within or against the sociopolitical status quo. But, as I have argued in the preceding chapters, that individual agency is also *itself* a narrative, a mythology with particular salience in American culture.

As central as the quest for meaningful individual agency is in the field of performance studies, performers of all kinds know that this is, in some sense, a fiction. For practitioners, performance is fundamentally relational, requiring not only an audience but, whether seen or unseen, other actors—actors whose past performances have made the present ones possible, actors whose work in the present supports this particular telling of this particular story. In performance, no one ever really acts alone.

In everyday life as on the stage, actors can never function wholly outside of existing structures of power, whether that structure primarily lends them authority or constrains their ability to act. This understanding drives many performance scholars to study systemic forms of oppression and, in the process, to align themselves with a diverse range of other, often historically undervalued subjects.

The previous chapters have focused on the libraries' representations of presidential performances as they embody or diverge from extant historical and cultural scripts. They have also explored the effects of those representations on the individual visitor's understanding of character, both the president's and her own. Here, I turn to the ways in which the libraries represent presidential character as inextricably linked with the presence and performance of others. Some of these others are family members, friends, and colleagues to whom the president's performance both in and out of office is indebted; some are historically undervalued subjects to whom the

president owes representation in both the political and artistic sense. To the extent that they work to incorporate these relationships into the performance of presidential character (and it is often a limited extent), the libraries demonstrate that an ability to acknowledge support from, work with, and care about others is also a core quality of American character.

One nonmerit factor in the success of individual performance is social capital or "who you know." McNamee and Miller explain that social capital "focuses attention on differential access to opportunities through social connections."[1] A number of presidents enjoyed unusually rich social capital—Roosevelt, Kennedy, Carter, and Bush through their families' wealth and political legacies, Truman through his relationship with the Pendergast family, and Reagan through his association with General Electric.

But because emphasizing these relationships would undermine the case for merit as the basis for success, the libraries typically do not emphasize the presidents' social capital. The visitor learns little, for example, of Truman's young adult relationship with "Boss" Pendergast, one of the most influential political operatives in Kansas City and his original sponsor in the political arena; and nothing of Reagan's early career relationship with Lemuel Boulware, the vice president of General Electric who was so influential in shaping the future president's ideology and style.[2] Nor, despite its considerable strengths, does the childhood display in the Carter Library mention the social influence of Carter's father, "a prospering merchant farmer of Sumter County," the head of one of the "two leading families around Plains" and eventually a state representative.[3]

Perhaps the most dramatic elisions of indebtedness govern nearly all of the libraries' displays on presidential campaigns. Since the full-fledged electronic mediation of the presidential campaign began with John F. Kennedy, few Americans would be so naive as to argue that the president is elected on strength of character alone. Yet as the libraries perform presidential campaigns, character speaks and acts for itself. Franklin Roosevelt and John F. Kennedy appear to have relied on their exceptionally wealthy families for some campaign legwork but not for financial or political influence. Nor do any of the soon-to-be presidents seem to have ever run a campaign ad, employed a speechwriter, or met a political consultant. I abandoned a planned chapter in this book on the representation of presidential campaigns in the museum because there is simply so little meaningful representation to be found.

Some of the libraries have taken baby steps away from this implausible one-man-show narrative. The Kennedy Library, for example, acknowledges

the pivotal role that the televised debates played in his electoral victory. But it also displays a number of campaign artifacts, most notably a typewritten set of instructions for local fundraisers, that create the impression of a wholly grassroots campaign by one of the nation's wealthiest and most politically engaged families. The Carter Library makes brief but specific mention of his campaign manager Jody Powell and advertising guru Gerald Rafshoon, and of the financial cost of his campaign.

The omissions, though, are egregious. The visitor to the Lyndon Johnson Library cannot see the Johnson campaign's "daisy ad," which suggested the imminence of a nuclear war in order to frighten voters about the dangers of a Goldwater presidency. Pulled from the air after one showing, the ad nonetheless had a significant impact on the campaign and remains one of the most famous—and controversial—political commercial ever run. The visitor to the George H. W. Bush Library cannot learn about the president's controversial campaign manager, Lee Atwater, who masterminded "one of the most relentlessly negative campaigns in modern presidential history."[4] Nor can the visitor learn anything about the media strategy companies that have figured prominently in every presidential campaign since at least the Clinton administration.

Without any look at how political campaigns are constructed, and without any indications of the social and financial capital on which the candidates drew, presidential campaigns become the ultimate performances of meritocracy. Far from surprising or disappointing visitors, greater representation of campaign dramaturgy would foster enhanced appreciation for presidential performances. It would also make visitors more sophisticated and more critical consumers of these performances in their lives beyond the museum.

Perhaps the best example of foregrounded social capital in the library system comes, unexpectedly, in a postpresidential gallery. The Hoover Library's display on his post-presidency strikingly demonstrates the collaborative nature of Hoover's postpresidential self. Specifically, it shows that Hoover could not have created the groundbreaking postpresidential self he did (see chapter 3) without the sponsorship of his second successor, Harry S. Truman.

One large panel in the Hoover museum's postpresidential exhibit is dedicated to Hoover's relationship with Truman. Below a candid, close-up photograph of the two men smiling easily in each other's company is a narrative about their alliance, which Hoover said added ten years to his life. The text includes an excerpt from a 1962 letter to Truman: "Yours has been a friendship which has reached deeper into my life than you know."[5] This is one of notably few instances in presidential libraries in which a president publicly acknowledges his indebtedness to another president.

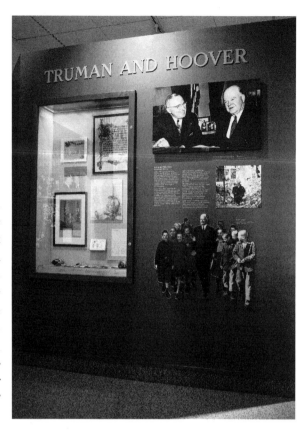

President Truman needed help on the job, and President Hoover needed help repairing his reputation. The Hoover Library highlights the unusual relationship that rescued them both. *Photo courtesy of Herbert Hoover Presidential Library and Museum.*

The Hoover Library's displays on the post-presidency demonstrate better than any other display in the library system the importance of social capital in individual achievement. It was because Hoover did not enjoy a warm relationship with Roosevelt that he was unable to act on the public stage for so long after leaving office. And it was because he developed such a relationship with Truman that he was able to return to meaningful work at the national and international levels. Even for an ex-president, then, who you know affects your ability to perform successfully.

Another important nonmerit factor in individual success is plain dumb luck. In both occupational and financial success, McNamee and Miller argue, "being at the right place at the right time also matters."[6] In the race for the presidency, to evaluate whether or not the candidate is in the right place at the right time is to consider broad social forces. Not only are these forces beyond the candidate's control but they also tend to become more visible as historical distance increases. Carter's status as a Washington outsider made

him clearly the right man at the right time to win the presidency following Richard Nixon's resignation (although his lack of public performance skills made him just as clearly the wrong man to win against Ronald Reagan in 1980). Eisenhower and Clinton had the good fortune to lead the nation in times of peace and relative economic prosperity. Although none of the three presidents who came to office without an election (Truman, Johnson, and Ford) would have said that the circumstances under which they did so were lucky, following as they did the literal or political death of a president, it was certainly chance that placed each of them in the Oval Office. Similarly, George W. Bush's presidency demonstrated how a national tragedy such as the terrorist attacks of September 11, 2001, can provide unexpected opportunities for leadership.

The only mention of luck as a factor in the presidential library system can be found in the George H. W. Bush Library, and it is a substantive one. On display in the library is a letter that Bush wrote to his parents after being appointed to the powerful Senate Ways and Means committee as a freshman. It reads, in part, "Let's face it, there's a lot of luck involved in this and I was in the right place at the right time. But no matter how you skin it, it's a real good break for a freshman congressman."[7] The idea that luck might play a significant role in an individual's ability to achieve is antithetical to the American narrative of success. The library's willingness to redouble Bush's private acknowledgment of this nonmerit factor by displaying it in a public museum ironically augments rather than diminishes the sense of this president as an honest, humble, and otherwise morally virtuous character.

In the galleries dedicated to his years of work in the Oval Office, relationships that shape presidential performance continue to be downplayed or, more often, entirely omitted. (The exception to this rule is the president's relationship with the first lady, although she is too often relegated to her own gallery outside the narrative flow of the exhibition and too often featured most prominently as a wearer of fancy dresses.[8]) In this way, the galleries conceal the extent to which a president creates his "character" through his collaborative work with other leaders.

Some libraries gesture toward the collaborative nature of the president's performance in office. In the Truman Library's decision theaters, one gets the impression that the president is consulting with others, some of whose names and faces briefly fly by, but the nature of the consultation is opaque. The Ford Library displays framed photographs of Ford's entire team of advisors,

along with a notebook filled with the professional profiles of each. From this, one can see the longevity of the political influence of, for example, Dick Cheney, Donald Rumsfeld, or George H. W. Bush, though one cannot determine who comprised the president's inner circle. At the LBJ Library's Vietnam decision consoles, the visitor can learn exactly who gave Johnson what advice. But who did Johnson trust most to give him good advice and why? Whose opinions did he devalue and why? Even here, there is no way to understand which relationships mattered most to the president.

A few libraries do feature at least one key relationship through which the president performs. One of the best examples of a foregrounded relationship in the library system is Kennedy's relationship with his attorney general. The library features a larger-than-life-sized photograph of the two men in consultation and a full gallery devoted to the attorney general's office. In this case, of course, the attorney general was not only a coworker but also part of the family, so the emphasis on Robert Kennedy's role performs a dual function, highlighting collaboration in the White House and, at the same time, displaying the moral virtue of valuing family.

The Clinton Library offers the most thorough treatment of the relationship between president and vice president. One of the fourteen central alcoves in the main exhibition room is dedicated to "The Work of the Vice President." The alcove contains significant textual and visual documentation of Gore's achievements. And, in a track on the audio tour dedicated to the vice president, the president's voice proclaims with surprising frankness, "Al Gore knew things that I didn't know." This is the only instance in the library system in which an exhibit attests to the role of the vice president in shaping presidential job performance.

What would it mean for presidential libraries to highlight key relationships between the president and other leaders? In representing the early years, it would mean acknowledging most future presidents' privileged starting place in the American race for success, whether because of inherited wealth or their families' high social standing in their communities. In the representation of campaigns, it would mean acknowledging the myriad collaborations that construct "presidential character" for the American public. And in the representation of the president's work in office, it would mean disabusing ourselves of the notion that any leader, no matter how talented, acts alone.

Presidents do not just perform with the help of others; they also perform on behalf of others. But, as my earlier discussion of neglect suggests, not *all* others. In their performances of American character, presidential libraries

too often elide the diversity of the citizenry and the differential experiences of certain groups of Americans.

This elision is reflected in visitor demographics. Although to date NARA has never conducted a visitor study that collected information on race, ethnicity, education level, or class (they have asked about age), it is clear that presidential libraries address what Michael Warner calls a "dominant public" rather than a "counterpublic." Acknowledging this reality, Deputy Director McClure observes wryly that he doesn't need a visitor survey to discover "how old and white we are."[9] This is not particularly surprising, since minority groups so rarely find their stories represented in the libraries' exhibits.

In addition, Falk and Dierking suggest that a lack of diversity is a long-standing issue in most American museums, regardless of their subjects. In terms of age, most adults who visit museums are between thirty-five and fifty. Regarding the ethnic makeup of museum visitors, they state anecdotally, "few museum professionals would dispute the fact that racial minorities are underrepresented among museum-goers. The few studies that have been done generally substantiate this assumption."[10]

The most successful library exhibition in addressing the diversity of the American experience is one of the oldest. The Eisenhower Library's discussion of the generally prosperous 1950s concludes with the sentence, "Not all Americans shared in the economic boom times."[11] The next gallery specifies this disparity of experience with a wall-length text display titled "The Other America." The display notes the shockingly high percentage of Americans living below the poverty line during Eisenhower's administration (20–25 percent), and the vulnerability of a range of groups including blacks in inner cities, whites in mining communities, rural southerners, Puerto Rican and Mexican Americans, Indians, migratory workers, and the elderly, each of which gets a brief but not superficial discussion in the display.

Another place where the diversity of citizens' experience is compellingly represented is in the George H. W. Bush Library's Gulf War Theater. Unique in the presidential library system, the Bush Library dedicates significant space to this immersive experience. Through it, visitors engage with another kind of "other America," the America of the soldier.

Visitors enter a circular tent made of wood and tarp to the sounds of gunfire and sit uncomfortably on long, narrow wooden crates. The soundscape is interrupted regularly by the voices of nine different servicemen, each of whom offers a reflection on the experience of fighting. Occasionally, a blast of light illuminates the otherwise dim space, revealing a carefully constructed scene. The setting includes a television—the Gulf War was the

first that citizens could watch on TV—a string of light bulbs hung from near the top of the tent, a curled color photograph of a woman and young girl, and at least a dozen other items carefully chosen to assist the visitor in entering the life of a Gulf War soldier. Finally, a small screen in the center of the tent's back wall projects film of the war as a soldier might have seen it out of an opening in the tent.

The theater is in no way high tech, although it makes use of technologies that would have been available at the time of the war. The ample (albeit uncomfortable) seating, the length and variety of the soldiers' testimonies, and the periods of soundscape between them encourage the visitor to stay in the space for a significant amount of time and to experience the gallery without conversation. Other presidential museums might consider exploring such immersive experiences as a way of offering visitors insight into one or more aspects of the diversity of American experience in the era they address.

Several other exhibits in presidential libraries work to incorporate ordinary American performances. The Eisenhower Library attempts something like this with brief video portraits of four Americans of different demographics, but the stories are scripted and carefully staged for the camera. The Hoover Library uses powerful, videotaped oral history interviews to document the suffering of Europeans during World War II—but not the suffering of Americans at home during the Great Depression.

Genuine engagement with the diversity of American experience would require the makers of presidential library exhibits to discard the myth of a coherent American community, acknowledging instead the existence of myriad American publics and counterpublics. Just as every presidential library could include a gallery of regrets (see chapter 5), every library could expand its structure to include an "Other America(s)" gallery. In this space, the exhibition could focus attention on populations that were particularly economically or politically vulnerable at the time of the president's work. As elsewhere, these spaces would ideally include audiovisual evidence.

In some cases, this would require presidential libraries to honor populations with which the leader's administration did not particularly concern itself. But as with the representation of presidential failure, libraries would have an opportunity to redress in some small measure, through performance, the privileging of some varieties of American experience over others.

To address diversity more substantively in the library system would require both exhibit designers and visitors to acknowledge the enormous socioeconomic disparities that have caused many American counterpublics

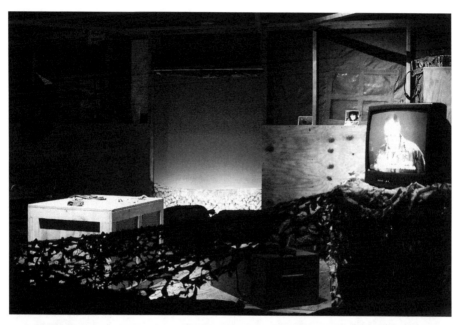

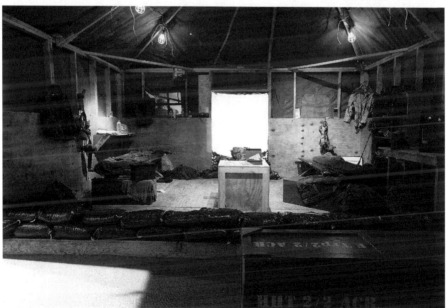

In the Gulf War theater, the shifting lighting, video screens, and careful design uniquely invite the visitor inside the American soldier's experience of the Gulf War. *Photos courtesy of the George Bush Presidential Library and Museum.*

to suffer disproportionately throughout our history. And it would require visitors to enter into rehearsals of disempowerment, in which the principal actor does not hold the most powerful office in the world. The representation of a diverse American community at presidential libraries would reflect well on the stakeholders who authorized the performance, including, even if posthumously, the president himself. Better representing American diversity might also help to bring a wider spectrum of visitors into the museums.

In addition to performing the presidency, presidential libraries also make an effort to represent the cultural context in which the chief executive acted. They do this through a structural component of most presidential libraries that I have not yet discussed and which I will call the culture gallery. This gallery usually appears somewhere in the midst of the presidential years displays and addresses the broader cultural milieu of the era in which the president served. Currently, most culture galleries provide extensive visual sampling of the mainstream culture of the day including fashion trends, movie posters, and album covers. Sometimes, this sampling is accompanied by audio clips of contemporary music. The effect is to create a cacophonous, sometimes overwhelming and generally celebratory atmosphere, full of color and life.

More selective curating of the cultural context could help visitors better explore some of the most vital expressions of the president's times. Particularly seminal artists or works could be identified and described. The visitor could experience these artists and performances at some length through touch screens, large projection screens, or audio recordings.

Particularly important performances of artristry bearing on presidential character could be included as well. Since the Ford administration, presidential impersonations have been a fixture of *Saturday Night Live*, and viewing these performances might be both educational and entertaining for visitors. Footage of presidents' inaugurations would reveal some of the musicians and literary artists who shaped the president's imagination. And rosters of live performances at White House concerts could afford visitors a sense of what kinds of artists and artristry were valued.

Not all of these expressions would be celebratory; often, it is the performing artist's role to represent struggle and conflict, or to break representational taboos. A deeper exploration of creative expression in the culture galleries would therefore shed more light on the cultural context in which the president acted than the current galleries do. More importantly, it would

underscore the existence of other stories of the era, some of them very different from the one the museum is working so diligently to tell.

Across the history of the presidential library system, the most important change in the larger museum culture has been museums' evolving shift from display to experience, inviting a more collaborative relationship with visitors. Susan Bennett warns that the danger of this newer "experience economy" is that it becomes "one more consumable directed not at any social benefit but towards the instantiation and affirmation of an individual. . . ." To guard against this danger, she advises experiential museum planners must raise the critical question, "Whose experience matters?"[12]

As another way of broadening their appeal to alternate publics, more presidential libraries might consider including scenes in which presidents express and evoke feeling. Counterpublics, Warner argues, value affect, play, and sociability. They may not be "organized by the hierarchy of faculties that elevates rational-critical reflection as the self-image of humanity" and may not "easily suppress from consciousness their own creative-expressive function."[13] The few, fleeting moments of intense affective impact in the museums—many highlighted and extended in this book's interludes—often do more work than the dominant narrative does in helping us to understand presidential character.

The libraries could also explore performance as a living art within the museum space, one that could give visitors live and embodied experiences of alternate perspectives.[14] Catherine Hughes, an expert on live theater in museum contexts, notes performance's ability "to present a prism of differing perspectives through various characters in subtle, nonthreatening ways."[15] While the decision theaters invite the visitor to act as the president, none of the presidential libraries make room for visitors to perform the role of another ordinary American. What if, for example, a visitor to the Hoover Library was invited to view the museum—or even a single display—through the narrative or the identity of a member of the Bonus Army? What if a visitor to the Kennedy Library was invited to experience the first one hundred days of his administration as an African American high school student? By encouraging visitors to engage actively with such perspectives, performance in the museum can productively disrupt the narrative of a single, cohesive American community.

The museums are beginning to encourage at least one kind of live performance: the visitors' enactment of their own stories. The most substantive effort in this regard to date is tucked into a dark corner of the new George

W. Bush Library, opposite a large-screen film about the terrorist attacks of September 11, 2001. There, at a small computer station, visitors can type in their own memories of the events with their name, state, and location. If applicable, they can choose to identify themselves as belonging to one of three communities: "I was there," "I was a first responder," or "I lost a loved one." All of the narratives on the interactive display originate with visitors. Visitors can also search through the narratives by location, subject category, title, or date. At this writing the database, just over one year old, contains approximately seventeen hundred narratives.

This simple idea has enormous potential for including visitors' stories in the presidential museums. Going forward, visitors could record their experiences of contemporary events and time periods on computer microphones or cameras, contributing and making available to other visitors their embodied

PRD Group's design for the September 11 memorial gallery at the new George W. Bush Library offers visitors a space to remember and reflect. *Photo by Jodie Steck; courtesy of the George W. Bush Presidential Library and Museum.*

memories of American history. As an alternate mode of performing history, the firsthand testimonial "opens a great vista of postmodern agency, embracing the lives of those whose accomplishments might not be the stuff of conventional history, but whose agency thrives in the tactical politics of everyday living."[16] The space of autobiographical storytelling is a fertile one for transforming visitors' understandings of their role in the practice of making history.

Presidential libraries are making progress, albeit slow progress, in demonstrating the roles that community plays in the performance of presidential character. In their representations of success in presidents' early lives, the libraries are beginning to acknowledge the future leaders' indebtedness to social capital, the often-powerful people they know. In their representations of presidents' achievements in office, they are acknowledging, at least in small ways, the critical work of their political collaborators. As they recognize these debts, they locate the president in a network of relationships on which his performance depends. And, paradoxically, in their willingness to display these dependencies, the libraries perform a more powerful presidential character.

The libraries are also making progress in performing the diversity of American experience. At least one library, Eisenhower's, has explicitly exhibited the experience of other American communities, those in which poverty, violence, bigotry and other injustices continue despite the successes of presidential performances. And, slowly, other libraries are making room in the space of presidential history for a greater diversity of voices and experiences.

CODA
Character 2.0—Reinventing the Presidential Library

It is September 7, 1993. President Bill Clinton and Vice President Al Gore stand on the White House South Lawn. In front of them is the American press. Behind them is a forklift filled with hundreds of pounds of paper containing government regulations. They are here to discuss "Reinventing Government," an apparently unprecedented reform program aimed at making the operations of the federal government more efficient.

In fact, Clinton and Gore are reinventing reinvention. The 1993 National Partnership for Reinventing Government is the eleventh federal reform effort of the twentieth century. Earlier programs were commissioned by presidents Franklin Roosevelt, Harry Truman, and Ronald Reagan. (Truman's first Hoover Commission, an effort to systematically reduce government waste, was an integral part of the rehabilitation of Herbert Hoover's reputation in his post-presidency.) And, in a real sense, America itself was a federal reform effort, the reinvention of a government that, the Founders felt, was failing to perform for its citizens.

Performance scholar Jon McKenzie describes the ways in which, since the latter half of the twentieth century, the American appetite for reinvention has come to dominate cultural performances of all kinds. McKenzie identifies the goal of this kind of performance as one of *efficacy*. The efficacy of cultural performance in America, he suggests, is most frequently measured by its ability to spur cultural actors on to new beginnings. "From the happenings, rock concerts, and political demonstrations of the 1960s to the drag shows, raves, and Culture Wars of the 1990s, cultural performance has been theorized as a catalyst to personal and social transformation."[1] The American appetite for reinvention is equally voracious in the realm of consumer practices, particularly since the middle of the twentieth century. Just as Pepsi successfully challenged Coke consumers in the 1950s to "be up to date with Pepsi," we now wait in line for hours to become first adopters of the newest iPad. We are hungry to see, taste, and touch the new.

In the case of presidential library system, meaningful reinvention will require the courage to reject, revise, and reimagine some of our most

cherished narratives about who our leaders were and, therefore, about who we are as Americans. It will require designers and curators to produce exhibitions that include disruptions in performance and counternarratives of American experience, and it will require presidents to authorize such exhibitions. It will require stakeholders to identify themselves with respect to the displays they authorize. And, borrowing from Scott Magelssen's categories of historical "simmings," it will require visitors to actively engage the museum display not as leisurely travelers through real historical events but, rather, as active participants in the performance of history who have come to "reimagine, improve on, revise, rub against, or oppose an original."[2]

In bits and pieces, this kind of reimagining is already taking place. Presidential museum professionals are revising the cultural script of who we are as citizens—that is, of American character. The renovated early years exhibit at the Carter Library; the nascent relational emphasis of the presidential years exhibit at the Clinton Library; the prominent representation of the social capital that facilitated Hoover's extraordinarily productive post-presidency; the redress of inattention to civil rights at the Kennedy Library; and the creative approaches to engaging legacy at the Truman, Eisenhower, and LBJ Libraries are all evidence that a more complex and nuanced representation of presidential character—and with it, American character—is possible. In these and other instances, stakeholders in the library system have been increasingly willing to subject the American Dream and the exhibition of merit it requires to a more expansive and complex representation of character, one that is of greater value to the visitor as she leaves the museum to reengage in the world.

Presidential libraries have also begun to "rub against" the cultural script of American history, replacing long-cherished narratives of cohesive community and continuous progress with more performative representations of the past that value disruption and failure, collaboration and diversity. The frank assessments of failures and historical contingencies in the Ford Library are exemplary in this regard, but the "Other America" display at the Eisenhower Library, the invitation to rehearse the soldier's experience in the George H. W. Bush Library, and the station at which visitors can share memories of September 11 at the George W. Bush Library provide glimpses into how museum displays might practice such a history.

How might the Barack Obama Presidential Library fashion a truly new performance of American character?

First the museum would need to be candid in its representation of how it is funded. It would need to make information about its investors and designers highly visible and easily available, not only at the museum entrance but inside the exhibition itself. The information would need to include the nature of contributors' relationships to the administration and, if applicable, their historiographic or other content expertise. All of this would enable the visitor to understand who is authorizing the presidential character on display, and to evaluate for themselves the reliability of that authority.

The museum would need to include representations of key relationships through which the president was supported in his early life, campaign, and term(s) of service. This information would enable the visitor to understand the more complex narrative behind individual achievements, including what is often referred to as Obama's "meteoric rise" to the presidency. It would also help visitors appreciate the fundamentally collaborative process of making American character. In Obama's case, it might be appropriate to include among these collaborators some of the civil rights pioneers who made it possible for the first African American to assume the presidency.

The museum would need to include a decision theater that engages the visitor in the practice of making history rather than in guessing the "right" answer. This would give visitors insight into the wide array of considerations involved in these decisions. It would encourage the visitor to think critically about the contingencies of presidential decision-making and, with it, the contingency of history itself. And it would enable the visitor to practice being an active collaborator in rather than an observer of historical narratives.

The museum would need to be willing to display a variety of presidential failures, including bad decisions and political defeats. The representation of these lapses, gaps, and losses in presidential performance would have a double benefit: it would help the visitor to better understand the discontinuous nature of history, and it would have a salutary effect on her experience of presidential character.

The museum would need to provide spaces for the voices of counterpublics, including members of those American communities that struggled to be heard during the president's tenure. The moral imperative to do so is especially strong for Obama, the nation's first black president, given the need for African American publics, even now, to insist that black lives matter. By incorporating diverse voices, the museum could deepen the visitor's affective engagement during the visit and create more sensitivity toward difference outside its walls.

Finally, the museum would need to open itself up more widely than any of its predecessors to visitors' affective and bodily engagement through a variety of performative strategies. Visitors should have the opportunity to experience substantial samples of major artistic performances that shaped or reflected the culture of the era. They should be invited to take on identities other than their own (and other than the president's) by seeing and hearing narratives of members of contemporary counter-publics. They should be able to access and contribute to a pool of performances recorded by museum visitors themselves. And they should be offered the tools to take action in the world beyond the library's walls. In the case of the Obama Library, a domestic version of the Carter Center focused on community organizing might be an appropriate vehicle for generating civic performance.

Beyond reinventing the model for a single project, it is time to make a serious critical assessment of the now seventy-five-year-old institution of the presidential library. Given the dramatically reduced need in our digital age for the archive portion of the presidential library, do we need to keep building the museums? When might it make sense to stop? One of the most frequently championed justifications for the museums' existence is that they make history available to citizens living all over the country, and not just in major metropolitan areas. But California now has two presidential libraries and Texas has three. How many is too many?

It would seem that we have little excuse for timidity in our reimagining. If there is one talent deeply encoded in the DNA of the American character, surely it is a talent for declaring our independence from the past.[3]

Notes

Introduction: Locating American Character
at the Presidential Libraries

1. Roosevelt Library and Museum website, "FDR Dedicated the First Presidential Library."
2. Howard Zinn, *A People's History of the United States* (New York: HarperCollins, 1980), 9.
3. Mike Wallace, *Mickey Mouse History and Other Essays on American Memory* (Philadelphia: Temple University Press, 1996), 16.
4. Cynthia M. Koch and Lynn A. Bassenese, "Roosevelt and his Library," *Prologue* 33, no. 2 (Summer 2001).
5. Roosevelt Library and Museum website, "FDR Dedicated the First Presidential Library."
6. Diana Taylor, *The Archive and the Repertoire* (Durham, NC: Duke University Press, 2003), 16.
7. The Franklin D. Roosevelt Library was the first presidential library to be administered by the National Archives and Records Administration (NARA). Although Herbert Hoover preceded FDR into office, in establishing his own presidential library under NARA, he followed his successor's example. Privately owned and administered presidential libraries, such as the Lincoln Library in Springfield, Illinois (completed in 2004), are not treated in this book.
8. Timothy Raphael, *The President Electric: Ronald Reagan and the Politics of Performance* (Ann Arbor: University of Michigan Press, 2009), 24
9. The presidential libraries' two core components are a museum of the presidency and an archive of presidential papers and other materials for use by scholars. Because the museum is the most visible and accessible part of the library, it is often what people, including the presidents themselves, mean when they refer to "presidential libraries." Unless otherwise specified, I use the terms "presidential library" and "presidential museum" interchangeably.
10. Benjamin Hufbauer, *Presidential Temples: How Memorials and Libraries Shape Public Memory* (Lawrence: University Press of Kansas, 2005), 7, 199.
11. Della Pollock, *Exceptional Spaces* (Chapel Hill: University of North Carolina Press, 1998), 10–11.
12. Barbara Kirshenblatt-Gimblett, *Destination Culture* (Berkeley: University of California Press, 1998), 3, 51.

13. Timothy W. Luke, *Museum Politics: Power Plays at the Exhibition* (Minneapolis: University of Minnesota Press, 2002), 13, xiii.

14. Hayden White, *The Content of the Form: Narrative Discourse and Historical Representation* (Baltimore: Johns Hopkins University Press, 1987), 180.

15. Seymour Martin Lipset, "A Changing American Character?" in *American Social Character*, ed. Rupert Wilkinson (New York: HarperCollins, 1992), 122

16. Ibid., 120.

17. This larger mission comes from NARA, which becomes the library's administrator after its dedication. As we will see in chapter 1, the mission of any individual library is subject to the influence of other stakeholders.

18. Neil Harris. *Humbug: The Art of P. T. Barnum* (Boston: Little, Brown and Company. 1973), 36.

19. Elaine Heumann Gurian, "Noodling around with Exhibition Opportunities," in *Exhibiting Cultures: The Poetics and Politics of Museum Display*, ed. Ivan Karp and Steven D. Lavine (Washington, DC: Smithsonian Institution Press, 1991), 182.

20. Susan Bennett, *Theatre and Museums* (New York: Palgrave Macmillan, 2013), 8.

21. Helen Reese Leahy, *Museum Bodies: The Politics and Practices of Visiting and Viewing* (Surrey, England: Ashgate, 2012).

22. Jill Stevenson, *Sensational Devotion: Evangelical Performance in Twenty-First Century America* (Ann Arbor: University of Michigan Press, 2013).

23. Tony Bennett, *Making Culture, Changing Society* (London: Routledge, 2013).

24. This is the topic with the longest scholarly history, beginning in the late 1980s. See, for example, Tony Bennett's *The Birth of the Museum* (London: Routledge, 1995) or Ivan Karp and Steven D. Lavine's anthology, *Exhibiting Cultures* (Washington, DC: Smithsonian Institution Press, 1991).

25. Jonas Barish, *The Anti-Theatrical Prejudice* (Los Angeles: University of California Press, 1981), 476.

26. Susan Bennett, *Theatre and Museums*, 60.

27. Luke, *Museum Politics*, 226.

28. Scott Magelssen, "Introduction," in *Enacting History*, ed. Rhona Malloy and Scott Magelssen (Tuscaloosa: University of Alabama Press, 2011), 8.

29. Rebecca Schneider, *Performing Remains: Art and War in Times of Theatrical Reenactment* (London: Routledge, 2011), 35, 36.

1. Character in Play: Performance Authority at the Presidential Library

1. Paul Bedard, "Peers Honor Nixon at Library Opening," *Washington Times*, July 20, 1990.

2. Carole Blair, Greg Dickinson, and Brian L. Ott, *Places of Public Memory: The Rhetoric of Museums and Memorials* (Tuscaloosa: University of Alabama Press, 2010), 24.

3. Benjamin Hufbauer, *Presidential Temples: How Memorials and Libraries Shape Public Memory* (Lawrence: University Press of Kansas, 2005), 1.

4. Ibid.

5. Sam McClure, personal communication, June 27, 2013.

6. Sharon Fawcett, "Presidential Libraries: A View from the Center," *Public Historian* 28, no. 3, (Summer 2006): 31.

7. Sharon Fawcett, personal communication, September 29, 2010.

8. Until it was included in NARA in 2007, the Nixon Library displayed only copies of presidential documents.

9. James Worsham, "Nixon's Library Now a Part of NARA," *Prologue* 39 no. 3 (Fall 2007).

10. Bedard, "Peers Honor Nixon."

11. John-Thor Dahlburg and Stuart Pfeifer, "For Feuding Nixon Sisters, Finally a Peace with Honor," *Los Angeles Times*, August 9, 2002.

12. David Greenberg, *Nixon's Shadow: The History of an Image* (New York: W. W. Norton and Company, 2003), xxxii.

13. Leon Whiteson, "Nixon Library Hits Close to Home," *Los Angeles Times*, July 19, 1990.

14. The building is often described as Spanish or California style because of its red-tiled roof. Immediately following the library's opening, Leon Whiteson described it for the *Los Angeles Times* as "unmonumental." The library's first addition, however, completed in 2004, included a new entrance pavilion of classical grandeur with exterior and interior architectural columns and a cavernous marble lobby, definitively changing the feel of the site.

15. Greenberg, *Nixon's Shadow*, xxvi.

16. Ibid., 272, 271.

17. Richard Nixon, First Inaugural Address, November 20, 1969, http://www.theus-gov.com/richarnixon%20Inaugural%20speech.htm.

18. See Robert Putnam, *Bowling Alone: The Collapse and Revival of American Community* (New York: Simon and Schuster), 2001. Putnam uses the waning of league bowling as a metaphor for decreased interconnectedness in America.

19. Greenberg, *Nixon's Shadow*, 152.

20. Ibid., 65.

21. Jon Wiener, *Professors, Politics, and Pop* (New York: Verso, 1991), 274.

22. Timothy Naftali, personal communication, July 27, 2011.

23. Greenberg, *Nixon's Shadow*, 345.

24. Dalia Sussman, "Most Americans Can't Explain Watergate," ABC News, June 17, 2002, retrieved at http://abcnews.go.com/US/story?id=90387.

25. Mike Wallace, *Mickey Mouse History and Other Essays on American Memory* (Philadelphia: Temple University Press, 1996), 26.

26. Richard Nixon, quoted in David Frost, *Frost/Nixon: Behind the Scenes of the Nixon Interviews* (New York: Harper Perennial, 2007), 250.

27. Naftali, personal communication, July 27, 2011.
28. Ibid., July 27, 2011.
29. Ibid., July 27, 2011.
30. Timothy Naftali, personal communication, October 4, 2011.
31. Although the Carter Library was closed for renovation for parts of both 2008 and 2009, its numbers are historically significantly lower than other libraries. The Carter Library's primary focus, as has been discussed, is on the work of the Carter Center and not on the museum. The Hoover Library, in addition to being the most chronologically distant, is in one of the most remote locations, West Branch, Iowa. It is also notable that the two least visited libraries both represent the histories of one-term presidencies.
32. Neil Kotler and Philip Kotler, "Can Museums Be All Things to All People? Missions, Goals, and Marketing's Role," in *Reinventing the Museum*, ed. Gail Anderson (Walnut Creek, CA: AltaMira Press, 2004), 168, 180.
33. The most recent visitor study, conducted in 2010 by Harris Interactive, did not ask respondents about their hopes, expectations, or experiences of the museums in relation to entertainment value.
34. In the case of the Nixon Library, NARA circumvented this refusal with a peremptory mandate that the Watergate exhibit be revised before the new library opened to the public.
35. Lynn Bassenese, personal communication, January 17, 2013.
36. McClure, personal communication.
37. Fawcett, "Presidential Libraries," 31.
38. Naftali, personal communication, October 4, 2011.

Interlude: Senator Richard Russell Reflects on the Many Characters of Lyndon Johnson

1. LBJ Library film, *The Johnson Treatment*, permanent exhibition.
2. Lyndon Johnson, conversation with Richard Russell, November 29, 1963, Lyndon B. Johnson Presidential Recordings, Miller Center at the University of Virginia.
3. Ibid.

2. Character in Motion: Visitor Performance

1. Helen Rees Leahy, *Museum Bodies: The Politics and Practices of Visiting and Viewing* (Surrey, England: Ashgate, 2012), 85.
2. Robert P. Jones and Daniel Cox, *Religion and the Tea Party in the 2010 Election: An Analysis of the Third Biennial American Values Survey* (Washington, DC: Public Religion Research Institute, October 2010), 17.
3. Howard Kurtz, "McCain Seeks Reagan Mantle," *Washington Post*, February 1, 2008.
4. Chris Bruce, quoted in Susan Bennett, *Theatre and Museums* (New York: Palgrave Macmillan, 2013), 44.

5. The Reagan Library was renovated in 2010 and reopened in time for Reagan's one hundredth birthday in 2011. This chapter deals with the original library exhibition, over which the Reagan family had the most direct control.

6. John Shelton Lawrence and Robert Jewett, *The Myth of the American Superhero* (Grand Rapids, MI: Eerdmans, 2002), 22.

7. Ronald Reagan, remarks at library dedication, Clay Walker, transcript, November 4, 1991.

8. Winthrop imagined a "city on a hill." Reagan made it a shining city.

9. Bill Clinton, remarks at dedication of William J. Clinton Presidential Center, "Transcript: Former President Clinton Speaks at Library Dedication," *Washington Post*, November 18, 2004.

10. *The William J. Clinton Presidential Center: Building a Bridge to the 21st Century* (New York: RAA Editions, 2006), 28.

11. Ibid.

12. The Clinton Library has continued its efforts in this area and, in 2007, was upgraded to a platinum rating.

13. Jill Stevenson, *Sensational Devotion: Evangelical Performance in Twenty-First Century America* (Ann Arbor: University of Michigan Press, 2013), 223.

14. Stephen L. Recken, Clinton Presidential Library review, *Public Historian* 28, no. 3 (Summer 2006): 215.

15. Barbara Kirshenblatt-Gimblett, *Destination Culture: Tourism, Museums, and Heritage* (Berkeley: University of California Press, 1998), 31.

16. John H. Falk and Lynn D. Dierking, *The Museum Experience* (Walnut Creek, CA: Left Coast Press, 2011), 78.

17. Elaine Heumann Gurian, "Noodling Around with Exhibition Opportunities," in *Exhibiting Cultures: The Poetics and Politics of Museum Display*, ed. Ivan Karp and Steven D. Lavine (Washington, DC: Smithsonian Institution Press, 1991), 181.

18. Ibid., 135.

19. Hayden White, *The Content of the Form: Narrative Discourse and Historical Representation* (Baltimore: Johns Hopkins University Press, 1987), 11.

20. Leahy, *Museum Bodies*, 60. Leahy helpfully traces the studies, which go back almost exactly one hundred years, to Benjamin Gilman's first article on the subject, published in 1916.

21. Sharon Fawcett, personal communication, October 14, 2010.

22. Ibid., 3, 4.

23. Kirshenblatt-Gimblett, *Destination Culture*, 134, 138, 132.

24. Dale Rogers-Evans, "Happy Trails," by Dale Evans and Roy Rogers, RCA Victor, 78 and 45 RPM, 1952, http://www.royrogers.com/happy_trails.html, accessed February 26, 2016.

25. Leahy, *Museum Bodies*, 48.

26. Bill Clinton, "Audio Tour of the William J. Clinton Presidential Library and Museum," William J. Clinton Presidential Center, Little Rock, AR, 2006.

27. Ibid.
28. Ibid.
29. Mark Crispin Miller, "Virtu, Inc.," in *Reagan as President: Contemporary Views of the Man, His Politics, and His Policies*, ed. Paul Boyer (Chicago: Ivan R. Dee, 1990), 80.
30. David Lusted, *The Western* (Essex, UK: Pearson Education Limited, 2003), 7.
31. Ronald Reagan Foundation and Library website.
32. Celsus: A Library Architecture Resource, "William J. Clinton Presidential Library (original construction)."
33. Bill Clinton, "Audio Tour."
34. Seamus Heaney, *The Cure at Troy* (New York: Farrar, Strauss and Giroux, 1991).
35. Bill Clinton, "Audio Tour."
36. See J. L. Austin, *How to Do Things with Words* (Oxford: Clarendon, 1962).
37. Ronald Reagan, "A Time for Choosing," televised campaign address for Goldwater Presidential Campaign, October 27, 1964, Ronald Reagan Presidential Library and Museum website.
38. Jan Hanska, *Reagan's Mythical America: Storytelling as Political Leadership* (New York: Palgrave MacMillan, 2012), 42.
39. Arthur W. Frank, *The Wounded Storyteller: Body, Illness, and Ethics* (Chicago: University of Chicago Press, 1997), 77, 90, 93.
40. Gil Troy, *Morning in America* (Princeton, NJ: Princeton University Press, 2005), 36, 35, 13.
41. George Gipp, "Knute Rockne's 'Win One for the Gipper' Speech," University of Notre Dame Archives.
42. Ronald Reagan Presidential Library, first-term gallery, permanent exhibition.

3. Character Forever: Yearning for Immortality

1. Peggy Phelan, *Unmarked: The Politics of Performance* (London: Routledge, 1993), 146. As Rebecca Schneider notes in her 2011 book, *Performing Remains*, Phelan's colleague, Richard Schechner, had begun formulating this association between performance and disappearance long before performance studies as a discipline existed. Phelan's contribution was to extend Schechner's ideas about performance to foster a general association between performance and death. Rebecca Schneider, *Performing Remains: Art and War in Times of Theatrical Reenactment* (London: Routledge, 2011).
2. Ibid., 27, 152.
3. Diana Taylor, *The Archive and the Repertoire* (Durham, NC: Duke University Press, 2003), 142.
4. Schneider, *Performing Remains*, 104–5.
5. Phelan, *Unmarked*, 19.
6. Herbert Hoover Library, permanent exhibit.

7. Richard Norton Smith and Timothy Walch, eds., *Farewell to the Chief: Former Presidents in American Public Life* (Worland, WY: High Plains Publishing Company, 1990), 35. From 1987 to 1993, Richard Norton Smith served as president of the Hoover Library.

8. George H. Nash, "Achieving Post-Presidential Greatness: Lessons from Herbert Hoover," in Smith and Walch, *Farewell to the Chief*, 41.

9. Mark Updegrove, *Second Acts: Presidential Lives and Legacies after the White House* (Guilford, CT: Lyons Press, 2006), 246.

10. Frank Newport, "Americans Say Reagan Is the Greatest U.S. President," Gallup, February 18, 2011.

11. Lloyd Bentsen, quoted in "The Vice Presidential Debate; Transcript of the Debate on TV between Bentsen and Quayle," *New York Times Archives*, October 6, 1988.

12. Alice George, *The Assassination of John F. Kennedy: Political Trauma and American Memory* (London: Routledge, 2013), 105.

13. Robert E. Gilbert, *The Mortal Presidency: Illness and Anguish in the White House* (New York: Fordham University Press, 1998), 148–49.

14. Ibid., 154–59.

15. Ibid., 68.

16. Alan Jay Lerner, "Camelot," in *Camelot* (Score) (New York: Chappell and Company, Inc., with Alfred Productions, Inc., 1960), 221–29.

17. John F. Kennedy Library, permanent exhibit.

18. Kennedy Library website.

19. Steven Cave, *Immortality: The Quest for Immortality and How It Drives Civilization* (New York: Crown Publishers, 2012), 230.

20. Timothy Raphael, *The President Electric: Ronald Reagan and the Politics of Performance* (Ann Arbor: University of Michigan Press, 2009), 132–33, 162.

21. Steven J. Ross, *Hollywood Right and Left: How Movie Stars Shaped American Politics* (Oxford: Oxford University Press, 2011), 161.

22. Ronald Reagan, Second 1984 Presidential Debate, October 28, 1984.

23. Gil Troy, *Morning in America* (Princeton, NJ: Princeton University Press, 2005), 13.

24. Ronald Reagan, Farewell Address, January 11, 1989.

25. Ronald Reagan Library, permanent exhibit.

26. Taylor, *Archive and the Repertoire*, 142.

27. Troy, *Morning in America*, 4.

28. Ronald Reagan, "Letter to the American People," November 5, 1994.

29. Taylor, *Archive and the Repertoire*, 144.

30. Jean Edward Smith, *Eisenhower in War and Peace* (New York: Random House, 2012), xiii.

31. Ibid., 516.

32. Dwight D. Eisenhower, Farewell Address, January 17, 1961.

33. Ibid.

34. Stephen E. Ambrose and Douglas G. Brinkley, *Rise to Globalism: American Foreign Policy since 1938* (New York: Penguin Books, 2011), 75, 79.

35. Dwight D. Eisenhower Library, permanent exhibit.

36. Truman Library, permanent exhibit.

37. David McCullough, *Truman* (New York: Simon and Schuster, 1992), 48.

38. LBJ Library, permanent exhibit.

39. Ibid.

40. Roosevelt's is another interesting case, though his library primarily represents his legacy as a legislative one.

4. Utopian Character: The Role of the Imaginary

1. Jill Dolan, *Utopia in Performance: Finding Hope at the Theater* (Ann Arbor: University of Michigan Press, 2008), 7.

2. Stephen J. McNamee and Robert K. Miller, *The Meritocracy Myth* (Lanham, MD: Rowman and Littlefield, 2004), 2.

3. Ibid., 2, 4.

4. Doris Kearns Goodwin, *Team of Rivals* (New York: Simon and Schuster, 2005), 29.

5. Ibid., 3.

6. McNamee and Miller, *Meritocracy Myth*, 16.

7. Dolan, *Utopia in Performance*, 6.

8. Hayden White, *The Content of the Form: Narrative Discourse and Historical Representation* (Baltimore: Johns Hopkins University Press, 1987), 111.

9. John H. Falk and Lynn D. Dierking, *The Museum Experience* (Walnut Creek, CA: Left Coast Press, 2011), 131.

10. White, *Content of the Form*, 110, 24.

11. David McCullough, *Truman* (New York: Simon and Schuster, 1992), 43, 44.

12. Ibid., 198.

13. Harry Truman Library, "Life and Times," permanent exhibit.

14. Harry Truman Library website.

15. White, *Content of the Form*, 14.

16. Jon Meacham, "Keeping the Dream Alive," *Time* (July 2, 2012): 33.

17. Carol Nackenoff, *The Fictional Republic: Horatio Alger and American Political Discourse* (New York: Oxford University Press, 1994), 3, 4, 8.

18. Jimmy Carter, *An Hour before Daylight: Memories of a Rural Boyhood* (New York: Simon and Schuster, 2001), 15.

19. McNamee and Miller, *Meritocracy Myth*, 31.

20. Martin Luther King Jr., "I Have a Dream," www.archives.gov/press/exhibits/dream-speech.pdf.

21. Seymour Martin Lipset, "A Changing American Character?," in *American Social Character*, ed. Rupert Wilkinson (New York: HarperCollins, 1992), 122.

22. This deprioritizing of difference in Republican administrations began to change with the campaign and presidency of George W. Bush. The change was evident in his active recruitment of Hispanic voters, including Spanish-language campaign ads; in his first inaugural address, the first in which an American president referred to mosques; and in his public repudiation of anti-Muslim sentiment in the United States following the terrorist attacks of September 11, 2001. Unfortunately, the George W. Bush museum does not highlight any of these performances.

23. Carter, *An Hour before Daylight*, 270.

24. McNamee and Miller, *Meritocracy Myth*, 41.

25. Robert Jones and Daniel Cox, *Religion and the Tea Party in the 2010 Election: An Analysis of the Third Biennial American Values Survey* (Washington, DC: Public Religion Research Institute, October 2010).

26. Sylvia Naguib, personal communication, May 7, 2015.

27. Jeff Walz, "Jimmy Carter and the Politics of Faith," in *Religion and the American Presidency*, ed. Mark J. Rozell and Gleaves Whitney, 2nd ed. (New York: Palgrave Macmillan, 2012), 158.

28. Richard M. Pious, *Why Presidents Fail* (Lanham, MD: Rowman and Littlefield, 2008), 111.

29. Nancy Gibbs and Michael Duffy, *The Presidents Club* (New York: Simon and Schuster, 2012), 404–5, 448.

30. Bruce Mazlish and Edwin Diamond, *Jimmy Carter: A Character Portrait* (New York: Simon and Schuster, 1979), 22.

31. Jimmy Carter Presidential Library website.

32. Richard Nixon Presidential Library, "Wilderness Years," permanent exhibition.

33. This essay deals with the 2010 renovation of the Reagan Library exhibition.

34. Ronald Reagan Presidential Library, "G.E. Theater," permanent exhibition.

35. Steven J. Ross, *Hollywood Left and Right: How Movie Stars Shaped American Politics* (New York: Oxford University Press, 2011), 158–59.

36. Herbert Hoover Library, permanent exhibition.

37. George H. W. Bush Presidential Library, early years display, permanent exhibition.

38. The Eisenhower Presidential Library dedicates significant space to the years of his early career but not, curiously, to the career itself. Instead, the several large rooms dedicated to these years function primarily as a lesson in World War II history—and, unfortunately, not a very good one.

39. McNamee and Miller, *Meritocracy Myth*, 12.

40. Dolan, *Utopia in Performance*, 171.

41. Ibid., 169–70.

42. Scott Magelssen, *Simming: Participatory Performance and the Making of Meaning* (Ann Arbor: University of Michigan Press, 2014), 93.

5. Character Failure: Efficiency and Discontinuity

1. Jon McKenzie, *Perform or Else: From Discipline to Performance* (London: Routledge, 2001), 5–6.

2. Ibid., 56. Italics in original.

3. Della Pollock, "Performing Writing," in *The Ends of Performance*, ed. Peggy Phelan and Jill Lane (New York: New York University Press, 1998), 91.

4. Thomas J. Craughwell, *Failures of the Presidents* (Beverly, MA: Fair Winds Press, 2008), 159, 301.

5. The description of the Bonus Army march narrates Hoover's reluctant agreement to send in troops and blames the incident on the disobedience of General MacArthur. The description of the Iranian hostage situation emphasizes Carter's personal concern for the Americans and the amount of private prayer the president dedicated to the crisis.

6. JFK Library website, "The Bay of Pigs."

7. JFK Library, permanent exhibition.

8. Stephen F. Knott and Jeffrey L. Chidester, *The Reagan Years* (New York: Facts on File, 2005), 49.

9. Charles Perrow and Mauro F. Guillen, *The AIDS Disaster: The Failure of Organizations in New York and the Nation* (New Haven: Yale University Press, 1990), 51.

10. Richard Miniter, *Losing Bin Laden: How Bill Clinton's Failures Unleashed Global Terror* (Washington, DC: Regnery Publishing, 2003), xvii.

11. William Nester, *Hearts Minds and Hydras* (Washington, DC: Potomac Books, 2012), 51–63.

12. William J. Clinton Library, permanent exhibit.

13. Benjamin Hufbauer, "Spotlights and Shadows: Presidents and Their Administrations in Presidential Museum Exhibits," *Public Historian* 28, no. 3 (Summer 2006): 124.

14. Gil Troy, *Morning in America* (Princeton, NJ: Princeton University Press, 2005), 252.

15. James P. Pfiffner, *The Modern Presidency*, 5th ed. (Boston, MA: Wadsworth, 2008), 263.

16. James P. Pfiffner, "Judging Presidential Character," *Public Integrity* 5, no. 1 (Winter 2002–3): 13.

17. Ronald Reagan, speech on Iran Arms and Contra Aid Controversy, March 4, 1987.

18. William J. Clinton Library, permanent exhibit.

19. David McCullough, *Character Above All*, PBS broadcast transcript, May 29, 1996.

20. Lewis L. Gould, *The Modern American Presidency*, 2nd ed. (Lawrence: University Press of Kansas, 2009), 254.

21. Herbert Hoover Library, permanent exhibit.

22. Ibid.

23. Gould, *Modern American Presidency*, 77.

24. Reagan Presidential Library website.

25. Starlee Kine, "Trickle Down History," *This American Life* no. 424, January 14, 2011.

26. Benjamin Hufbauer, *Presidential Temples: How Memorials and Libraries Shape Public Memory* (Lawrence: University Press of Kansas, 2005), 173.

27. Robert Justin Goldstein, "Prelude to McCarthyism: The Making of a Blacklist," *Prologue Magazine* 38, no. 3 (Fall 2006).

28. Truman Library, second decision theater.

29. Ford Library, cabinet room decision program.

30. Ford Library, permanent exhibit.

31. Ibid.

32. Dwight D. Eisenhower: "Farewell Radio and Television Address to the American People," January 17, 1961. Online by Gerhard Peters and John T. Woolley, *The American Presidency Project*.

33. Lyndon B. Johnson: "Annual Message to the Congress on the State of the Union," January 14, 1969. Online by Gerhard Peters and John T. Woolley, *The American Presidency Project*.

34. See for example Tania Bryer's interview with the former president on *CNBC Meets*, March 20, 2013.

Interlude: Ivaniz Silva Remembers Saying Good-Bye to the Bushes

1. Kate Andersen Brower, *The Residence: Inside the Private World of the White House* (New York, HarperCollins, 2015), 70.

6. Performing the American Community

1. Stephen J. McNamee and Robert K. Miller Jr., *The Meritocracy Myth* (Lanham, MD: Rowman and Littlefield, 2004), 79.

2. Steven J. Ross, *Hollywood Left and Right: How Movie Stars Shaped American Politics* (New York: Oxford University Press, 2011), 159.

3. Bruce Mazlish and Edwin Diamond, *Jimmy Carter: A Character Portrait* (New York: Simon and Schuster, 1979), 22.

4. Ryan J. Barrilleaux and Mark J. Rozell, *Power and Prudence: The Presidency of George H. W. Bush* (College Station Texas A&M University Press, 2004), 8.

5. Herbert Hoover Library, permanent exhibition.

6. Ibid., 161.

7. George H. W. Bush Library, permanent exhibition.

8. The presidents' relationships with foreign leaders are another exception. This is not surprising, since it is difficult if not impossible to claim radical individualism in foreign relations. The Nixon, Carter, Reagan, and Clinton Libraries happily foreground the presidents' relationships with Mao Zedong, Itzhak Rabin, Mikhail Gorbachev, and Nelson Mandela, respectively.

9. Sam McClure, personal communication. June 27, 2013.

10. John H. Falk and Lynn D. Dierking, *The Museum Experience* (Walnut Creek, CA: Left Coast Press, 2011), 23.

11. Dwight D. Eisenhower Library, permanent exhibit.

12. Susan Bennett, *Theatre and Museums* (New York: Palgrave Macmillan, 2013), 4, 77, 64.

13. Michael Warner, *Publics and Counterpublics* (New York: Zone Books, 2002), 122–23.

14. Many American history museums feature live performances, among them the Smithsonian's National Museum of American History and the privately administered Lincoln Library.

15. Catherine Hughes, *Museum Theatre: Communicating with Visitors through Drama* (Portsmouth, NH: Heinemann, 1998), 51.

16. Della Pollock, "Introduction: Making History Go," in *Exceptional Spaces*, ed. Della Pollock (Chapel Hill: University of North Carolina Press, 1998), 18.

Coda: Character 2.0—Reinventing the Presidential Library

1. Jon McKenzie, *Perform or Else: From Discipline to Performance* (London: Routledge, 2001), 30.

2. Scott Magelssen, *Simming: Participatory Performance and the Making of Meaning* (Ann Arbor: University of Michigan Press, 2014), 10.

3. Ibid., 255.

Bibliography

Allmendinger, Blake. *The Cowboy: Representations of Labor in an American Work Culture*. New York: Oxford University Press, 1992.

Ambrose, Stephen E., and Douglas G. Brinkley. *Rise to Globalism: American Foreign Policy since 1938*. New York: Penguin Books, 2011.

Barish, Jonas. *The Anti-Theatrical Prejudice*. Los Angeles: University of California Press, 1981.

Barrilleaux, Ryan J., and Mark J. Rozell. *Power and Prudence: The Presidency of George H. W. Bush*. College Station: Texas A&M University Press, 2004.

Bassenese, Lynn. Personal communication, January 17, 2013.

Beatty, Jack. "The President's Mind." In Boyer, *Reagan as President*, 51–52.

Bedard, Paul. "Peers Honor Nixon at Library Opening." *Washington Times*. July 20, 1990.

Bellah, Robert N. *The Broken Covenant: American Civil Religion in a Time of Trial*. New York: Seabury Press, 1975.

Bennett, Susan. *Theatre and Museums*. New York: Palgrave Macmillan, 2013.

Bennett, Tony. *Making Culture, Changing Society*. New York: Routledge, 2013.

Bentsen, Lloyd. Remarks in "October 5, 1988 Debate Transcript." Bentsen-Quayle Vice Presidential Debate. Commission on Presidential Debates. www.debates.org.

Bernstein, Carl, and Bob Woodward. *All the President's Men*. New York: Simon and Schuster, 1994.

Bin, Alberto, Richard Hill, and Archer Jones. *Desert Storm: A Forgotten War*. Westport, CT: Praeger, 1998.

Birch, Harold. "Vietnam and the Gulf War: Comparing Decision-Making in America's Longest and Shortest Wars." In Whicker et al., *Presidency and the Persian Gulf War*, 133–52.

Blair, Carole, Greg Dickinson, and Brian L. Ott. "Introduction: Rhetoric/Memory /Place." In Blair, Dickinson and Ott, *Places of Public Memory*, 1–54.

Bowman, Ruth Laurion, "Humbug and Romance in the American Marketplace." In Pollock, *Exceptional Spaces*, 121–41.

Boyer, Paul, ed. *Reagan as President: Contemporary Views of the Man, His Politics, and His Policies*. Chicago: Ivan R. Dee, 1990.

Brinkley, Douglas. *Cronkite*. New York: Harper Collins, 2012.

Brooks, Stephen. *American Exceptionalism in the Age of Obama*. New York: Routledge, 2013.

Brower, Kate Andersen. *The Residence: Inside the Private World of the White House.* New York: HarperCollins, 2015.

Bush, George H. W. *All the Best.* New York: Scribner, 2013.

Bush, George W. "Transcript of Bush-Blair News Conference," May 25, 2006. National Public Radio. http://www.npr.org/templates/story/story.php?storyId=5433122.

———. "Commencement Address at Yale University in New Haven, Connecticut," May 21, 2001. Online by Gerhard Peters and John T. Woolley, *The American Presidency Project.* http://www.presidency.ucsb.edu/ws/?pid=45895.

Butler, Judith. *Bodies That Matter: On the Discursive Limits of Sex.* New York and London: Routledge, 1993.

Canon, Lou. "Five Presidents and a Place in History: Past Chiefs and First Ladies Dedicate $57 Million Reagan Library." *Washington Post*, November 5, 1991, B1.

Carter, Jimmy. *Living Faith.* New York: Random House, 1996.

———. *An Hour before Daylight: Memories of a Rural Boyhood.* New York: Simon and Schuster, 2001.

Cave, Steven. *Immortality: The Quest for Immortality and How It Drives Civilization.* New York: Crown Publishers, 2012.

Celsus: A Library Architecture Resource. "William J. Clinton Presidential Library (original construction)." http://libraryarchitecture.wikispaces.com.

Clinton, Bill. "Audio Tour of the William J. Clinton Presidential Library and Museum." William J. Clinton Presidential Center, Little Rock, AR. 2006.

———. Remarks at dedication of William J. Clinton Presidential Center. "Transcript: Former President Clinton Speaks at Library Dedication." *Washington Post*, November 18, 2004. http://www.washingtonpost.com/wp-dyn/articles /A60393–2004Nov18_4.html.

Cohen, Richard. "Palaces: Presidential Museum Honors the Mediocre." *Washington Times*, September 22, 1981.

Cooper, Matthew. "Here's to Flip-Flops." *National Journal Magazine*, April 23, 2011.

Craughwell, Thomas J. *Failures of the Presidents.* Beverly, MA: Fair Winds Press, 2008.

Dahlburg, John-Thor, and Stuart Pfeifer. "For Feuding Nixon Sisters, Finally a Peace with Honor." *Los Angeles Times*, August 9, 2002.

Dallek, Robert. *Lyndon B. Johnson: Portrait of a President.* Oxford: Oxford University Press, 2004.

Davis, Tracy. "Performance and the Real Thing in the Postmodern Museum." *Drama Review* 39, no. 3 (Fall 1995): 15–40.

De Certeau, Michel. *The Practice of Everyday Life.* Translated by Steven Rendell. Berkeley: University of California Press, 1984.

Decker, Jeffrey Louis. *Made in America: Self-Styled Success from Horatio Alger to Oprah Winfrey.* Minneapolis: University of Minnesota Press, 1997.

Denzin, Norman K. "The Politics and Ethics of Performance Pedagogy." In *The Sage Handbook of Performance Studies*, edited by D. Soyini Madison and Judith Hamera, 325–38. Thousand Oaks, CA: Sage, 2006.

Dickinson, Greg, Carole Blair, and Brian L. Ott, eds. *Places of Public Memory: The Rhetoric of Museums and Memorials*. Tuscaloosa: University of Alabama Press, 2010.

Dolan, Jill. *Utopia in Performance: Finding Hope at the Theater*. Ann Arbor: University of Michigan Press, 2005.

———. *Geographies of Learning: Theory and Practice, Activism and Performance*. Middleton, CT: Wesleyan University Press, 2001.

Donaldson, Gary A. *The First Modern Campaign: Kennedy, Nixon, and the Election of 1960*. Lanham, MD: Rowman and Littlefield, 2007.

Dunn, Charles W., ed. *American Exceptionalism*. Lanham, MD: Rowman and Littlefield, 2013.

Eisenhower, Dwight D. "Farewell Radio and Television Address to the American People," January 17, 1961. Online by Gerhard Peters and John T. Woolley, *The American Presidency Project*. http://www.presidency.ucsb.edu/ws/?pid=12086.

Falk, John H., and Lynn D. Dierking. *The Museum Experience*. Walnut Creek, CA: Left Coast Press, 2011.

Farber, David. *The Rise and Fall of American Conservatism*. Princeton, NJ: Princeton University Press, 2010.

Fausold, Martin L. *The Presidency of Herbert Hoover*. Lawrence: University Press of Kansas, 1985.

Fawcett, Sharon. Personal communication, October 14, 2010.

———. Personal communication, September 29, 2010.

———. "Presidential Libraries: A View from the Center." *Public Historian* 28, no. 3 (Summer 2006): 13–36.

Fischer, David Hackett. *Growing Old in America*. Oxford: Oxford University Press, 1978.

Foucault, Michel. "Discipline and Punish." In *A Critical and Cultural Theory Reader*, edited by Anthony Easthope and Kate McGowan, 94–101. 2nd ed. Toronto: University of Toronto Press, 2004.

Frank, Arthur W. *The Wounded Storyteller: Body, Illness, and Ethics*. Chicago: University of Chicago Press, 1997.

Friedan, Betty. *The Fountain of Age*. New York: Simon and Schuster, 1993.

Genoways, Hugh H., and Mary Anne Andrei. *Museum Origins*. Walnut Creek, CA: Left Coast Press, 2008.

George, Alice. *The Assassination of John F. Kennedy: Political Trauma and American Memory*. London: Routledge, 2013.

Gibbs, Nancy, and Michael Duffy. *The Presidents Club: Inside the World's Most Exclusive Fraternity*. New York: Simon and Schuster, 2012.

Gilbert, Robert E. *The Mortal Presidency: Illness and Anguish in the White House*. New York: Fordham University Press, 1998.

Goldstein, Robert Justin. "Prelude to McCarthyism: The Making of a Blacklist." *Prologue* 38, no. 3 (Fall 2006).

Goodwin, Doris Kearns. *Team of Rivals*. New York: Simon and Schuster, 2005.

Gordon, T. David. "Taking Exception to American Exceptionalism." In Dunn, *American Exceptionalism*, 79–94.

Gould, Lewis L. *The Modern American Presidency*. 2nd ed. Lawrence: University Press of Kansas, 2009.

Greenberg, David. *Nixon's Shadow: The History of an Image*. New York: W. W. Norton and Company, 2003.

Greenfield, Meg. "The Great Personifier." In Boyer, *Reagan as President*, 251–52.

Gurian, Elaine Heumann. "Noodling Around with Exhibition Opportunities." In Karp and Lavine, *Exhibiting Cultures*, 176–90.

Hakes, Jay. Personal communication. August 3, 2011.

Hamera, Judith, ed. *Opening Acts: Performance in/as Communication and Cultural Studies*. Thousand Oaks, CA: Sage, 2006.

Hanska, Jan. *Reagan's Mythical America: Storytelling as Political Leadership*. New York: Palgrave MacMillan, 2012.

Harding, James. *Alpha Dogs*. New York: Farrar, Straus and Giroux, 2008.

Harris, John F. "Unity Shines in the Rain at Clinton Library Dedication." *Washington Post*, November 19, 2004, A01.

Harris, Neil. *Humbug: The Art of P. T. Barnum*. Boston: Little, Brown and Company. 1973.

Heaney, Seamus. *The Cure at Troy*. New York: Farrar, Strauss and Giroux, 1991.

Hofstadter, Richard. *Anti-intellectualism in American Life*. New York: Alfred A. Knopf, 1963.

Hoover, Herbert. Inaugural Address, March 4, 1929. Miller Center at the University of Virginia. http://millercenter.org/scripps/archive/speeches/detail/3570.

Hufbauer, Benjamin. "Spotlights and Shadows: Presidents and Their Administrations in Presidential Museum Exhibits," *Public Historian* 28, no. 3 (Summer 2006): 117–31.

———. *Presidential Temples: How Memorials and Libraries Shape Public Memory*. Lawrence: University Press of Kansas, 2005.

Hughes, Catherine. *Museum Theatre: Communicating with Visitors through Drama*. Portsmouth, NH: Heinemann, 1998.

Johnson, Lyndon B. "Annual Address to Congress on the State of the Union," January 12, 1966. LBJ Presidential Library. http://www.lbjlibrary.net/collections/selected-speeches/1966/01–12–1966.html.

———. "Annual Message to the Congress on the State of the Union," January 14, 1969. Online by Gerhard Peters and John T. Woolley, *The American Presidency Project*. http://www.presidency.ucsb.edu/ws/?pid=29333.

———. Conversation with Richard Russell. November 29, 1963 (K6311.06). Lyndon B. Johnson Presidential Recordings. Miller Center at the University of Virginia.

Jones, Robert, and Daniel Cox. *Religion and the Tea Party in the 2010 Election: An Analysis of the Third Biennial American Values Survey*. Washington, DC: Public Religion Research Institute, October 2010.

Kahlenberg, Richard D., ed. *Affirmative Action for the Rich: Legacy Preferences in College Admissions.* New York: The Century Foundation, 2010.

Kammen, Michael. *Mystic Chords of Memory.* New York: Vintage Books, 1991.

Karp, Ivan, and Steven D. Lavine, eds. *Exhibiting Cultures: The Poetics and Politics of Museum Display.* Washington, DC: Smithsonian Institution Press, 1991.

Kimmel, Michael. *Manhood in America.* 3rd ed. New York: Oxford University Press, 2012.

King, Martin Luther. "I Have a Dream." Address delivered at the March on Washington for Jobs and Freedom. Washington, D.C., August 28, 1963. www.archives.gov/press/exhibits/dream-speech.pdf.

Kine, Starlee. "Trickle Down History." *This American Life* no. 424, January 14, 2011.

Kirshenblatt-Gimblett, Barbara. *Destination Culture: Tourism, Museums, and Heritage.* Berkeley: University of California Press, 1998.

Klein, Joe. *Politics Lost.* New York: Doubleday, 2006.

Knott, Stephen F., and Jeffrey L. Chidester. *The Reagan Years.* New York: Facts on File, 2005.

Koch, Cynthia M., and Lynn A. Bassenese. "Roosevelt and his Library." *Prologue* 33, no. 2 (Summer 2001).

Kondracke, Morton, "Reagan's I.Q." in Boyer, *Reagan as President*, 47–51.

Kotler, Neil, and Philip Kotler. "Can Museums Be All Things to All People? Missions, Goals, and Marketing's Role." In *Reinventing the Museum*, edited by Gail Anderson, 167–86. Walnut Creek, CA: AltaMira Press, 2004.

Kurtz, Howard. "McCain Seeks Reagan Mantle." *Washington Post*, February 1, 2008.

Lawrence, John Shelton, and Robert Jewett. *The Myth of the American Superhero.* Grand Rapids, MI: Eerdmans, 2002.

Leahy, Helen Rees. *Museum Bodies: The Politics and Practices of Visiting and Viewing.* Surrey, UK: Ashgate, 2012.

Lelyveld, Joseph. "The Selling of a Candidate." *New York Times*, March 28, 1976, 189.

Leonhardt, David. "McCain's Fiscal Mantra Becomes Less Is More." *New York Times*, January 26, 2008, A1.

Lerner, Alan Jay. "Camelot." *Camelot* (Score). New York: Chappell and Company, Inc., with Alfred Productions, Inc., 1960.

Lincoln, Abraham. "Gettysburg Address," November 19, 1863. Cornell University New Student Reading Project. http://reading.cornell.edu/lincoln_at_gettysburg/gettysburg_address_print.cfm.

Lipset, Seymour Martin. "A Changing American Character?" In *American Social Character*, edited by Rupert Wilkinson, 98–133. New York: HarperCollins, 1992.

Loeb, Marshall, Lee Smith, and Ann Reilly Dowd. "Reagan on Decision-Making, Planning, Gorbacev and More." *Fortune*, September 15, 1986.

Luke, Timothy W. *Museum Politics: Power Plays at the Exhibition.* Minneapolis: University of Minnesota Press, 2002.

Lusted, David. *The Western.* Essex, UK: Pearson Education Limited, 2003.

Magelsson, Scott. *Simming: Participatory Performance and the Making of Meaning*. Ann Arbor: University of Michigan Press, 2014.

———. "Introduction." In *Enacting History*, edited by Rhona Malloy and Scott Magelsson, 1–9. Tuscaloosa: University of Alabama Press, 2011.

Mast, Jason L. *The Performative Presidency: Crisis and Resurrection during the Clinton Years*. Cambridge: Cambridge University Press, 2013.

Mazlish, Bruce, and Edwin Diamond, *Jimmy Carter: A Character Portrait*. New York: Simon and Schuster, 1979.

McAllister, Ted. Reagan Presidential Library Exhibit Review in *Public Historian* 28, no. 3 (Summer 2006): 208–11.

McClure, Sam. Personal communication. June 27, 2013.

McCullough, David. *Truman*. New York: Simon and Schuster, 1992.

———. *Character Above All*. PBS broadcast transcript, May 29, 1996.

McKenzie, Jon. *Perform or Else: From Discipline to Performance*. New York: Routledge, 2001.

McNamee, Stephen J., and Robert K. Miller Jr. *The Meritocracy Myth*. Lanham, MD: Rowman and Littlefield, 2004.

McNeil/Lehrer Productions. PBS Video. "Character above All." Williamsburg, VA, 1996.

Meacham, Jon. "Keeping the Dream Alive." *Time*, July 2, 2012, 26–39.

Miller, Mark Crispin, "Virtu, Inc." In Boyer, *Reagan as President*, 75–82.

Miniter, Richard. *Losing Bin Laden: How Bill Clinton's Failures Unleashed Global Terror*. Washington, DC: Regnery Publishing, 2003.

Moore, Raymond A. "The Case FOR the War." In Whicker et al., *Presidency and the Persian Gulf War*, 91–110.

Nackenoff, Carol. *The Fictional Republic: Horatio Alger and American Political Discourse*. New York: Oxford University Press, 1994.

Naftali, Timothy. Personal communication. July 27, 2011.

———. Personal communication. October 4, 2011.

Nash, George H. "Achieving Post-Presidential Greatness: Lessons from Herbert Hoover." In Norton and Walch, *Farewell to the Chief*, 36–43.

National Archives and Records Administration. "Report on Alternative Models for Presidential Libraries." September 25, 2009.

Nester, William. *Hearts, Minds, and Hydras*. Washington, DC: Potomac Books, 2012.

Newport, Frank. "Americans Say Reagan Is the Greatest U.S. President." Gallup, February 18, 2011.

Nichols, Bill and Richard Benedetto, "Clinton Library Opening Draws Stars." *USA Today*, November 19, 2004, 1A.

Nixon, Richard. First Inaugural Address, November 20, 1969. http://www.theusgov.com/richarnixon%20Inaugural%20speech.htm.

———. Quoted in David Frost. *Frost/Nixon: Behind the Scenes of the Nixon Interviews*. New York: Harper Perennial, 2007.

Nora, Pierre. "Between Memory and History: Les Lieux de Memoire." *Representations* no. 26 (Spring, 1989): 7–24.

Perrow, Charles, and Mauro F. Guillen. *The AIDS Disaster: The Failure of Organizations in New York and the Nation*. New Haven, CT: Yale University Press, 1990.

Pfiffner, James P. *The Modern Presidency*. 5th ed. Boston: Wadsworth, 2008.

———. "Judging Presidential Character," *Public Integrity* 5, no. 1 (Winter 2002–3): 7–24.

———. "Presidential Policy-Making and the Gulf War." In Whicker et al., *Presidency and the Persian Gulf War*, 3–23.

Phelan, Peggy. *Unmarked: The Politics of Performance*. London: Routledge, 1993.

Pineau, Elyse Lamm. "Critical Performance Pedagogy." In Stucky and Wimmer, *Teaching Performance Studies*, 41–54.

Pious, Richard M. *Why Presidents Fail*. Lanham, MD: Rowman and Littlefield, 2008.

Pollock, Della. "Introduction: Making History Go." In Pollock, *Exceptional Spaces*, 1–48.

———. "Performing Writing." In *The Ends of Performance*, edited by Peggy Phelan and Jill Lane, 73–103. New York: New York University Press, 1998.

Pollock, Della, ed. *Exceptional Spaces*. Chapel Hill: University of North Carolina Press, 1998.

Raphael, Timothy. *The President Electric: Ronald Reagan and the Politics of Performance*. Ann Arbor: University of Michigan Press, 2009.

Reagan, Ronald. Farewell Address, January 11, 1989. Miller Center, University of Virginia. http://millercenter.org/president/speeches/detail/3418.

———. Letter to the American People, November 5, 1994. Public Broadcasting System. WGBH "American Experience." http://www.pbs.org/wgbh/americanexperience/features/primary-resources/reagan-alzheimers/.

———. Remarks at Library Dedication, November 4, 1991. Transcribed by Clay Walker. http://www.planbproductions.com/postnobills/reagan1.html.

———. Second 1984 Presidential Debate, October 28, 1984. "Debating Our Destiny," Public Broadcasting System. http://www.pbs.org/newshour/debatingourdestiny/84debates/2prez2.html.

———. Speech on the Iran Arms and Contra Aid Controversy, March 4, 1987. Public Broadcasting System. WGBH "American Experience." http://www.pbs.org/wgbh/americanexperience/features/primary-resources/reagan-iran-contra/.

———. "A Time for Choosing," Televised Campaign Address for Goldwater Presidential Campaign, October 27, 1964. Ronald Reagan Presidential Library and Museum website. http://www.reagan.utexas.edu/archives/speeches/major.html#.UlQdASR56Ic.

———. *Where's the Rest of Me?* New York: Karz-Segil Publishers, 1981.

"Reagan." American Experience. Public Broadcasting Corporation. http://www.pbs.org/wgbh/americanexperience/features/biography/reagan-ronald/

Recken, Stephen L. Clinton Presidential Library Review. *Public Historian* 28, no. 3 (Summer 2006): 211–16.

Reinhardt, Uwe E. "Reaganomics, R.I.P." In Boyer, *Reagan as President*, 122–27.

Richardson, Valerie. "It's Morning in Simi Valley; Reagan's California Library Sees the Dawn." *Washington Times*, November 4, 1991, D1.

Rivera-Servera, Ramon H. "Exhibiting Voice/Narrating Migration: Performance-Based Curatorial Practice in '¡Azúcar! The Life and Music of Celia Cruz.'" *Text and Performance Quarterly* 29, no. 2 (April 2009): 131–64.

Roach, Joseph. *Cities of the Dead: Circum-Atlantic Performance*. New York: Columbia University Press, 1996.

Rockne, Knute. "Knute Rockne's 'Win One for the Gipper' Speech." University of Notre Dame Archives. http://archives.nd.edu/research/texts/rocknespeech.htm.

"Ronald Reagan Presidential Library and Museum." Visitor information pamphlet.

Rogers-Evans, Dale. "Happy Trails." Dale Evans and Roy Rogers. RCA Victor, 78 and 45 RPM. 1952. Accessed February 26, 2016. http://www.royrogers.com/happy_trails.html.

Roosevelt, Franklin D. "Address to Congress Requesting a Declaration of War with Japan," December 8, 1841. Franklin Delano Roosevelt Library. http://docs.fdrlibrary.marist.edu/tmirhdee.html.

Roosevelt Library and Museum website. "FDR Dedicated the First Presidential Library." http://www.fdrlibrary.marist.edu/library/dedication.html.

Rorabaugh, W. J. *The Real Making of the President: Kennedy, Nixon, and the 1960 Election*. Lawrence: University Press of Kansas, 2009.

Rosenzweig, Roy, and David Thelen. *The Presence of the Past: Popular Uses of History in American Life*. New York: Columbia University Press, 1998.

Ross, Steven J. *Hollywood Left and Right: How Movie Stars Shaped American Politics*. New York: Oxford University Press, 2011.

Rozell, Mark J., and Gleaves Whitney, eds. *Religion and the American Presidency*. 2nd ed. New York: Palgrave Macmillan, 2012.

Rozell, Mark J., and Clyde Wilcox, eds. *The Clinton Scandal and the Future of Government*. Washington, DC: Georgetown University Press, 2000.

Schmidt, Peter. "A History of Legacy Preferences and Privilege." In Kahlenberg, *Affirmative Action for the Rich*, 33–69.

Schneider, Rebecca. *Performing Remains: Art and War in Times of Theatrical Reenactment*. New York: Routledge, 2011.

Seelye, Katharine Q. "Clinton Library Reflects Its Subject's Volatile Era." *New York Times*, November 18, 2004.

Sheehy, Gail. "Reality? Just Say No." In Boyer, *Reagan as President*, 226–28.

Smith, Jean Edward. *Eisenhower in War and Peace*. New York: Random House, 2012.

Smith, Richard Norton, and Timothy Walch, eds. *Farewell to the Chief: Former Presidents in American Public Life*. Worland, WY: High Plains Publishing Company, 1990.

Spitzer, Robert J. "The Conflict between Congress and the President over War." In Whicker et al., *Presidency and the Persian Gulf War*, 25–44.

Sterngold, James. "Nixon Daughters Battle over $19 Million Bequest." *New York Times*, March 16, 2002.

Stevenson, Jill. *Sensational Devotion: Evangelical Performance in Twenty-First Century America*. Ann Arbor: University of Michigan Press, 2013.

Stucky, Nathan, and Cynthia Wimmer, eds. *Teaching Performance Studies*. Carbondale: Southern Illinois University Press, 2002.

Sussman, Dalia. "Most Americans Can't Explain Watergate." ABC News. June 17, 2002. Retrieved at http://abcnews.go.com/US/story?id=90387.

Taylor, Diana. *The Archive and the Repertoire*. Durham, NC: Duke University Press, 2003.

———. "Dancing with Diana: A Study in Hauntology." *Drama Review* 43, no. 1 (1999): 56–79.

Thelan, David, ed. *Memory and American History*. Bloomington: Indiana University Press, 1990.

Troy, Gil. *Morning in America*. Princeton, NJ: Princeton University Press, 2005.

Tumulty, Karen. "American Exceptionalism: An Old Idea and a New Political Battle." *Washington Post*, November 29, 2010.

Updegrove, Mark. *Indomitable Will: LBJ in the Presidency*. New York: Crown, 2012.

———. Personal communication, August 7, 2013.

———. Personal communication, August 21, 2013.

———. *Second Acts: Presidential Lives and Legacies after the White House*. Guilford, CT: The Lyons Press, 2006.

———. "The Vice-Presidential Debate; Transcript of the Debate on TV between Bentsen and Quayle." *New York Times Archives*, October 6, 1988.

Wallace, Mike. *Mickey Mouse History and Other Essays on American Memory*. Philadelphia: Temple University Press, 1996.

Walsh, Kenneth T. *Family of Freedom: Presidents and African Americans in the White House*. Boulder, CO: Paradigm, 2011.

Walz, Jeff. "Jimmy Carter and the Politics of Faith." In Rozell and Whitney, *Religion and the American Presidency*, 57–73.

Warner, Michael. *Publics and Counterpublics*. New York: Zone Books, 2002.

Whicker, Marcia Lynn, "The Case AGAINST the War." In Whicker et al., *Presidency and the Persian Gulf War*, 111–32.

Whicker, Marcia Lynn, James P. Pfiffner, and Raymond A. Moore, eds. *The Presidency and the Persian Gulf War*. Westport, CT: Praeger, 1993.

White, Hayden. *The Content of the Form: Narrative Discourse and Historical Representation*. Baltimore: Johns Hopkins University Press, 1987.

White, John Kenneth, and Matthew R. Kerbel. *Party On! Political Parties from Hamilton and Jefferson to Today's Networked Age*. Boulder, CO: Paradigm, 2012.

Whiteson, Leon. "Nixon Library Hits Close to Home." *Los Angeles Times*, July 19, 1990.

Wiener, Jon. *Professors, Politics, and Pop*. New York: Verso, 1991.

The William J. Clinton Presidential Center: Building a Bridge to the 21st Century. New York: RAA Editions, 2006.

Winchell, N. H. "Museums and Their Purpose." In Genoways and Andrei, *Museum Origins*, 269–73.

Worsham, James. "Nixon's Library Now a Part of NARA." *Prologue* 39, no. 3 (Fall 2007).

Zinn, Howard. *A People's History of the United States.* New York: HarperCollins, 1980.

———. "The Power and the Glory: Myths of American Exceptionalism." *Boston Review,* Summer 2005.

Index

Page numbers in italics indicate illustrations.

Jodi Kanter is an associate professor of theatre at the George Washington University and the author of *Performing Loss: Rebuilding Community through Theater and Writing.*

Theater in the Americas

The goal of the series is to publish a wide range of scholarship on theater and performance, defining theater in its broadest terms and including subjects that encompass all of the Americas.

The series focuses on the performance and production of theater and theater artists and practitioners but welcomes studies of dramatic literature as well. Meant to be inclusive, the series invites studies of traditional, experimental, and ethnic forms of theater; celebrations, festivals, and rituals that perform culture; and acts of civil disobedience that are performative in nature. We publish studies of theater and performance activities of all cultural groups within the Americas, including biographies of individuals, histories of theater companies, studies of cultural traditions, and collections of plays.

Queries and Submissions
Scott Magelssen, Editor
magelss@uw.edu

Founder and Editor, Robert A. Schanke, 2000–2014

Other Books in the Theater in the Americas Series

*Shadowed Cocktails: The Plays of
Philip Barry from "Paris Bound"
to "The Philadelphia Story"*
Donald R. Anderson

*A Gambler's Instinct: The Story of
Broadway Producer Cheryl Crawford*
Milly S. Barranger

*Unfriendly Witnesses: Gender, Theater,
and Film in the McCarthy Era*
Milly S. Barranger

*The Theatre of Sabina Berman: "The
Agony of Ecstasy" and Other Plays*
Translated by Adam Versényi
With an Essay by Jacqueline E. Bixler

*Experiments in Democracy: Interracial
and Cross-Cultural Exchange in
American Theatre, 1912–1945*
Edited by Cheryl Black
and Jonathan Shandell

*Staging Social Justice: Collaborating
to Create Activist Theatre*
Edited by Norma Bowles
and Daniel-Raymond Nadon

*Messiah of the New Technique:
John Howard Lawson, Communism,
and American Theatre, 1923–1937*
Jonathan L. Chambers

*Composing Ourselves: The Little
Theatre Movement and the
American Audience*
Dorothy Chansky

*Ghost Light: An Introductory
Handbook for Dramaturgy*
Michael Mark Chemers

*The Hanlon Brothers: From Daredevil
Acrobatics to Spectacle Pantomime,
1833–1931*
Mark Cosdon

*Richard Barr: The
Playwright's Producer*
David A. Crespy

*Women in Turmoil: Six Plays by
Mercedes de Acosta*
Edited and with an Introduction
by Robert A. Schanke

*Rediscovering Mordecai Gorelik: Scene
Design and the American Theatre*
Anne Fletcher

*A Spectacle of Suffering: Clara Morris
on the American Stage*
Barbara Wallace Grossman

American Political Plays after 9/11
Edited by Allan Havis

*Performing Loss: Rebuilding
Community through Theater
and Writing*
Jodi Kanter

*Unfinished Show Business:
Broadway Musicals as
Works-in-Process*
Bruce Kirle